Canon® EOS Digital Rebel XTi/400D Digital Field Guide

Canon® EOS Digital Rebel XTi/400D Digital Field Guide

Charlotte K. Lowrie

BICENTENNIAL
1807
WILEY
2007
BICENTENNIAL

Wiley Publishing, Inc.

Canon® EOS Digital Rebel XTi/400D Digital Field Guide

Published by
Wiley Publishing, Inc.
111 River Street
Hoboken, N.J. 07030-5774
www.wiley.com

Copyright © 2007 by Wiley Publishing, Inc., Indianapolis, Indiana

Published simultaneously in Canada

Library of Congress Control Number: 2006939458

ISBN: 978-0-470-11007-2

Manufactured in the United States of America

10 9 8 7 6 5 4 3

1K/ST/QR/QX/IN

For general information on our other products and services or to obtain technical support, please contact our Customer Care Department within the U.S. at (800) 762-2974, outside the U.S. at (317) 572-3993 or fax (317) 572-4002.

Wiley also publishes its books in a variety of electronic formats. Some content that appears in print may not be available in electronic books.

WILEY

About the Author

Charlotte Lowrie is an award-winning freelance journalist and professional photographer based in the Seattle area. She shoots portraits and editorial assignments, as well as stock photography. Her writing and photography have appeared in newsstand magazines and newspapers, and on industry Web sites including the Canon Digital Learning Center and TakeGreatPictures.com (www.TakeGreatPictures.com). Charlotte is the author of four books, including the *Canon EOS Digital Rebel XT Digital Field Guide, Adobe Camera Raw Studio Skills, Canon EOS 30D Digital Field Guide*, and *Teach Yourself Visually Digital Photography, 2nd Edition*, all published by John Wiley & Sons.

She teaches photography classes on BetterPhoto.com (www.BetterPhoto.com).

You can see more of her work at www.wordsandphotos.org.

Credits

Acquisitions Editor
Kim Spilker

Project Editor
Cricket Krengel

Copy Editor
Marylouise Wiack

Editorial Manager
Robyn Siesky

Vice President & Group Executive Publisher
Richard Swadley

Vice President & Publisher
Barry Pruett

Business Manager
Amy Knies

Project Coordinator
Adrienne Martinez

Graphics and Production Specialists
Brooke Graczyk
Jennifer Mayberry
Rashell Smith
Amanda Spagnuolo

Quality Control Technician
Dwight Ramsey

Cover Design
Michael Trent

Proofreader
Jennifer Stanley

Indexer
Sherry Massey

*This book is dedicated with love to my mother,
who is a continual delight, and to God,
whose creation and love inspires and guides me.*

Acknowledgments

Special thanks to Cricket Krengel, an extraordinary Wiley project editor and a gifted photographer, and to Bryan Lowrie, Sandy Rippel, and Peter Burian who all kindly contributed images for this book. Also special thanks to Heath Hamblen, Keiley, and others who graciously donated their time to model for images in this book, and to the Rev. Mike Howerton and others at Overlake Christian Church in Redmond, WA, who allowed me to photograph during services.

Contents at a Glance

Introduction . xxi

Quick Tour . 1

Part I: Using the Digital Rebel XTi/400D **11**
Chapter 1: Exploring and Setting Up the Digital Rebel XTi/400D 13
Chapter 2: Using Your Digital Rebel XTi/400D 35

Part II: Creating Great Photos with the Digital Rebel XTi/400D . . **67**
Chapter 3: Photography Basics . 69
Chapter 4: Let There Be Light . 83
Chapter 5: The Art and Science of Lenses 95
Chapter 6: Composition Basics . 107
Chapter 7: Techniques for Great Photos 119
Chapter 8: Downloading and Editing Pictures. 221

Part III: Appendixes . **233**
Appendix A: Custom Functions . 235
Appendix B: Internet Resources . 239
Glossary . 243

Index. 253

Contents

Introduction xxi

Quick Tour 1

Taking Your First Pictures 1
Setting Up the Digital Rebel
 XTi/400D 3
 Set the date and time 3
 Set the image recording quality 3
 Set the ISO 4
 Set the white balance 4
Basic Zone Shooting 5
Creative Zone Shooting 5
Setting the Autofocus Point 7
Setting the Drive Mode 7
Setting the Metering Mode 8
Transferring Images to the Computer 8

**Part I: Using the Digital
Rebel XTi/400D 11**

**Chapter 1: Exploring and
Setting Up the Digital Rebel
XTi/400D 13**

Camera and Lens Controls 14
Rear Camera Controls 15
The LCD 17
Viewfinder Display 17
Setting Up the Digital Rebel
 XTi/400D 18
About Media Cards 19
Setting the Date and Time 20
Choosing the File Format and
 Quality 21
 JPEG format 22
 RAW format 22

Choosing a White-Balance Option 24
 Cover your white-balance
 bases 26
 Mixed light? No problem 26
Choosing a Picture Style 27
Setting Monochrome Filter and
 Toning Effects 31
Changing File Numbering 33

**Chapter 2: Using Your Digital
Rebel XTi/400D 35**

Mode Dial 36
 Basic Zone modes 36
 Full Auto mode 37
 Portrait mode 38
 Landscape mode 38
 Close-up mode 39
 Sports mode 39
 Night Portrait mode 40
 Flash-off mode 41
 Creative Zone modes 41
 P mode 42
 A-DEP mode 42
 Av mode 43

 Tv mode 44
 M mode 45
Metering Modes 45
 Evaluative metering 46
 Center-weighted Average
 metering 47
 Partial metering 47
Exposure Compensation 47
Auto Exposure Bracketing 48
AE Lock 49
Evaluating Exposure 50
Focus and Autofocus Modes 52
Understanding Autofocus Point
 Selection 53
Using Drive Modes 55
 Single-shot mode 55
 Continuous mode 55
Viewing and Playing Back Images 56
 Single-image playback 56
 Index Display 57
 Auto Playback 57
 The DISP button 58
Erasing Images 59
Protecting Images 59
Using a Flash 60
 Red-eye reduction 62
 FE lock 62
Using the EOS Integrated
 Cleaning System 63
 Automatic sensor cleaning 63
 Obtaining Dust Delete Data 64
 Applying Dust Delete Data 65

Part II: Creating Great Photos with the Digital Rebel XTi/400D 67

Chapter 3: Photography Basics 69

Time: The Role of Shutter Speed 78
Equivalent Exposures 80
Putting It All Together 82

Chapter 4: Let There Be Light 83

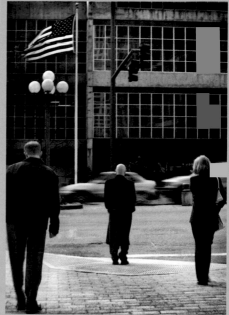

The Four Elements of Exposure 69
Sensitivity: The Role of ISO 71
Intensity: The Role of the Aperture 73
 Wide aperture 73
 Narrow aperture 73
 Aperture in Basic Zone modes 74
 Aperture in Creative Zone modes 74
 Choosing an aperture 75
What is Depth of Field? 76
 Shallow depth of field 76
 Extensive depth of field 76

Color Hues 83
The Colors of Light 86
 Sunrise 86
 Midday 86
 Sunset 87
 Diffused light 87
 Electronic flash 88
 Tungsten light 88
 Fluorescent and other light 89
Metering Light 90
Additional Characteristics of Light 90
 Hard/harsh light 90
 Soft light 91
 Directional light 92

Chapter 5: The Art and Science of Lenses 95

Chapter 6: Composition Basics 107

Lens Choices	95
Wide angle	96
Normal	96
Telephoto	96
Macro	97
Understanding Zoom and Single-Focal-Length Lenses	97
Zoom lens advantages	98
Zoom lens disadvantages	98
Single-focal-length lens advantages	98
Single-focal-length lens disadvantages	99
Understanding the Focal-Length Multiplication Factor	99
Using Wide-Angle Lenses	100
Using Normal Lenses	102
Using Telephoto Lenses	102
Using Macro Lenses	103
Extending the Range of Any L-Series Lens	105

Understanding Composition	108
Using the Rule of Thirds	109
Symmetry	110
Is symmetry good or bad?	110
Create a sense of balance	111
Tone	111
Direction	111
What lines convey	112
Fill the frame	113
Check the background	113
Frame the subject	114
Composing with Color	114
Controlling the Focus and Depth of Field	115
Defining Space and Perspective	117

Chapter 7: Techniques for Great Photos 119

Privacy Notes 120
Architectural Photography 120
 Inspiration 122
 Taking architectural and
 interior photographs 123
 Architectural
 photography tips 125
Action and Sports Photography 125
 Inspiration 127
 Taking action and sports
 photographs 128
 Action and sports
 photography tips 130
Black-and-White Photography 130
 Inspiration 132
 Taking black-and-white
 photographs 133
 Black-and-white
 photography tips 134
Business Photography 135
 Inspiration 135
 Taking business photographs 136
 Business photography tips 138

Candid Photography 138
 Inspiration 139
 Taking candid photographs 140
 Candid photography tips 141
Child Photography 142
 Inspiration 144
 Taking child photographs 144
 Child photography tips 146
Environmental Portrait
 Photography 146
 Inspiration 147
 Taking environmental
 portrait photographs 148
 Environmental portrait
 photography tips 149
Event Photography 150
 Inspiration 151
 Taking event photographs 152
 Event photography tips 153
Fine-Art Photography 154
 Inspiration 155
 Taking fine-art photographs 155
 Fine-art photography tips 157
Flower and Macro Photography 157
 Inspiration 158
 Taking flower and macro
 photographs 159
 Flower and macro
 photography tips 161
Landscape and Nature
 Photography 161
 Inspiration 163
 Taking landscape and nature
 photographs 163
 Landscape and nature
 photography tips 165
Low-Light and Night Photography 165
 Inspiration 168
 Taking low-light and night
 photographs 169
 Low-light and night
 photography tips 171
Panoramic Photography 171
 Inspiration 172

Taking panoramic
 photographs 173
Panoramic photography tips 174
Pet and Animal Photography 174
Inspiration 175
Taking pet and animal
 photographs 176
Pet and animal
 photography tips 178
Photojournalism 178
Inspiration 179
Taking photojournalism
 photographs 180
Photojournalism
 photography tips 181
Portrait Photography 182
 Lens choices 182
 Backgrounds and props 182
 Lighting 183
 Flash 183
 Posing 184
 Clothing 185
 Rapport 185
Inspiration 185
Taking portrait photographs 186
Portrait photography tips 188
Still-Life Photography 188
Inspiration 190
Taking still-life photographs 191
Still-life photography tips 193
Stock Photography 193
Inspiration 195
Taking stock photographs 196
Stock photography tips 198
Street Photography 198
Inspiration 199
Taking street photographs 201
Street photography tips 203
Sunset and Sunrise Photography 203
Inspiration 205
Taking sunset and sunrise
 photographs 205

Sunset and sunrise
 photography tips 207
Travel Photography 207
Inspiration 209
Taking travel photographs 210
Travel photography tips 211
Weather and Seasonal
 Photography 212
 Falling rain and snow 212
 Fog 213
 Snow 213
 Stormy skies 213
Inspiration 213
Taking weather and
 seasonal photographs 214
Weather and seasonal
 photography tips 215
Wedding Photography 216
Inspiration 217
Taking wedding
 photographs 218
Wedding photography tips 219

Chapter 8: Downloading and Editing Pictures 221

Downloading with a USB Cable 221
Downloading with a Card Reader 224
Downloading with a PCMCIA
 Card 225
Converting RAW Images 225
Editing Images 228
Updating Firmware and Software 231

Part III: Appendixes 233

Appendix A: Custom Functions 235

Changing a Custom Function 235
Custom Functions and Options 236

Appendix B: Internet Resources 239

Canon 239
Photography Publications and
 Web Sites 240
Photography Workshops 240

Glossary 243

Index 253

Introduction

One of my favorite photographers, Henri Cartier-Bresson, said in his book *The Mind's Eye: Writings on Photography and Photographers*, "Of all means of expression, photography is the only one that fixes forever the precise and transitory instant. We photographers deal in things that are continually vanishing, and when they have vanished, there is no contrivance on earth that can make them come back again. . . for photographers, what has gone is gone forever."

In this quote, Cartier-Bresson encapsulated the immediacy of photography, its singular ability to capture a fleeting moment in time, and the need to capture moments before they're gone forever. Regardless of the subjects that you most enjoy photographing, the ability to capture timeless moments is what both photography and this book are about.

You may already know that the Digital Rebel XTi/400D makes digital photography easy and fun. If you're ready to take the next step in becoming more familiar with the camera and developing your skills as a photographer, then this book can help you to achieve both. I've packed the book with easy-to-use techniques — techniques that can help you to make pictures similar to those that you admire and wish that you had taken.

In.1 An inexpensive, basic 50mm lens provides great results. Of course, a good and happy subject helps, too.

And, if you are holding a Digital Rebel XTi in your hands right now and wondering about the references to the 400D (or vice versa), not to worry. The XTi and the 400D are the very same camera, but they have different model numbers depending on what part of the world you live in.

It's All About Having Fun

Photography has always been fun. Digital photography makes it even more so. The Digital Rebel XTi opens the door to limitless fun, practice, experimentation, and a creative freedom — freedom to try things that were too expensive to try with film photography or too advanced to try with a compact camera.

I encourage you to take the Digital Rebel XTi/400D to its creative limits. Don't worry if you don't have a large collection of lenses. For even complex photos, the lens that came with the camera is often enough to give you the range that you need to get great results. If you do have a bag full of lenses, you'll find great uses for them in this book.

As you use this book and try the photo projects, always remember that it is the photographer who makes the picture, not the camera, although having a camera as great as the Digital Rebel is definitely a plus.

Getting the Most from This Book

If you just can't wait to take some shots with your new Digital Rebel XTi/400D, the Quick Tour is exactly what you need. It takes you step-by-step through taking your first pictures and getting a finished image — whether it is for the Web, to print and frame, or to e-mail to a friend. Once you've satisfied your curiosity by taking those first few shots, Chapters 1 and 2 take you on a detailed tour of camera features, functions, and setup procedures. You may already be familiar with some of the information, but it's worth browsing through the chapters with an eye toward anything that may be new. This strategy fulfills an important goal: helping you get to know the camera thoroughly. Ultimately, you want to get to know your camera so well that you can use it with confidence, even in the dark.

Subsequent chapters review the basics of photography, light, and lenses. After years of working with all levels of photographers, I've found that many photography hobbyists know some, but not all, of the basics of photography. These chapters can be a great foundation for beginners and a helpful refresher for more experienced photographers.

Most important, these chapters can help you to understand how controls and functions on the Digital Rebel XTi/400D work together with your photography knowledge to make a picture. When you know how the exposure is made, you'll be much more confident when changing settings because you will know what results you can expect.

In.2 As you learn how the exposure elements work together, you'll be more confident in experimenting with camera settings.

After all the basics are covered, the book switches gears to discuss specific photography topics. Chapter 7 is rather long at first glance, but within its many pages, you will find a wealth of information that aims at helping you make the most of specific scenarios. It is broken down into popular photography subjects ranging from portraits and travel to abstracts and sports, each one providing do-it-yourself techniques for making the best possible pictures.

Within each subject topic, you'll find:

✦ Example photos

✦ Discussions about each type of subject

✦ Inspiring ideas for making pictures of these subjects

✦ A practice photo with specific information on how the picture is made including setup, lighting, lens, exposure mode and exposure settings, and optional accessories that you may find helpful

✦ Composition and perspective pointers

Also scattered throughout the chapter are creative suggestions and techniques for handling difficult photography scenes. Finally, Chapter 8 provides an overview of downloading, editing, and printing the pictures that you make.

Now is a great time to get started reading and shooting. The editor, the staff at Wiley, and I all hope that you'll enjoy using this book as much as we enjoyed creating it for you.

Quick Tour

✦ ✦ ✦ ✦

In This Chapter

Taking your first pictures

Setting up the Digital Rebel XTi/400D

Basic Zone shooting

Creative Zone shooting

Setting the autofocus point

Setting the Metering mode

Transferring images to the computer

✦ ✦ ✦ ✦

Welcome to the world of digital SLR photography. Your new Canon Digital Rebel XTi/400D provides a gateway into a creative world of visual fun and excitement.

The thought of taking pictures and getting them onto your computer may seem daunting if you're new to digital photography, but the Digital Rebel XTi400D and your image-editing software should make the process easy and fast. Not only will you have the instant gratification of seeing your pictures as you take them, but you will also have a powerful tool to improve your photography skills and your pictures. You will also soon discover that the amount of control that you have over the final image is unprecedented.

At this point, you should already have completed the essentials, such as attaching the lens, charging the battery, inserting a CompactFlash (CF) card, and reading the manual. Once you've come that far, this Quick Tour will help you to quickly get started using the Digital Rebel XTi/400D to take your first pictures and get them onto your computer.

Taking Your First Pictures

Having charged and inserted the battery, inserted the CF card, attached the lens, and turned the camera on, you're ready to set up the camera to take your first pictures.

To get a feel for the camera, you can set the camera to Full Auto mode by turning the Mode dial on top of the camera to the green rectangle. In Full Auto mode, the camera sets all exposure settings for you, and you can use it just as you would use a point-and-shoot camera.

Note *The Digital Rebel XTi/400D automatically performs sensor cleaning each time you turn the power on or off. Cleaning takes approximately one second to complete. You can override the cleaning by pressing the Shutter button to focus and begin shooting. See Chapter 2 for more details on sensor cleaning.*

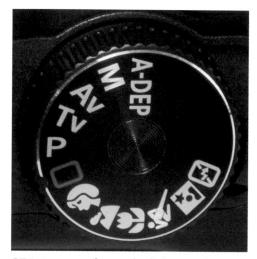

QT.1 Just turn the Mode dial to set the Exposure mode that you want to use. Full Auto mode is a good starting point for quick snapshots.

Just press the Shutter button halfway down — the Shutter button is located on the top right of the camera — to focus on a subject. The camera finds the subject that is closest to it, chooses the appropriate autofocus point (displayed in the viewfinder as a dot within a rectangle), and focuses on the subject. Now, press the Shutter button down

the rest of the way to take the picture. In Full Auto mode, the Digital Rebel XTi/400D records high-resolution JPEG images and sets all the exposure settings for you. If the light is low, the built-in flash automatically pops up and fires. That's how easy taking your first picture is with the Digital Rebel XTi/400D.

Caution *Never open the CompactFlash card door while the red access light on the back of the camera is lit. The access light shows that the camera is recording the last picture that you took to the CompactFlash card. If you open the CompactFlash card door, you can lose the images that are being recorded.*

The images that you take display briefly on the LCD. To scroll through pictures, press the Playback button, which is located to the left side of the LCD, and then press the left and right cross keys (shown in figure QT.2) to move through your pictures.

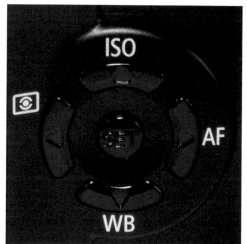

QT.2 You can use the left and right cross keys as menu shortcuts, to select items on camera menus, and to scroll through pictures that you're playing back.

Once you have a feel for the camera, you can spend some time setting it up, or verify that you've set it up correctly.

 Cross-Reference *For an overview of camera controls, see Chapter 1.*

Setting Up the Digital Rebel XTi/400D

Setting up the Digital Rebel XTi/400D is simple and requires only a few basic steps to get started.

Set the date and time

Setting the date and time provides a handy record that you can use to recall when you took pictures, and using the date can help organize pictures on your computer. When you first turn on the camera, it displays the Date/Time menu for the first setup.

To set the date and time, follow these steps:

1. **Press the Menu button on the back of the camera.**

2. **Press the right cross key to select the Set-up 1 tab.**

3. **Press the down cross key to select Date/Time.**

4. **Press the Set button.** The Date/Time screen appears.

5. **Press the up or down cross key to change the month.**

6. **Press the right cross key to move to the Day field.**

7. **Repeat Step 5 to change the remaining entries.**

8. **Press the Set button to return to the Menu.**

Set the image recording quality

The file format and quality level that you use to take your pictures is one of the most important decisions that you can make. These settings ultimately determine not only the number of images that you can store on the CompactFlash card, but also the sizes at which you can later enlarge and print these images from the Digital Rebel XTi/400D. The higher the image quality that you choose, the larger the print that you can make. You can set image quality for JPEG images that you take in Basic Zone modes as well as for JPEG and JPEG + RAW images that you take in Creative Zone modes.

Cross-Reference *For an overview of image quality settings, see Chapter 1.*

To set the image recording quality, follow these steps:

1. **Turn the Mode dial to a Basic Zone mode.** Basic Zone modes are shown with icons such as a person's head, mountains, a flower, and so on.

2. **Press the Menu button on the back of the camera, and then select the Shooting 1 menu.**

3. **Press the down cross key to select Quality.**

4. **Press the Set button.** The Quality menu appears.

5. **Press the down or right cross key to select the option that you want.**

6. **Press the Set button again.**

7. **Turn the Mode dial to a Creative Zone mode.** The Creative Zone modes are P, Tv, Av, M, and A-DEP.

8. **Repeat Steps 2 through 6 to set the image quality for these shooting modes.**

9. **Lightly press the Shutter button to return to shooting.**

Set the ISO

The ISO setting determines how sensitive the Digital Rebel XTi/400D image sensor is to light. The higher the ISO number, the less light that you need to make a picture.

Cross-Reference *For an overview of ISO, see Chapter 3. For an overview of camera controls, see Chapter 1.*

To set the ISO, follow these steps:

1. **Turn the Mode dial to a Creative Zone mode.** The Creative Zone modes are P, Tv, Av, M, and A-DEP.

Note *You can only set the ISO in Creative Zone modes. In Basic Zone modes, the camera automatically sets the ISO for you and you cannot change it.*

2. **Press the ISO button on the back of the camera.** The camera displays the ISO menu with settings from 100 to 1600.

3. **Press the down or left cross key to select the ISO.**

4. **Lightly press the Shutter button to return to shooting.**

Tip *When you make changes on the menus that you access by pressing the cross keys on the back of the camera, you can confirm these changes without having to press the Set button. For example, to change the ISO, press the ISO cross key, and then use the cross keys to change the setting. Then you can begin shooting. For other menus, however, be sure to press the Set button to confirm changes that you make.*

Set the white balance

White-balance settings tell the camera the type of light that is in the scene so that the camera can render white and other colors accurately.

To change the white balance, follow these steps:

1. **Press the WB (White Balance) button on the back of the camera.** The White Balance menu appears. Different types of light are shown with icons such as a light bulb for Tungsten light, a sun icon for Daylight, and so on.

2. **As you watch the LCD, press the cross keys until you have selected the setting that matches the light in the scene.** You can also turn the Main dial to select the setting.

3. **Lightly press the Shutter button to return to shooting.**

Basic Zone Shooting

For easy and quick shooting, you can choose one of the Basic Zone modes. These modes are grouped together on the Mode dial with symbols that depict the type of scene for which they are best suited. For example, Portrait mode is indicated by the image of a person's head.

In Basic Zone modes, all you do is set the Mode dial to the type of scene that you're shooting, and the camera automatically sets the exposure for you — similar to a point-and-shoot camera. Focus on the subject by pressing the Shutter button halfway down, and then depress it fully to take the picture.

Cross-Reference *For an overview of camera controls, see Chapter 1.*

The Digital Rebel XTi/400D offers these Basic Zone modes:

✦ Full Auto

✦ Portrait

✦ Landscape

✦ Close-up

✦ Sports

✦ Night Portrait

✦ Flash off

Creative Zone Shooting

Creative Zone modes offer automatic, semi-automatic, or manual control over some or all exposure settings. Some of these modes are similar to the mode settings on film SLR cameras. Using different Creative Zone modes, you can determine whether the background is sharp or blurred, and whether action is frozen or shown as a blur.

Cross-Reference *For a complete discussion of Creative Zone modes, see Chapter 2.*

The following list introduces the Creative Zone modes and presents a brief summary of how to use each one.

✦ **Program AE.** This mode displays as P on the Mode dial and is a fully automatic, but *shiftable* mode. Shiftable means that you can change the exposure by changing (or shifting) either the shutter speed or aperture, while the camera automatically adjusts the other setting to maintain the same or equivalent exposure. First, turn the Mode dial to P. Then, to shift the exposure, turn the Main dial. The aperture and shutter speed shift to an equivalent exposure shown in the viewfinder and on the LCD. To focus on the subject using the active autofocus point, press the Shutter button halfway down. Continue to hold the Shutter button halfway down to lock focus. Recompose the picture by moving the camera if necessary, and then press the Shutter button fully to take the picture.

✦ **Shutter-priority AE.** This mode displays as Tv (Time value) on the Mode dial. In this mode, you set the shutter speed, and the camera automatically chooses an appropriate aperture. First, turn the mode to Tv, and then turn the Main dial to set the shutter speed shown in the viewfinder and on the LCD. To focus on the subject using the active autofocus point, press the Shutter button halfway down. Continue to hold the Shutter button halfway down to lock focus. Recompose the picture by moving the camera if necessary, and then press the Shutter button fully to take the picture.

✦ **Aperture-priority AE.** This mode displays as Av (Aperture value) on the Mode dial. This mode allows you to set the aperture (f-stop) to control depth of field while the camera automatically chooses the appropriate shutter speed. First, turn the mode to Av, and then turn the Main dial to set the aperture (f-stop) shown in the viewfinder and on the LCD. To focus on the subject using the active autofocus point, press the Shutter button halfway down. Continue to hold the Shutter button halfway down to lock focus. Recompose the picture by moving the camera if necessary, and then press the Shutter button fully to take the picture.

✦ **Manual exposure.** This mode displays as M on the Mode dial. Turn the mode to M, and turn the Main dial to set the shutter speed. Then press and hold the Aperture/Exposure (Av) compensation button on the back of the camera while turning the Main dial to set the aperture (f-stop). In the viewfinder, the marker at the bottom of the light meter moves as you change the aperture. Then turn the Main dial to change the shutter speed. To get an average exposure, adjust the shutter speed and aperture until the marker is at the center point of the light meter. To focus on the subject using the active autofocus point, press the Shutter button halfway down. Continue to hold the Shutter button halfway down to lock focus. Recompose the picture by moving the camera if necessary, and then press the Shutter button fully to take the picture.

✦ **Automatic depth of field.** This mode displays as A-DEP on the Mode dial. It automatically calculates the best depth of field between near and far subjects. First, turn the mode to A-DEP, and focus on the subject by pressing the Shutter button halfway down. The camera automatically selects the autofocus points and displays the selected autofocus points in red in the viewfinder. Then press the Shutter button fully to take the picture. In A-DEP mode, the camera chooses the aperture and shutter speed.

Setting the Autofocus Point

The Digital Rebel XTi/400D offers nine autofocus points. The autofocus points allow you to focus on the subject whether the subject is in the center of the frame or off-center. Selecting an autofocus point allows you to set the sharpest point of focus in the image. You can set the autofocus mode in Creative Zone modes. In Basic Zone modes, the camera automatically sets the autofocus mode.

Cross-Reference *For details on autofocus modes, see Chapter 2.*

In Basic Zone modes and in A-DEP mode, the camera automatically selects the autofocus point. In all Creative Zone modes except for A-DEP, you can select the autofocus point. Be sure to select only one autofocus point.

To select the autofocus point, follow these steps:

1. **Set the Mode dial to any Creative Zone mode except for A-DEP.** Creative Zone modes are P, Tv, Av, and M.

2. **Press the AF point selection button on the back of the camera.** The button is at the top right of the back of the camera and is indicated by an icon that has a plus sign inside a magnifying glass below the button.

3. **Watch in the viewfinder as you turn the Main dial until the autofocus point that you want is highlighted.**

4. **Lightly press the Shutter button to dismiss autofocus point selection mode, focus on the subject by pressing the Shutter button halfway down, and then take the picture.**

QT.3 The AF point selection button is at the top right of the back of the camera.

Setting the Drive Mode

The Drive mode determines whether you can shoot one image at a time or several images in rapid sequence. The Digital Rebel XTi/400D has three Drive modes that are appropriate in different shooting situations: Single, Continuous, and Self-timer/Remote control. You can set the Drive mode when you're shooting in one of the Creative Zone modes.

QT.4 The Drive mode selection button.

To change Drive modes, follow these steps:

1. **Press the Drive mode button on the back of the camera.** The Drive mode button has tiled rectangles and a timer icon under it.

2. **Press the left or right cross key to change the Drive mode.** One-shot drive mode is shown as a single rectangle icon. Continuous drive mode is shown with a tiled rectangles icon, and Self-time mode is shown with a clock icon.

3. **Lightly press the Shutter button to focus on the subject, and then press the Shutter button completely to take the picture.**

Setting the Metering Mode

To make a good exposure, the camera has to know the amount of light that illuminates the subject or scene. The camera's built-in light meter measures the amount of light in the scene, and, based on the ISO, the camera calculates the aperture and shutter-speed combinations that are required to make the exposure.

The Digital Rebel XTi/400D has three metering modes that differ by the amount of the subject that the meter measures to calculate exposure. The metering modes are:

✦ **Evaluative.** This metering mode analyzes light from all nine autofocus points in the viewfinder.

✦ **Partial.** This metering mode meters from the centermost nine percent of the viewfinder.

✦ **Center-weighted Average.** This metering mode includes light from the entire viewfinder but gives more weight to the area within the center autofocus points.

In Basic Zone modes, the Digital Rebel XTi/400D automatically sets and uses the Evaluative metering mode. In Creative Zone modes, the camera defaults to Evaluative metering, but you can change to Partial or Center-weighted Average metering.

To change Metering modes, follow these steps:

1. **Set the camera to a Creative Zone mode.** Creative Zone modes are P, Tv, Av, M, and A-DEP.

2. **Press the Metering mode button on the back of the camera.** The Metering mode button is the left cross key. The Metering mode menu appears.

3. **Press the right cross key to select a metering mode.**

4. **Lightly press the Shutter button to focus on the subject, and then press the Shutter button completely to take the picture.**

> **Cross-Reference** *To learn more about metering modes, see Chapter 2.*

Transferring Images to the Computer

Before you transfer images to your computer, ensure that you have installed the programs from the Canon EOS Digital Solution Disk. The disk includes programs

for viewing, organizing, and editing your images. You can use other programs for these tasks such as Adobe Photoshop CS2 or Adobe Elements.

The easiest way to download images is to use a card reader. A card reader is a small, inexpensive device that plugs into your computer with a USB cable. When you're ready to download images, you insert the media card into the card-reader slot.

After installing the card reader according to manufacturer recommendations, follow these steps to download images from the CF card.

1. **Remove the CF card from the camera and insert it face up into the card reader, pushing firmly to seat the card.**

2. **On the Windows desktop, double-click My Computer.**

3. **In the list of Devices with Removable Storage, double-click the icon for the CF card.** The card reader appears in the list as a Removable Disk.

4. **Click and drag the DCIM folder to the computer's hard drive.** You can also double-click the DCIM folder to display and drag individual image files to a folder on the hard drive.

5. **Start the Canon ZoomBrowser EX program, and open the folder that contains the images that you downloaded.**

The Digital Rebel XTi/400D offers a Direct Image Transfer feature for downloading one or more images to your computer. Images

can be stored directly in dated folders on your computer's hard drive in the My Pictures folder in Windows or in the Pictures folder on a Mac.

To download images from the Digital Rebel XTi/400D using Direct Image Transfer, follow these steps:

1. **Turn off the camera, attach the supplied USB cable to the camera, and then attach the other end to the computer's USB slot.**

2. **Turn the camera on.** A selection screen appears on your computer.

3. **Select EOS Utility.** The EOS Utility screen appears on the computer and the Direct Transfer screen appears on the camera's LCD monitor.

4. **Select or confirm that the All images option is selected on the Direct Transfer screen on the camera.**

5. **Press the Print/Share button on the back of the camera at the top, above the LCD.** The camera's Print/Share button displays a blue light that blinks during image transfer and remains lit after the transfer is complete. Do not disconnect the cable or remove the CF card while the blue light is blinking.

6. **When the transfer is complete, turn off the camera and disconnect the USB cable.**

Cross-Reference *To learn more about transferring images to the computer, see Chapter 8.*

Once you have the pictures on your computer, you can edit the pictures as necessary and display an image as the desktop background on your screen. In addition, you can create a slideshow of images, share photos in e-mail or on a photo Web site, and display images on your Web site.

Using the Digital Rebel XTi/400D

P A R T

I

In This Part

Chapter 1
Exploring and Setting
Up the Digital Rebel
XTi/400D

Chapter 2
Using Your Digital
Rebel XTi/400D

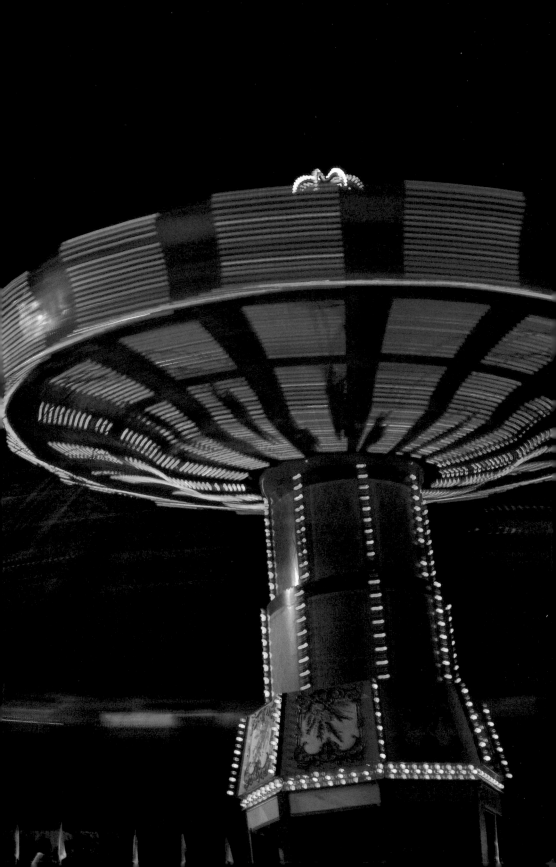

Exploring and Setting Up the Digital Rebel XTi/400D

✦ ✦ ✦ ✦

In This Chapter

Camera and lens controls

Rear camera controls

The LCD

Viewfinder display

Setting up the Digital Rebel XTi/400D

About media cards

Setting the date and time

Choosing the file format and quality

Choosing a white-balance option

Choosing a Picture Style

Setting monochrome filter and toning effects

Changing file numbering

✦ ✦ ✦ ✦

Professional photographers know that the most important first step in photography is learning the camera so thoroughly that he or she can operate it blindfolded. Then, you can make camera adjustments instinctively and confidently without missing a shot.

Knowing your camera inside and out not only instills confidence, but it allows you to react quickly and to get those important brag-book shots that you might otherwise miss or wish had been better.

Because of its design, the EOS Digital Rebel XTi/400D makes mastering the camera both easy and fun. Body controls translate into ease of use, while the full-function features offer exceptional creative control. Internally, Canon's high-resolution CMOS (complementary metal-oxide semiconductor) sensor dependably delivers vivid, crisp images, especially at the highest image-quality settings.

Camera and Lens Controls

The better that you know the Digital Rebel XTi/400D controls, the faster you are able to change settings for specific images. The following sections help you to explore and master these controls.

Remote control sensor

Red-eye reduction/Self-timer lamp

Shutter button

EF lens mount index

Built-in flash

Lens release button

Flash pop-up button

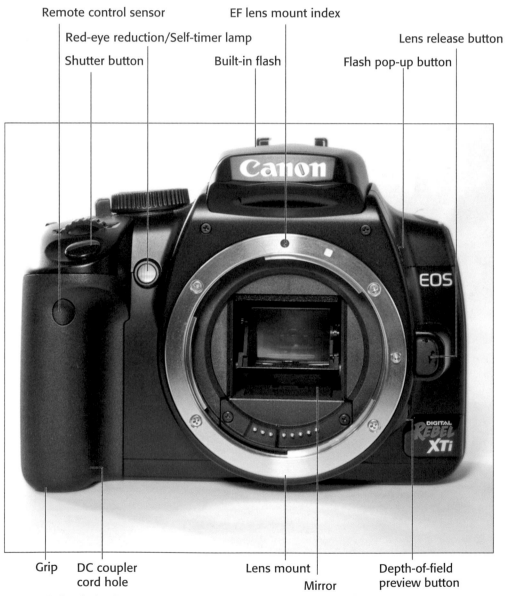

Grip

DC coupler cord hole

Lens mount

Mirror

Depth-of-field preview button

1.1 Digital Rebel XTi/400D front camera controls.

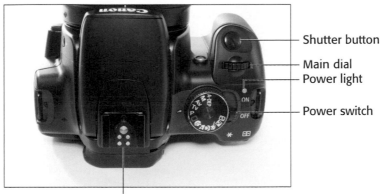

Shutter button
Main dial
Power light
Power switch

Hot shoe

1.2 Digital Rebel XTi/400D top camera controls.

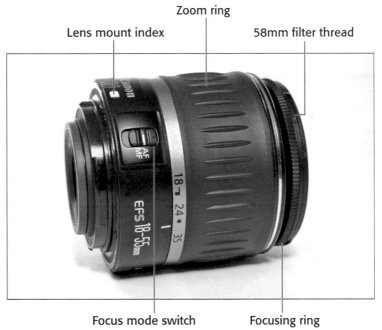

Zoom ring
Lens mount index
58mm filter thread

Focus mode switch
Focusing ring

1.3 Lens controls.

Rear Camera Controls

You use the rear camera controls most often. The Digital Rebel XTi/400D offers shortcut buttons that are handy for making quick adjustments while you're shooting. In particular, the WB (white balance), ISO, Menu, and AF (Auto Focus) selectors are handy for making quick changes.

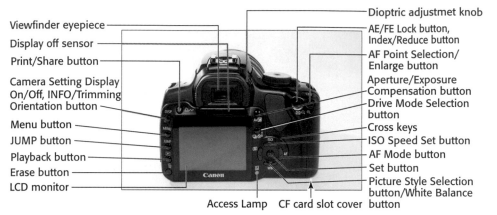

Viewfinder eyepiece
Display off sensor
Print/Share button
Camera Setting Display On/Off, INFO/Trimming Orientation button
Menu button
JUMP button
Playback button
Erase button
LCD monitor

Dioptric adjustmet knob
AE/FE Lock button, Index/Reduce button
AF Point Selection/ Enlarge button
Aperture/Exposure Compensation button
Drive Mode Selection button
Cross keys
ISO Speed Set button
AF Mode button
Set button
Picture Style Selection button/White Balance button

Access Lamp CF card slot cover

1.4 Digital Rebel XTi/400D rear camera controls.

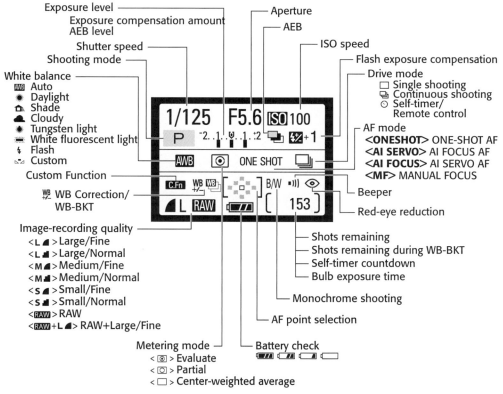

Exposure level
Exposure compensation amount
AEB level
Shutter speed
Shooting mode
White balance
 Auto
 Daylight
 Shade
 Cloudy
 Tungsten light
 White fluorescent light
 Flash
 Custom
Custom Function
 WB Correction/ WB-BKT
Image-recording quality
 <L ◢ > Large/Fine
 <L ◣ > Large/Normal
 <M ◢ > Medium/Fine
 <M ◣ > Medium/Normal
 <S ◢ > Small/Fine
 <S ◣ > Small/Normal
 <RAW> RAW
 <RAW+L ◢ > RAW+Large/Fine
Metering mode
 < ◉ > Evaluate
 < ◎ > Partial
 < ☐ > Center-weighted average

Aperture
AEB
ISO speed
Flash exposure compensation
Drive mode
 ☐ Single shooting
 ⤵ Continuous shooting
 ⊙ Self-timer/ Remote control
AF mode
 <ONESHOT> ONE-SHOT AF
 <AI SERVO> AI FOCUS AF
 <AI FOCUS> AI SERVO AF
 <MF> MANUAL FOCUS
Beeper
Red-eye reduction
Shots remaining
Shots remaining during WB-BKT
Self-timer countdown
Bulb exposure time
Monochrome shooting
AF point selection
Battery check

1.5 Digital Rebel XTi/400D LCD display.

The LCD

One obvious advantage of digital photography is the ability to view an image on the LCD immediately after it is taken. When the LCD is not displaying the most recent image, it shows the exposure settings, remaining frames, battery status, and camera settings so you can review them quickly before shooting.

> **Note** *Some information on the LCD panel and in the viewfinder only displays for about five seconds. You can restore it by lightly pressing the Shutter button.*

Viewfinder Display

On the Digital Rebel XTi/400D, the optical viewfinder displays approximately 95 percent of the image that the sensor captures. In addition to displaying the scene that you're shooting, the viewfinder displays the aperture, shutter speed, flash readiness level, and frames remaining during continuous shooting.

Focusing screen

AF point display indicator(.)

AF points

✳ AE lock
AEB in progress

● Focus confirmation light

⚡ Flash-ready
Improper FE lock
warning

Maximum burst

White balance correction

ʜ High-speed
sync (FP flash)

Exposure level indicator
Exposure compensation amount
AEB level
Red-eye reduction lamp on

Flash exposure
compensation

Shutter speed
FE lock (FEL)
Busy (buSY)
Built-in flash recycling (⚡ buSY)

CF card full warning (FuLL CF)
CF card error warning (Err CF)
No CF card warning (No CF)

Aperture

1.6 Digital Rebel XTi/400D viewfinder display.

Auto Focus (AF) points are etched in the focusing screen. If you manually change AF points, the viewfinder highlights them as you rotate the Main dial. If the camera automatically selects an AF point, the selected point displays in red on the focusing screen when you press the Shutter button halfway down.

To ensure that the viewfinder image and focusing screen elements are adjusted for your vision, you can adjust the diopter setting from -3 to +1 dpt. Simply move the diopter switch — located to the right of the viewfinder eyecup — up or down until the image in the viewfinder is sharp.

Setting Up the Digital Rebel XTi/400D

Setting up the Digital Rebel XTi/400D is the first step in getting pictures from the camera that you'll treasure for years to come. Although this chapter offers important pointers on setting up your camera, ultimately the best way to get great pictures from the Digital Rebel XTi/400D is to experiment with settings. Unlike paying for film and prints, the pictures that you take with the Digital Rebel XTi/400D are "free." This gives you the freedom to explore different camera settings until you get pictures with a combination of color, saturation, and contrast that's pleasing to your eye and that creates vibrant prints.

Many people are afraid that changing camera settings will "mess up" the pictures that they're getting, and that they will forget how to reset the camera if they don't like the changes they've made. Canon provides a reset option, which means that you can always revert to the original settings on the Digital Rebel XTi/400D. Once you clear the settings, you have a fresh start.

To reset the camera to the default settings, just press the Menu button, press the right cross key to select the Tools 2 menu, and then press the down cross key to select Clear settings. Then press the Set button.

Battery Basics

Before you can set up the Digital Rebel XTi, be sure that the NB-2LH lithium-ion Battery Pack is fully charged. A charging cycle for a fully depleted battery is approximately 90 minutes. To complete the charging cycle, it's important to leave the battery in the charger for an hour or longer after the green light displays. For longer shooting durations, you can purchase the optional Battery Grip BG-E3, which holds two NB-2LH Battery Packs. A date/time backup lithium battery is also included in the battery compartment.

In normal operating temperatures (68 degrees F), a battery charge delivers 400 to 600 shots. However, in freezing or colder temperatures, battery life decreases to 350 to 450 shots per charge.

When shooting outdoors in cold weather, keep the camera under your coat when you're not shooting. It's also a good idea to carry a spare battery in an inside pocket, close to your body, to keep it warm.

You may have already completed some of the setup tasks in this chapter. If you have, then you can skim through the chapter and look for tips that you may have missed in your initial setup.

Tip *Lithium-ion batteries have a two- to three-year life span, regardless of use. It's best to buy newly manufactured batteries.*

About Media Cards

The Digital Rebel XTi/400D accepts CompactFlash (CF) Type I and Type II media cards, as well as microdrives. Also, because the camera supports the FAT32 file system, you can use media cards with capacities of 2GB and larger.

Not all media cards are created equal, and the type and speed of media that you use affects the Digital Rebel XTi/400D's response times. These include the ability to write images to the media card and to continue shooting during the image-writing process, the speed at which images display on the LCD, and how quickly you can zoom images on the LCD.

The type of file format that you choose also affects the speed of certain tasks. For example, when writing images to the media card, JPEG image files write to the card faster than RAW or RAW + Large JPEG files. JPEG and RAW file formats are discussed in detail later in this chapter.

Media cards are rated by speed and use various designations such as High Speed, Ultra, Write Acceleration, and numeric speed ratings such as III or IV. However, the speed of the card becomes a moot point when it exceeds the camera's speed in delivering data to the card. As a result, although fast cards are a good investment, there is a point of diminishing returns. You can determine the best card for you based on speed, capacity, and price. However, with the burst speed of the Digital Rebel XTi/400D being 27 Large/Fine JPEG images, it is important to have a fast card.

Tip *For performance results of various media cards and cameras, including the EOS Digital Rebel XTi/400D, visit Rob Galbraith's Web site at* www.robgalbraith. com.

As you take pictures, the LCD on the Digital Rebel XTi/400D shows the *approximate* number of images that remain on the media card. The number is approximate because each image varies slightly, depending on the ISO setting, the file format and resolution, the parameters chosen on the camera, and the image itself (different images compress differently).

You insert the card into the card slot on the camera, with the front of the card facing the back of the camera. When you buy a new card, always format it in the camera, and never format it on your computer. However, be sure that you off-load all images to the computer before you format the card because formatting erases images. Formatting a media card in the camera also sets the data structure on the card for the Digital Rebel XTi/400D.

To format a card in the camera, follow these steps:

1. **Press the Menu button on the back of the camera.**

2. **Press the Jump button or the up and down cross keys to select the Tools 1 tab on the top row.**

3. **Press the down cross key to select Format.**

4. **Press the Set button.** The format screen appears asking you to confirm that you want to format the card.

5. **Press the right cross key to select OK.**

6. **Press the Set button.** The Digital Rebel XTi/400D formats the card, and then displays the Tools 1 menu.

It is generally a good idea to format media cards every few weeks to keep them clean. If you've used a media card in another camera, be sure to format it in the Digital Rebel XTi/400D to ensure that proper data structure is set, and to clean up the card.

Note *It is possible to take pictures when no memory card is in the camera, although I can't think of a reason why you would want to do that. You can prevent this from happening by turning off the option to shoot without a card. Just press the Menu button, choose the Shooting 1 menu, and press the down cross key to select Shoot w/o card. Press the Set button, select Off, and press the Set button again.*

Setting the Date and Time

Setting the date and time on the Digital Rebel XTi/400D ensures that the data that travels with each image file has the correct date and time stamp. This data is commonly referred to as metadata. Metadata is a collection of all of the information about an image, including the filename, date created, size, resolution, color mode, camera make and model, exposure time, ISO, f-stop, shutter speed, lens data, and white-balance setting. EXIF, used interchangeably with the term metadata, is a particular form of metadata.

It is very helpful to have the date and time information for the image when you want to organize your image collection. In fact, the Digital Rebel XTi/400D's Direct Image Transfer function can store images in dated folders on your computer's hard drive.

Cross-Reference *For details on the Direct Image Transfer function for the Digital Rebel XTi/400D, see Chapter 8.*

To set the date and time on your Digital Rebel XTi/400D, follow these steps:

1. **Press the Menu button on the back of the camera.**

2. **Press the Jump button, or the up or down cross keys, to select the Tools 1 tab.**

3. **Press the down cross key to select Date/Time.**

4. **Press the Set button.**

Avoid Losing Images

When the camera's red access light—located at the bottom of the back of the camera—is blinking, it means that the camera is recording or erasing image data. When the access light is blinking, do not open the CF card slot cover, do not attempt to remove the media card, and do not remove the camera battery. Any of these actions can result in a loss of images and damage to the media card and camera. What's more, if you open the CF slot cover, there is no audible warning to let you know that you've just lost the image being written as well as any images in the camera's buffer. In short, don't open the CF card slot cover if the access light is on.

5. **Press the up or down cross keys to change the Month field.**

6. **Press the right cross key to move to the Day field.**

7. **Repeat steps 5 and 6 for each entry.**

8. **When all options are set, press the Set button.** The Tools 1 menu appears.

9. **To close the menu, press the Menu button.**

 Note *Remember to reset the date and time to adjust for daylight savings time or when you change time zones.*

Choosing the File Format and Quality

The file format and quality level that you use to take your pictures is one of the most important decisions that you make. These settings determine not only the number of images that you can store on the media card, but also the sizes at which you can later enlarge and print images from the Digital Rebel XTi/400D. Table 1.1 explains the options that you can choose from.

Because of the high-quality images that this camera delivers, you can make beautiful enlargements from these images. Even if you don't foresee needing anything larger than a 4 × 5-inch print from an image, you may change your mind in the future and decide to print it at a larger size. For this reason, and to take advantage of the Digital Rebel XTi/400D's fine image detail and high resolution, it pays to choose a high-quality setting and to leave it there for all of your shooting.

The JPEG quality options on the Digital Rebel XTi/400D indicate the compression level of the files and the recording size. Compression discards some pixels from the image to make the file size smaller. The higher the compression level, the smaller the file and the more images that you can put on the media card. However, at the same time, as compression increases, the image quality diminishes, as does the size at which you can print the images, as shown in Table 1.1.

Table 1.1
Digital Rebel XTi/400D File Format and Quality

Image Quality	Approximate Recording Size	Format	File Size (MB)	Print Size
L (Large Fine)	10.1 megapixels	JPEG (.jpg)	3.8 /3888 × 2592	16.5" × 11.7"
L (Large Normal)			2.0/3888 × 2592	
M (Medium Fine)	5.3 megapixels		2.3/2816 × 1880	11.7" × 8.3"
M (Medium Normal)			1.2/2816 × 1880	
S (Small Fine)	2.5 megapixels		1.3/1936 × 1288	7" × 5" or smaller
S (Small Normal)			0.7/1936 × 1288	
RAW + L	10.1 megapixels	RAW + JPEG (.CR2 & JPEG)	9.8/3888 × 2592	16.5" × 11.7"

JPEG format

JPEG, which stands for Joint Photographic Experts Group, is a lossy file format that compresses the image file size by discarding some image data before storing it on your media card. Because JPEG images are compressed, you can store more images on the CF card. However, as the compression ratio increases, more of the original image data is discarded, and the image quality degrades.

Other important things to know about choosing JPEG formats are that, unlike RAW images that allow you to change many settings after pictures are captured, JPEG images are processed by Canon's internal software before being stored on the media card. This means there is less editing leeway in making significant changes to the image during editing. Because JPEG is a common file format, you can open JPEG images in any image-editing program and print them directly from your computer.

If you choose the JPEG format, then you can choose from among different image sizes and compression ratios that range from low (Fine settings) to high (Normal and Small settings) as shown in Table 1.1.

RAW format

RAW stores data directly from the image sensor to the media card with a minimum of in-camera processing. RAW data gives you ultimate flexibility because you can change camera settings after you take the picture. For example, if you didn't set the correct white balance or exposure, you can change it in a RAW conversion program on the computer. This gives you a second chance to correct underexposed or overexposed images, and to correct the color balance after you take the picture.

However, unlike JPEG images, which you can view in any image-editing program, you must view RAW files using the Canon File Viewer Utility software or another RAW-compatible program such as Adobe Bridge and Camera Raw. You must also convert them using Canon's Digital Photo Professional program or a third-party RAW-conversion program that supports the Canon Digital Rebel XTi/400D RAW file format. You can choose to shoot either RAW images or RAW+JPEG, which records the RAW file and a Large/Fine JPEG image. This is handy when you want a JPEG image for quick viewing on your computer or a Web site, and you want the ability to convert and process the RAW file at a later time for printing.

Because RAW is a lossless format (no loss of image data), image quality is not degraded by compression. However, you can store fewer RAW images on the media card than JPEG images. Table 1.2 shows the file size and approximate number of images that you can store on 512MB media cards for the Digital Rebel XTi/400D.

To set the image quality, follow these steps:

1. **Turn the Mode dial to a Basic Zone mode.** Basic Zone modes are indicated by icons such as a person's head, mountains, or a flower.

2. **Press the Menu button on the back of the camera.**

3. **On the Shooting 1 tab, press the down cross key to select Quality.**

4. **Press the Set button.** The Quality screen appears.

5. **Press the down cross key to select the size and quality that you want.** In Basic Zone modes, you can choose only JPEG options at different levels of compression.

6. **Press the Set button.**

7. **Turn the Mode dial to a Creative Zone mode.** Creative Zone modes are indicated by P, Tv, Av, M, and A-DEP on the Mode dial.

8. **Repeat steps 2 to 6 to set the quality for Creative Zone modes.** In Creative Zone modes, you can also choose RAW or RAW +JPEG file formats.

Table 1.2
JPEG versus RAW

Digital Rebel XTi/400D: 512MB Card

	Approximate File Size in MB	*Number of Pictures*
Large JPEG; Fine or Normal	3.8 / 2.0	130 / 240
Medium JPEG; Fine or Normal	2.3 / 1.2	216 / 410
Small JPEG; Fine or Normal	1.3 / 0.7	376 / 719
RAW	9.8	50
RAW + Large/Fine	13.6	36

Choosing a White-Balance Option

A white-balance setting tells the camera the type of light that is in a scene so that the camera can render white and other colors accurately in the image. Light temperature varies according to the source and time of day. For example, the temperature, or color, of light at sunset is very different from the temperature of light at noon, which is also different from the temperature of common household light.

While the human eye sees white as white, regardless of the temperature of light in the scene, a digital camera does not make the same kind of automatic adjustments to detect differences in light temperatures. As a result, you must choose a white-balance option to tell the camera the type of light in

which you're taking the picture. The Digital Rebel offers eight white-balance settings for a variety of different light temperatures: AWB (Auto White Balance), Daylight, Shade, Cloudy/Twilight/Sunset, Tungsten, White Fluorescent, Flash, and Custom.

 Chapter 4 provides more details on light and color temperature.

Of course, the Digital Rebel XTi/400D, like other digital cameras, includes an automatic white-balance setting (AWB). When you use the AWB option, the camera looks at the colors in the overall scene and makes a "best guess" of white balance. This strategy works admirably in most cases; however, it does not work in scenes that are dominated by one or two colors, or where no white is present. Consequently, you'll get the best image color if you set the camera for the specific type of light in your scene.

Adjusting the Color Temperature

The Digital Rebel XTi/400D takes white balance a step further by allowing you to correct the standard white balance in a way that is very similar to using color-correction filters in film photography. In film photography, conversion filters allow you to use film in light that it isn't balanced for. For example, with the correct color conversion filter, you can use daylight film (balanced to 5500 degrees K) in tungsten light (balanced to 3200 degrees K). Without the filter, the pictures will have an orange tint. But with a cooling color-conversion filter, certain wavelengths of light are prevented from passing through to the lens, thereby shifting colors so that they are more natural.

On the Digital Rebel XTi/400D, you can replicate the effect of a color-conversion filter using the WB SHIFT/BKT function to shift the color bias. To adjust the white balance, press the Menu button, move to the Shooting 2 tab, select WB SHIFT/BKT, and then press the Set button. Then use the cross keys to shift the color balance toward Blue (B), Amber (A), Magenta (M), or Green (G). To cancel a bias correction, move the cursor back to the center (0,0) point.

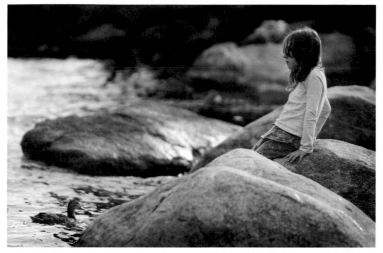

1.7 This image was made using a Daylight white-balance setting that renders the grays and whites accurately.

1.8 This image was made using a Shade white-balance setting that does not match the light in the scene and adds a yellow hue to the overall image.

To take pictures with accurate color, it is important to change the white balance; fortunately, choosing the setting is easy. To change the white balance on the Digital Rebel XTi/400D, follow these steps:

1. **Press the WB (White Balance) button on the back of the camera.** The white-balance menu appears.

2. **As you watch the LCD, press the down or left cross key to select the setting that you want.**

3. **Lightly press the Shutter button to return to shooting.** The white-balance setting displays on the LCD.

Cover your white-balance bases

If you're shooting JPEG images, you can use white-balance auto bracketing to ensure that the nuances of color are accurate. White-balance bracketing captures three images, each with +/-3 one-stop differences in color from the base current white-balance setting. With white-balance auto bracketing, the camera captures one image at the current white-balance setting, a second image with a blue/amber bias, and a third image with a magenta/green bias.

To set white-balance auto bracketing, follow these steps:

1. **If you have the image quality set to RAW in a Creative Zone mode, reset the image recording to one of the JPEG recording settings, such as Large/Fine.** The image Quality option is on the Shooting 1 menu.

2. **Press the Menu button on the back of the camera and select the Shooting 2 menu.**

3. **Press the down cross key to select WB SHIFT/BKT.**

4. **Press the Set button.**

5. **Rotate the Main dial to select the bracketing level and direction, either blue/amber or magenta/green.** As you rotate the Main dial, the cursor changes to

three squares, indicating the three points that will be used to bracket images.

6. **Rotate the Main dial to set the direction and amount of white-balance bracketing.** The BKT (Bracketing) on the right of the screen indicates the direction and level of bracketing.

7. **Press the Set button.**

8. **Lightly press the Shutter button to return to shooting.**

The bracketed sequence begins with normal white balance, and then continues with either blue-and-amber bias images, or magenta-and-green bias images. When you combine white-balance correction with auto-exposure bracketing, a total of nine images are taken for each single shot. You can cancel white-balance bracketing by turning the camera off.

Mixed light? No problem

Mixed-light scenes, such as tungsten and daylight, used to drive photographers crazy. Shooting film in these scenes meant that you had to hold your breath and hope for the best. However, digital photography has changed everything. With the Digital Rebel XTi/400D, you can set a custom white balance to get accurate color in mixed light, as well as in other less-than-perfect lighting situations. By setting a custom white balance, you tell the camera what should appear white in the specific light that you're shooting in. As long as you are shooting in that light, the custom white balance should render whites accurately. Setting a custom white balance saves time that you would otherwise spend color-correcting images on the computer. For example, in figure 1.9, I set a custom white balance that neutralized skin tones and left only a hint of the

overhead temperature and light color in areas of the subject's hair because the left side of the subject's face was lit by diffused daylight, and the right side was lit by overhead fluorescent lights.

To set a custom white balance, ensure that the camera is not set to the black-and-white Picture Style. Then, follow these steps:

1. **Position the camera so that a sheet of white paper fills the center of the viewfinder, and take a picture of the paper.** If the camera cannot focus, switch the button on the side of the lens to MF (Manual Focusing), and focus on the paper manually by turning the focusing ring. Also ensure that the exposure is neither underexposed nor overexposed.

1.9 Using a custom white balance compensates for less-than-perfect lighting.

2. **Press the Menu button.**

3. **On the Shooting 2 tab, press the down cross key and select Custom WB.**

4. **Press the Set button.** The camera displays the most recent image. If the image of the white paper is not selected, use the left or right cross key to select it.

5. **Press the Set button again.** The Digital Rebel imports the white-balance data from the selected image. A caution screen appears briefly to remind you to set the WB setting to Custom WB. The Shooting 2 menu appears.

6. **Lightly press the Shutter button to dismiss the menu, and then press the WB cross key.** The White Balance screen appears.

7. **Press a cross key to select Custom White Balance.** The Custom WB option is the last option on the menu.

8. **Lightly press the Shutter button to return to shooting.** As long as you are shooting in the same light that you used to set the custom white balance, the color will be accurate. If you change to a different type of lighting, reset the white balance to match the type of light in the scene or set a new custom white balance.

Choosing a Picture Style

Picture Styles on the Digital Rebel XTi/400D are a set of camera instructions that adjust the image for contrast, sharpness, saturation, and color tone, for different appearances or

"looks." These styles simulate the different looks of different films that each offer characteristic looks that vary by color tone, color saturation, and contrast. On the Digital Rebel, you can use Picture Styles to simulate different looks.

The Standard Picture Style on the Digital Rebel XTi/400D delivers visually pleasing contrast, color tone, sharpness, and saturation for general shooting. However, if you're shooting a portrait, you may want slightly less contrast and more subdued color. If you're shooting landscapes, you may want more vivid greens and blues in the image. In these situations, Picture Styles offer a way to quickly adjust the image color, contrast, and saturation, based on the scene or subject.

Your camera offers six preset Pictures Styles that you can choose from to change how your images appear. In addition, you can customize preset Picture Styles and create your own styles.

The Digital Rebel XTi/400D offers the following Picture Styles:

✦ **Standard.** This Picture Style offers images that have saturated color and good sharpness. For most scenes, Standard is a good Picture Style to use. In Basic Zone modes, Standard Picture Style is automatically chosen in all modes except for Portrait and Landscape.

✦ **Portrait.** This Picture Style delivers pleasing, healthy-looking skin tones. Moderate sharpness produces a soft look to minimize details such as skin pores and imperfections, which makes this style appropriate for women, children, and babies. The Portrait Picture Style is automatically chosen in Portrait mode.

✦ **Landscape.** This Picture Style offers vivid blues and greens to enhance landscape images. This style also works well for sunset, twilight, sunrise, and night images. This Picture Style is automatically chosen in Landscape mode.

✦ **Neutral.** This Picture Style produces natural colors with subdued contrast and saturation. These settings allow editing leeway for photographers who prefer to manually adjust color and saturation in an image-editing program.

✦ **Faithful.** Like Neutral, this Picture Style produces natural colors with subdued contrast and saturation. This style is best for shooting under light at 5200 K because the image color is colorimetrically adjusted to match the subject color.

✦ **Monochrome.** Monochrome offers excellent black-and-white images with the option to add a yellow, red, orange, or green filter. The Yellow filter increases overall contrast and provides a sense of depth to the image. The Red filter produces stronger contrast than the Yellow filter; it also produces a gradient effect in a blue sky that goes to black, and brightens fall colors. The Orange filter darkens complementary green and blue colors as well as sunset colors, and it enhances contrast in landscape scenes. The Green filter intensifies complementary red tones and renders greens and blues brightly. In addition, you can adjust the Monochrome Picture Style to apply toning effects that include Sepia, Blue, Purple, or Green.

The following series of images shows the differences in Canon's Picture Styles using the same scene.

1.10 This image was taken using the Standard Picture Style.

1.13 This image was taken using the Neutral Picture Style.

1.11 This image was taken using the Portrait Picture Style.

1.14 This image was taken using the Faithful Picture Style.

1.12 This image was taken using the Landscape Picture Style.

1.15 This image was taken using the Monochrome Picture Style.

You can download additional Picture Styles from the Picture Style File on the Canon Web site at www.canon.co.jp/Imaging/picturestyle/file/. You can not only apply these styles in any EOS digital SLR that supports Picture Styles, you can also use them in Canon's Digital Photo Professional software and apply them after you capture an image. Instructions for downloading additional Picture Styles is provided on the Web site.

You can create and save up to three user-defined Picture Styles using your own settings for contrast, sharpness, saturation, and color tone. However, I recommend trying the preset Picture Styles to see the results they produce before you either create your own user-defined styles or modify an existing Picture Style. Evaluate the images for each characteristic and determine which characteristics you want to adjust. For example, unless you print directly from the camera, I recommend leaving extra sharpening to the last stage of image editing on your computer, after you size the image for printing or Web display. Conversely, you may find that the contrast may be higher than you like, and that decreasing it can give you more editing leeway on the computer.

Table 1.3 shows the default settings for each Picture Style.

Table 1.3

EOS Digital Rebel XTi/400D Picture Style

Picture Style	Description	Tonal Curve	Color Saturation	Default Settings
Standard	Vivid, moderately sharp, crisp	Higher contrast	High saturation	3,0,0,0
Portrait	Enhanced skin tones, soft texture, lower sharpness	Higher contrast	Medium saturation	2,0,0,0
Landscape	Vivid blues and greens, high sharpness	Higher contrast	High saturation for greens/ blues	4,0,0,0
Neutral	Natural but subdued color. No sharpness applied.	Medium, subdued contrast	Low saturation	0,0,0,0
Faithful	Colorimetrically adjusted to match 5200 degrees K. No sharpness applied.	Medium, subdued contrast	Low saturation	0,0,0,0
Monochrome	Black-and-white or toned images with medium sharpness	Higher contrast	Low saturation; yellow, orange, red, and green filter effects available	3,0

To choose a Picture Style, follow these steps:

1. **Press the Menu button.**

2. **Select the Shooting 2 tab.**

3. **Press the down cross key to select Picture Style.**

4. **Press the Set button.** The Picture Style screen appears.

5. **Press the down cross key to select a Picture Style.**

6. **Press the Set button.** The Shooting 2 menu appears.

7. **Lightly press the Shutter button to return to shooting.**

Setting Monochrome Filter and Toning Effects

You can set color filter and toning effects for the Monochrome Picture Style. There are four Monochrome color-filter options to choose from. The Yellow filter makes skies look natural with clear, white clouds. The Orange filter darkens the sky and adds brilliance to sunsets. The Red filter darkens a blue sky and makes fall leaves look brighter and crisper. The Green filter makes tree leaves look crisp and bright. When you set the Monochrome Contrast to a positive setting, this increases the effect of the filter. You can choose to have a toning effect applied in the camera when you are taking Monochrome images. The Toning-effect options include None, Sepia (S), Blue (B), Purple (P), and Green (G).

To set a Monochrome Picture Style filter or toning effect, follow these steps:

1. **Press the Menu button.**

2. **Select the Shooting 2 tab.**

3. **Press the down cross key to select Picture Style.**

4. **Press the Set button.** The Picture Style screen appears.

5. **Press the down cross key to select Monochrome.**

6. **Press the Jump button.**

7. **Press the down cross key to select Filter effect or Toning effect.**

8. **Press the Set button.** The options appear for the filter effects or toning effects.

9. **Press the down cross key to select the filter or toning effect that you want.**

10. **Press the Set key.**

11. **Press the Menu button twice.** The Monochrome Picture Style and filter effect remain until you change them.

12. **Lightly press the Shutter button to return to shooting.**

To create and save your own Picture Style , follow these steps:

1. **Press the Menu button.**

2. **Select the Shooting 2 tab.**

3. **Press the down cross key to select Picture Style.**

4. **Press the Set button.** The Picture Style screen appears.

5. **Press the down cross key to select User Def. 1.** The style that you create is based on the Standard Picture Style.

6. **Press the Jump button.** The Detail set for User Def. 1 appears.

7. **Press the down cross key to move to the Sharpness field, and then press the Set button to activate the sharpness control adjustments.**

8. **Press the left or right cross key to adjust the Sharpness setting, and then press the Set button.**

9. **Repeat steps 7 and 8 to move to the next fields and make adjustments.**

10. **Press the Menu button.** The Picture Style menu appears.

11. **Press the Set button.** The Shooting 2 menu appears, displaying User Def.1 as the selected Picture Style. This style is used for shooting until you change to another Picture Style.

12. **Lightly press the Shutter button to return to shooting.**

If you want to apply a color filter or toning effect to the Monochrome Picture Style, follow steps 1 to 4 in the previous set of steps, and then press the Jump button. Press the down cross key to select Filter effect or Toning effect, and then press the Set button. Press the down cross key to select the filter or toning effect that you want from the list, and then press the Set button. Press the Set button again to return to the Shooting 2 menu.

Changing Color Space

A color space defines the range of colors that can be reproduced. Some color spaces contain more colors than others, and some color spaces are better for printing, while others are better for pictures that display on the Web.

The Digital Rebel XTi/400D offers two color spaces: Adobe RGB and sRGB. The Adobe RGB color space offers the widest color range. It is the choice for advanced and professional photographers who edit their images for custom or commercial printing. Images that you take with this color space have much more subdued color, saturation, and sharpness than images that you take with sRGB.

In the sRGB color space, the range of colors is not as wide, and colors appear brighter and more saturated than with the Adobe RGB color space. This is a good color space to use for images that you display on the Web or send in e-mail, and for images that you print directly from the CF card to a printer.

To change the color space, follow these steps:

1. **Press the Menu button.**

2. **Press the right cross key to select the Shooting 2 tab**.

3. **Press the down cross key to select Color space, and then press the Set button.** The color space options appear.

4. **Press a cross key to select sRGB or Adobe RGB, and then press the Set button.** If you select Adobe RGB, image filenames begin with _MG_.

5. **Lightly press the Shutter button to return to shooting.**

If you want to adjust the preset Picture Styles, you can select them and adjust the settings by following the preceding steps. If you don't like the changes, you can select [Default set.] on the Picture Style screen to return to the original Picture Style settings.

Changing File Numbering

With the Digital Rebel XTi/400D, you can set the camera to number images using one of three different options: Continuous, Auto reset, and Manual reset. These options allow you to number your images sequentially, to restart numbering each time you change the media card, or to choose to manually reset numbering.

With the first option — Continuous file numbering — images are numbered sequentially using a unique, four-digit number from 0001 to 9999. With unique filenames, managing and organizing images on the computer is easy because there is no chance that images will have duplicate filenames. This option is also useful to track the total number of images, or actuations, that are on your camera. The Digital Rebel XTi/400D's default setting is Continuous file numbering.

With the second option, Auto reset, you can reset the frame numbering so that it restarts each time you change the media card. If you like to organize images by media card, this can be a useful option. However, if you use this option, be aware that multiple images will have the same number or filename. This means that you should create separate folders for each off-load and otherwise follow scrupulous folder organization to avoid filename conflicts and potential overwriting of images.

If you use the third option, Manual reset, then a new folder is created, and images that you save to the folder are numbered starting at 0001. The Manual reset option is handy if you want separate folders for images that you take over a span of several days. After Manual reset, file numbering returns to Continuous or Auto reset. On the Digital Rebel XTi/400D, you can create up to 999 folders with up to 9,999 images stored in each folder. If you reach these capacities, a message appears telling you to change the CF card even if there is room remaining on the card.

To change the file-numbering method on the Digital Rebel, follow these steps:

1. **Press the Menu button.**

2. **Press the right cross key to select the Tools 1 tab.**

3. **Press the down cross key to select File numbering.**

4. **Press the Set button.**

5. **Press a cross key to select Continuous, Auto reset, or Manual reset.** Manual reset creates a new folder and resets the file numbering at 0001 for images that you save to the folder.

6. **Press the Set button.**

7. **Lightly press the Shutter button to return to shooting.**

Using Your Digital Rebel XTi/400D

✦ ✦ ✦ ✦

In This Chapter

Mode dial

Metering modes

Exposure compensation

Auto exposure bracketing

AE lock

Evaluating exposure

Focus and Autofocus modes

Understanding Autofocus point selection

Using Drive modes

Viewing and playing back images

Erasing images

Protecting images

Using a flash

Using the EOS Integrated Cleaning System

✦ ✦ ✦ ✦

Once the Digital Rebel XTi/400D is set up, you're ready to begin a fun-filled and satisfying journey into the creative world of digital photography. Most people begin by using the automated shooting functions of the camera, and that's a good place to start.

The automated Basic Zone modes of the Digital Rebel XTi/400D set all of the exposure elements so that you can concentrate on capturing the moment. In these modes, you can use the Digital Rebel XTi/400D similarly to a point-and-shoot camera, but with the ability to change lenses to bring the subject closer or to get a wide, sweeping view of a scene. If you're shooting fast action, the Digital Rebel XTi/400D automatically sets the camera to shoot in rapid-fire sequence, and it tracks the subject movement to maintain sharp focus. Whether you're shooting close-ups, landscapes, or portraits, the Digital Rebel XTi/400D's Basic Zone modes set the exposure to give you good results.

If you are like most photographers, you are also anxious to move beyond the automated modes and to exercise your creativity by setting the exposure yourself. This is where the fun truly begins. In the Creative Zone modes, you can choose to have partial or full control over some or all of the exposure settings. As a result, you not only control the focus point, but also how the background will be rendered in the image — either as a soft blur to make the subject in a portrait stand out from the background, or with front-to-back sharpness for landscape shots. The possibilities are both endless and exciting.

Because you can choose between modes, you may find that you enjoy using Sports mode in the Basic Zone, but you prefer using Aperture-priority (Av) mode in the Creative Zone for

other shots. With the Digital Rebel XTi/400D, you can switch between modes and be assured of getting great shots in any mode that you choose.

This chapter explains each of the Basic and Creative Zone shooting modes on the Digital Rebel XTi/400D to help you get the most out of them. After you read about the Basic and Creative Zone modes, be sure to continue to Chapter 3, which explains the elements of photographic exposure in detail.

Let's begin the journey.

Mode Dial

The Mode dial allows you to choose a shooting mode. A shooting mode determines how exposure settings are set — either by the camera or by you. Some modes are fully automatic, while others are semiautomatic or manual. The Mode dial is divided into two sections: the Basic Zone and the Creative Zone. The Basic Zone includes modes that are designated by icons, including Full Auto mode (designated by a green rectangle) and scene-specific modes, as shown in figure 2.1.

On the other side of the dial is the Creative Zone, which is indicated by letter abbreviations. These modes allow you either partial or full control over the camera settings. This means that you can control depth of field, how subject motion appears in the image, white balance, and AF point selection. Creative Zone modes range from semiautomatic and Manual modes to a fully automatic but "shiftable" Program mode, which is described in detail later in this chapter.

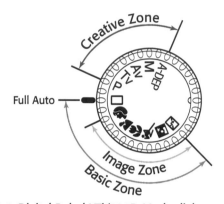

2.1 Digital Rebel XTi/400D Mode dial.

Basic Zone modes

To make a picture, the camera requires that the ISO, shutter speed, and aperture be set correctly, based on the amount of light in the scene. When all three elements are set correctly, you get a well-exposed picture. Some or all of the exposure settings can be set by you or by the camera. In Canon's Basic Zone modes, the camera automatically sets all of the exposure settings, but you provide some control over the way the picture looks by specifying the type of scene that you're shooting.

Basic Zone modes are a great choice for quick shots because all you do is set the Mode dial to the type of scene that you're shooting, and then focus and shoot — the camera automatically sets the exposure for you. For example, if you're making a portrait and you want a softly blurred background, you can select Portrait mode to set a wide aperture (f-stop), which allows the subject in the foreground to be sharp, but blurs the background. Conversely, if you are shooting a landscape and you want everything from front to back to be sharp, you can select Landscape mode to set a narrow aperture

to give front-to-back sharpness. As you can see, each Basic Zone mode is programmed to render the subject that its mode name represents in predictable ways.

> **Cross-Reference** *For details on the photographic exposure elements, including ISO, aperture, and shutter speed, be sure to read Chapter 3.*

In addition to setting the exposure elements, the Digital Rebel XTi/400D also automatically sets other aspects of the image. For example, it sets the image recording quality to JPEG — although you can select the level of JPEG quality.

In all Basic Zone modes, the camera also automatically sets:

✦ Auto White Balance

✦ Evaluative metering

✦ The sRGB Color Space

✦ Whether or not to fire the built-in flash

In Basic Zone modes, you cannot change the camera settings. Other settings are also automatically set, depending on the Basic Zone mode that you choose. These settings are detailed in each of the mode descriptions that follow.

Full Auto mode

In Full Auto mode, the Digital Rebel XTi/400D automatically selects all of the settings. Because the camera does everything, this is a good mode to use for quick snapshots. However, keep in mind that the camera defaults to using the built-in flash in low-light scenes, even though you may not want or need to use the flash. Also remember that in all modes, the lens that you choose enhances your creative control.

In Full Auto mode, the camera automatically sets:

✦ Standard Picture Style

✦ AI focus with automatic AF point selection. This means that the camera automatically switches between One-Shot AF and AI Servo AF, based on the subject's movement or lack of movement.

✦ Single-shot (one-image-at-a-time) drive mode

✦ Automatic flash

See Table 2.2 later in this chapter for more information on each of these settings.

2.2 This image was taken in Portrait mode, and it shows how the Digital Rebel XTi/400D sets a wide aperture to blur the background. The exposure for this image was ISO 200, f/4, 1/15 second.

Portrait mode

In Portrait mode, the Digital Rebel XTi/400D sets a wide aperture (small f-stop number) that makes the subject stand out against a softly blurred background. Obviously, Portrait mode is great for people portraits, but it's also a great mode for taking pet portraits, indoor and outdoor still-life shots, and nature shots such as flowers that you photograph from a moderate distance.

In Portrait mode, the camera automatically sets:

✦ Portrait Picture Style

✦ One-shot autofocus and automatic AF point selection

✦ Continuous drive mode so that you can take as many as 27 Large/Fine JPEG images in a burst sequence

✦ Automatic flash with the option to turn on Red-eye reduction

 Note *To enhance the effect that Portrait mode provides of bringing the subject out of the background, you can use a telephoto lens or have the subject move farther from the background.*

Landscape mode

In Landscape mode, the Digital Rebel XTi/400D chooses a narrow aperture (large f-stop number) to ensure that both background and foreground elements are sharp. It also chooses the fastest shutter speed possible, depending on the amount of light in the scene. As it does in all Basic Zone modes, the camera uses Evaluative metering to measure the light in the scene to determine the exposure settings.

2.3 This image was taken in Landscape mode, and it shows excellent sharpness from back to front. Taken at ISO 100, with the camera set at f/8 at 1/640 second.

In lower light, the camera sets slower shutter speeds to maintain a narrow aperture for good depth of field. As the light fades, watch the viewfinder or LCD to monitor the shutter speed. If the shutter speed is 1/30 second or slower, or if you're using a telephoto lens, be sure to steady the camera on a solid surface or use a tripod.

In Landscape mode, the camera automatically sets:

✦ Landscape Picture Style

✦ One-shot autofocus and automatic AF point selection

✦ Single-shot drive mode

✦ Flash-off mode

Close-up mode

In Close-up mode, the Digital Rebel XTi/400D allows a close focusing distance. You can further enhance the close-up effect by using a macro lens. If you're using a zoom lens, zoom to the telephoto end of the lens.

All lenses have a minimum focusing distance that varies by lens. To ensure sharpness, never focus closer than the minimum focusing distance of the lens. You know that the camera has achieved good focus when you hear the autofocus beep from the camera.

In Close-up mode, the camera automatically sets:

✦ Standard Picture Style

✦ One-shot autofocus with automatic AF point selection

✦ Single-shot drive mode

2.4 This picture was taken in Close-up mode. The Digital Rebel XTi/400D automatically chose ISO 100, f/5.6 at 1/500 second for this exposure.

✦ Automatic flash with the option to turn on Red-eye reduction

Sports mode

In Sports mode, the Digital Rebel XTi/400D sets a fast shutter speed to freeze subject motion. This mode is great for capturing athletes in mid-air, sliding toward a base, or even capturing the antics of pets and children. Use Sports mode in any scene where you want to suspend motion.

In this mode, the camera automatically focuses on the moving subject and tracks the subject until it achieves good focus. If you continue to hold the Shutter button

2.5 This picture was taken in Sports mode. The Digital Rebel automatically chose ISO 100, f/5.6, 1/1000 second for this exposure.

down, the camera maintains focus for continuous shooting. In Sports mode, the camera automatically sets:

✦ Standard Picture Style

✦ AI Servo autofocus with automatic AF point selection. In AI Servo AF, the focus tracks a moving subject, and exposure is set when you take the picture.

✦ Continuous drive mode. Continuous drive mode enables a maximum burst rate of 27 Large/Fine JPEG images.

✦ Flash-off mode

Night Portrait mode

In Night Portrait mode, the Digital Rebel XTi/400D combines flash with a slow synch speed to correctly expose both the person and the background. With a longer exposure such as this, it's important that the subject remain still during the entire exposure to avoid blur. Be sure to use a tripod or set the camera on a solid surface to take night portraits.

You should use this mode when people are in the picture, rather than for general night shots, because the camera blurs the background similar to the way it does in Portrait mode. For night scenes without people, use Landscape mode and a tripod.

In Night Portrait mode, the camera automatically sets:

✦ Standard Picture Style

✦ One-shot autofocus with automatic AF point selection

✦ Single-shot drive mode

✦ Automatic flash with the ability to turn on Red-eye reduction

Flash-off mode

In Flash-off mode, the Digital Rebel XTi/400D does not fire the built-in flash or an external Canon Speedlite, regardless of how low the scene light is. In low-light scenes using Flash-off mode, be sure to use a tripod.

In Flash-off mode, the camera automatically sets:

✦ Standard Picture Style

✦ AI autofocus with automatic AF point selection. This means that the camera automatically switches between One-Shot AF and AI Servo AF, based on the subject's movement or lack of movement, and

the camera automatically selects the AF point.

✦ Single-shot drive mode

✦ Flash-off mode

You can easily change to any of the Basic Zone modes: turn the Mode dial to one of the Basic Zone modes, press the Shutter button halfway down to focus, and take the picture.

Creative Zone modes

Creative Zone modes offer automatic, semi-automatic, or manual control over some or all exposure settings. This zone includes two automatic modes, P (Program AE) and A-DEP (Automatic depth-of-field), which offer creative choices not found in the automatic Basic Zone modes. The three remaining Creative Zone modes—Tv (Shutter-priority

How is Program Mode Different from Full Auto Mode?

While the names of these two modes are similar, they vary greatly in the amount of control that they allow you. In Full Auto mode, the camera sets the exposure for you and you cannot change it. However, in Program mode, you can change the shutter speed and aperture settings to achieve an equivalent exposure to if you were using a different aperture or shutter speed. Program mode also allows you to set the following functions that you can't set in Full Auto mode:

✦ **Shooting settings.** AF mode and AF point selection, Drive mode, Metering mode, Program shift, Exposure compensation, Auto Exposure Bracketing, AE lock, Depth-of-field preview, Clear all camera settings, Custom Functions and Clear all Custom Functions, and Sensor cleaning.

✦ **Built-in flash settings.** Flash on/off, Flash-exposure Lock, and Flash exposure compensation.

✦ **Image-recording settings.** RAW, RAW+Large JPEG selection, ISO, White balance, Custom white balance, White balance correction, White balance bracketing, Color space, and Picture Style.

AE), Av (Aperture-priority AE), and M (Manual exposure) — put full or partial creative control of the exposure in your hands. These exposure modes are very similar to the mode settings that you may have used on film SLR cameras.

P mode

Program AE, shown as P on the Mode dial, is a fully automatic but shiftable mode. Shiftable means that you can change programmed exposure by changing or shifting the shutter speed or aperture. When you shift one exposure element, the camera automatically adjusts other settings to maintain the same or equivalent exposure.

 Cross-Reference *To learn about exposures and maintaining the same, or equivalent, exposure, see Chapter 3.*

P mode is handy when you want to control depth of field and shutter speed with a minimum of adjustment. For example, the camera may set the aperture at f/8, but you may want to soften the background using a wide aperture. In this situation, you can turn the Main dial to shift the programmed exposure settings to a wider aperture. The camera then automatically adjusts the shutter speed to maintain the same overall exposure. In many ways, P mode is very similar to using Av mode, which is described later in this chapter.

While this sounds a lot like other modes, such as Full Auto mode, Program AE mode offers you the advantage of increased control. For example, in Program AE mode, you can select RAW or RAW+JPEG, the ISO, Picture Style, White Balance setting, AF mode and AF point, and Drive and Metering modes. You can also use Auto Exposure Bracketing and AE lock, as well as control flash usage.

Note *If you're using P mode and you see 30 and the maximum lens aperture or 4000 and the minimum lens aperture blinking in the viewfinder, this indicates an underexposure and overexposure, respectively. In these instances, you can increase or decrease the ISO, accordingly.*

Cross-Reference *To learn about ISO settings, see Chapter 3.*

To switch to P mode, follow these steps:

1. **Turn the Mode dial to P.** The Digital Rebel sets the aperture and shutter speed.

2. **To shift the program, change the exposure, press the Shutter button halfway, and then turn the Main dial until the aperture or shutter speed that you want displays in the viewfinder.** You cannot shift the program if you're using the flash.

A-DEP mode

A-DEP, or Automatic Depth-of-Field, mode automatically calculates the optimum depth of field between near and far subjects. This is a handy mode for group photos when subjects are at staggered distances — where one subject is close to the camera and the other subjects are each at progressively greater distances from the first subject. A-DEP mode uses nine AF points to detect near and far subject distances, and provides sufficient depth of field to keep all subjects in sharp focus.

In A-DEP mode, you can select all exposure and drive settings except for the AF mode and the AF point. The camera automatically sets the AF mode to One-shot and chooses the AF points.

Cross-Reference *You can learn more about depth of field in Chapter 3.*

To change to A-DEP mode, follow these steps:

1. **Ensure that the lens is set to AF (autofocus).** The focus switch is located on the side of the lens.

2. **Turn the Mode dial to A-DEP.**

3. **Focus on the subject.** In the viewfinder, verify that the AF points displayed in red cover the subjects, and then take the picture. If the correct AF points aren't selected, shift the camera position slightly and refocus.

Av mode

Aperture-priority AE mode is shown on the camera Mode dial as Av. It allows you to set the aperture (f-stop) to control depth of field while the camera automatically chooses the appropriate shutter speed to make a good exposure. The aperture is the primary factor that controls the depth of field, or how much of the image is in reasonably sharp focus from back to front. A wide aperture, such as f/3.5, provides a narrow depth of field that softly blurs the background. A narrow aperture, such as f/11, provides an extensive depth of field that shows both foreground and background elements reasonably sharp.

Cross-Reference *To learn about aperture, see Chapter 3.*

For most day-to-day shooting, you want to be able to control the depth of field by quickly changing the aperture or f-stop. Av mode gives you this control. In Av mode, you can control all exposure settings and choose the Drive and AF modes.

2.6 I used Aperture-priority mode combined with a telephoto lens for this image to ensure that the background was rendered as a blur. The exposure for this image was ISO 100, f/5 at 1/600 second.

Note *You can preview the depth of field for an image by pressing the Depth-of-field preview button on the front of the camera. When you press the button, the lens diaphragm closes to the aperture that you've set so that you can see the range of acceptable focus.*

If you choose this mode, then check the shutter speed in the viewfinder; if it is 1/30 second or slower, be sure to use a tripod. Another rule of thumb is that the slowest shutter speed that you should use for hand-holding the camera is the reciprocal of the focal length of the lens. For example, if you're using a 300mm lens, then the slowest shutter speed at which you can hand-hold the camera and get a sharp image is 1/300 second. For a 50mm lens, the shutter speed would be 1/50 second, and so on.

To change to Av mode, follow these steps:

1. **Turn the Mode dial to Av.**

2. **Turn the Main dial to the aperture that you want.** Aperture values display in the viewfinder

and LCD in 1/3-stop increments, such as 5.6, 6.3, 7.1, and so on. The higher the f-number, the smaller the aperture, and the greater the depth of field. The smaller the f-number, the larger the aperture, and the less the depth of field. The camera sets the shutter speed automatically.

3. **Press the Shutter-button halfway down to focus on the subject, and then take the picture.**

Tv mode

Shutter-priority AE mode is shown as Tv on the Mode dial, and allows you to set the shutter speed and control whether the subject's motion is frozen or shown as a blur. Setting a fast shutter speed freezes subject motion, while setting a slow shutter speed shows motion blur. In this mode, you set the shutter speed, and the camera automatically chooses the aperture.

The shutter speeds that you can choose from depend on the light in the scene. In low-light scenes without a flash, you may not be able to get a fast enough shutter speed to freeze the action.

> **Cross-Reference** *To learn about shutter speeds, see Chapter 3.*

This is a good mode to use in low-light scenes when you want to ensure that the shutter speed is fast enough to prevent blur in the image due to camera shake when you handhold the camera. For sports and other action scenes, Tv mode allows you to quickly change the shutter speed while the camera automatically sets the appropriate aperture to make a good exposure. You can

2.7 Using Tv (Shutter-priority AE) mode, I used 1/25 second and f/32 to add a soft blur to the motion of the water in this image. The ISO was set to 100.

also control all exposure settings and choose the Drive and AF modes.

To change to Tv mode, follow these steps:

1. **Turn the Mode dial to Tv.**

2. **Turn the Main dial to the shutter speed that you want.** Shutter speed values display in the viewfinder and LCD in 1/3-stop increments; for example, 125 indicates 1/125 second, and "0"6" indicates 0.6 seconds. If the f-stop blinks, it means that a suitable aperture is not available at that shutter speed under the prevailing light conditions. In this situation, you can switch to a higher ISO or a slower shutter speed. The camera sets the aperture automatically.

3. **Press the Shutter-button halfway down to focus on the subject, and then take the picture.**

M mode

As the name implies, Manual mode allows you to set both the aperture and the shutter speed, based on the camera's light-meter reading. Indicated by an M on the Mode dial, Manual mode is helpful in difficult lighting situations when you want to override the camera's automatic settings in either Av or Tv modes, and in situations where you want consistent exposures across a series of photos, such as for a panoramic series. Note that because it takes more time to set all of the exposure settings yourself, many people prefer to routinely use semiautomatic modes such as Av and Tv. In Manual mode, you can control all exposure settings and choose the Drive and AF modes.

To change to Manual mode, follow these steps:

1. **Turn the Mode dial to M.**

2. **Turn the Main dial to the shutter speed that you want.**

3. **Press and hold the Aperture value (Av) button on the back of the camera, and then turn the Main dial to set the aperture that you want.**

4. **Press the Shutter-button halfway down to focus on the subject.** The camera displays the exposure level index in the viewfinder to show how far the exposure is from the standard exposure.

5. **For a standard exposure, turn the Main dial to change the aperture or shutter speed until the marker moves to the center of the exposure index that appears in the viewfinder.** Or you can also repeat Steps 2 and 3 to set the exposure above (to over-expose) or below (to underexpose) the standard exposure, and then take the picture.

Metering Modes

To make a good exposure, the camera has to know the amount of light that illuminates the subject or scene. To determine this, the camera's light meter measures the amount of light in the scene, and, based on the ISO, the camera calculates the aperture and shutter-speed combinations that are required to make the exposure.

Most cameras, including the Digital Rebel XTi/400D, use a meter that measures light reflected from the subject back to the camera. Reflective light meters assume that all scenes have an average distribution of light, medium, and dark tones. When calculating exposure, the meter also assumes that the average of all tones in the scene is medium, or 18 percent, gray.

And, in average scenes, the meter is correct and produces a properly exposed image. However, not all scenes contain average tonality; for example, a snow scene is predominantly white, while a scene with a large expanse of water is predominantly dark. Nonetheless, the meter assumes an average tonality and tries to average the tones to medium gray. In a snow scene, the result is gray snow. Conversely, in a scene with a large expanse of dark water, the camera produces gray water.

As a corollary, if you're making a portrait, you care most that the subject is correctly exposed. While it would be nice to have a proper background exposure, this is less important than the subject exposure. If the background light is very bright and detail is lost, then so be it — as long as the subject, the person, is properly exposed.

To get a precise exposure for the subject, it's best to take a meter reading on a small part of the scene, such as the subject's face. A spot meter, which reads from a very small area of the subject, is the best tool for this job. On the Digital Rebel XTi/400D, the rough equivalent of a spot meter is the Partial metering mode. When you use Partial metering, the camera measures a small area, approximately nine percent, at the center of the viewfinder. Depending on your distance from the subject, this type of reading disregards the background and provides the exposure settings that are necessary to properly expose the subject.

The Digital Rebel XTi/400D offers three metering modes that are differentiated by the size of viewfinder area that the meter uses to take the reading. Although you can choose metering modes in Creative Zone modes, you cannot choose them in Basic Zone modes. If you are shooting in any Creative Zone mode except Manual, you can use Auto Exposure Bracketing, Exposure compensation, and AE lock in any of the metering modes.

Evaluative metering

Evaluative metering is the default metering mode on the Digital Rebel XTi/400D, and it analyzes light from virtually the entire viewfinder area. Canon's 35-zone Evaluative metering system is linked to the AF system. The meter analyzes the point of focus and automatically applies compensation if the surrounding areas are much lighter or darker than the point of focus. To determine exposure, the camera analyzes subject position, brightness, background, front- and backlighting, and camera orientation.

Evaluative metering produces excellent exposures in average scenes that include a distribution of light, medium, and dark tones. However, in scenes where there is a large expanse of predominantly light or dark areas, the metering averages the tones to middle gray, thereby rendering snow scenes and large expanses of dark water as gray. In these situations, it's good to use exposure compensation to increase or decrease exposure by one to two stops for scenes with

predominantly light or dark tones, respectively. Evaluative metering mode is the default for all Basic Zone modes.

To select Evaluative metering mode, press the Metering mode (left cross) key on the back of the camera, and use the left or right cross keys to select the icon that resembles a solid dot within a circle.

Center-weighted Average metering

Center-weighted Average metering gives more weight to the area of the scene within the seven AF points in the center of the viewfinder. Then the camera averages the reading for the entire scene. This metering mode is handy for backlit subjects and scenes where the tones are not average and require exposure compensation.

 Note *There are nine AF points, but in center-weighted metering not all of the AF points are used — only the seven AF points in the center, hence the name, center-weighted.*

To select Center-weighted Average metering mode, press the Metering mode (left cross) key on the back of the camera, and use the left or right cross keys to select the icon that resembles a circle within a rectangle.

Partial metering

Partial metering meters from a central nine percent of the viewfinder. Partial metering is especially handy in backlit or side-lit scenes where you want to ensure that the main subject is properly exposed. For example, if you take a portrait of a person who is backlit, you can use Partial metering mode to

ensure that the person's face is properly exposed.

Note *The Digital Rebel XTi/400D's exposure meter is sensitive to stray light that can enter through the viewfinder. If you're using the self timer or you set the camera on a tripod in bright light but you don't keep your eye pressed against the viewfinder, then stray light entering the viewfinder can result in underexposed images. When you don't have your eye firmly against the eyecup, be sure to use the viewfinder eyepiece cover that is attached to the camera strap, or cover the viewfinder with your hand.*

To select Partial metering mode, press the Metering mode (left cross) key on the back of the camera, and use the left or right cross keys to select the icon that is an empty rectangle.

Exposure Compensation

Some scenes can fool the camera's meter. In these situations, you can use exposure compensation to override the camera's default exposure; for example, in scenes that have large expanses of predominantly light tones such as snow scenes or in scenes that have large expanses of predominantly dark tones. Exposure compensation resets the camera's standard exposure setting by the amount of compensation (in partial or whole f-stops) that you choose.

For example, if you're taking a picture of a snow scene, setting positive exposure

compensation increases the exposure so that the snow is white snow instead of gray. In a snow or white sand scene, a positive compensation of +1 to +2 f-stops will do the trick.

Exposure compensation is set in 1/3- or 1/2-stop increments up to +/-2 f-stops. You can use exposure compensation in all Creative Zone modes except for Manual mode, and you can combine exposure compensation with Auto Exposure Bracketing.

You can set exposure compensation by following these steps:

1. **Switch to any Creative Zone mode except for Manual, and then press the Shutter button halfway down.** Holding the shutter half-pressed is optional. If you release it and the exposure compensation indicator disappears, then lightly press the Shutter button to restore it.

2. **While looking in the viewfinder or on the LCD, press the Exposure compensation button (the button marked Av) on the back of the camera.**

3. **At the bottom of the viewfinder, watch the exposure index as you turn the Main dial.** To set positive (right of the center mark) compensation, turn the Main dial to the right. To set negative (left of the center mark) compensation, turn the Main dial to the left.

Exposure compensation remains in effect until you reset it back to the center mark by repeating steps 1 to 3.

Auto Exposure Bracketing

Auto Exposure Bracketing (AEB), a favorite technique of photographers for years, is a way to ensure that at least one exposure in a series of three images is acceptable. With AEB turned on, you can take three pictures at three different exposures: one picture at the standard exposure set by the camera, one picture at an increased (lighter) exposure, and another picture at a decreased (darker) exposure. You can set AEB in 1/3- or 1/2-stop increments up to +/- 2 stops.

While bracketing isn't necessary in all scenes, it's a good technique to use in scenes that are difficult to set up or that can't be reproduced. It is also useful in scenes with tricky lighting such as a landscape with a dark foreground and a much lighter sky. You can't use AEB with the flash or when the shutter is set to Bulb—a setting where the shutter remains open until you release the Shutter button.

Tip *AEB is handy because it produces three different exposures that you can combine in an image-editing program. For example, if a scene has a wide difference between highlight and shadow areas, bracketed exposures provide exposures of both extremes as well as the standard exposure. In an image-editing program, you open the standard exposure, composite the darker bracketed exposure to add detail in the highlights that may be missing in the standard image, and then composite the lighter bracketed exposure to reveal detail in shadow areas.*

It's worthwhile to learn how AEB works in the different drive modes:

✦ In Continuous and Self-Timer modes, pressing the Shutter button once automatically takes three bracketed exposures.

✦ In Single-shot drive mode, you have to press the shutter three separate times to get the three bracketed exposures.

You cannot use AEB with the built-in flash.

The camera takes the standard exposure first, the decreased exposure second, and then the increased exposure. If you combine AEB with Exposure compensation, the shots are taken based on the compensation amount. However, AEB settings are temporary. If you change lenses, replace the CF card or battery, or turn off the camera, the AEB settings are cancelled.

You can set AEB by following these steps:

1. **Press the Menu button on the back of the camera.**

2. **Press the left cross key to select the Shooting 2 tab.**

3. **Press the down cross key, and select AEB.**

4. **Press the Set button.** The bracketing scale is activated.

5. **Press the right cross key to select the bracketing amount in 1/3- or 1/2-stop increments.** Markers that show increased and decreased exposure settings are displayed on the scale.

6. **Press the Set button, and then press the Shutter button to begin shooting.**

You can turn off AEB by turning the camera off, changing lenses, or changing memory cards.

AE Lock

With the Digital Rebel XTi/400D, both the exposure and the focus are set when you press the Shutter button halfway down to focus. However, there are times when you don't want to set the exposure on the same area where you set the focus. For example, if a person that you're photographing is lit by a spotlight, the brightest light may fall on the subject's forehead. In this situation, you want to set the exposure for the forehead highlight, but focus on the person's eyes. To do this, you have to de-couple the exposure metering from autofocusing. You can do this by using AE (Auto-exposure) lock.

By pressing and holding the AE Lock button, you can set the exposure, and then move the camera and focus on a different area of the scene. This is one of the most useful features on the Digital Rebel XTi/400D for preventing blowout of detail in the highlights, and for ensuring precise exposure.

You can use AE lock in all Creative Zone modes except for Manual mode. Table 2.1 shows how AE lock works with each metering mode and AF point.

You can set AE lock by following these steps:

1. **Point the camera to the part of the scene that you want to be exposed correctly, and then press the Shutter button halfway down.** The exposure is displayed in the viewfinder.

	Table 2.1	
	AE Lock	
Metering Mode	*Auto AF-point Selection*	*Manual AF-point Selection*
Evaluative metering	AE lock is applied at the AF point that achieves focus.	AE lock is applied at the selected AF point.
Partial metering	AE lock is applied at the center AF point.	
Center-weighted Average metering		AE lock is applied at the center AF point.

2. **Continue to hold the Shutter button halfway down as you press and hold the AE Lock button on the back of the camera.** The AE Lock button has an asterisk icon above it on the camera. An asterisk icon appears in the viewfinder to indicate that AE lock is activated. You can now release the Shutter button.

3. **Move the camera to recompose the shot, focus on the subject, and then take the picture.** As long as you hold down the AE Lock button, you can take additional pictures using the locked exposure.

Evaluating Exposure

Getting an accurate exposure is critical to getting a good image, but you may be wondering how you can judge whether an image is accurately exposed at the time you take the picture. On the Digital Rebel XTi/400D, you can evaluate the exposure immediately after you take the picture by looking at the image histogram.

If you're new to digital photography, the concept of a histogram may also be new. A histogram is a bar graph that shows either the grayscale brightness values in the image — from black (level 0) to white (level 255) — or the Red, Green, and Blue (RGB) brightness levels, along the bottom. The vertical axis displays the number of pixels at each location.

Naturally, some scenes can cause a distribution of values that are weighted more toward one side of the scale or the other, specifically in scenes that have predominantly light or dark tones. However, in average scenes, the goal of good exposure is to have the values, or tones, with a fairly even distribution across the entire graph and, in most cases, to avoid having pixels crowded against the far left or right side of the graph.

It is important to know that half of the tonal values in an image are contained in the first f-stop of bright tones. In an image with a six-stop dynamic range (12 bits per channel per pixel, for a possible 4,096 levels in each channel), the first f-stop contains 2,048 levels, while the second f-stop contains 1,024 levels, the third f-stop contains 512 levels, the fourth f-stop contains 256 levels, the fifth f-stop contains 128 levels, and the sixth f-stop, the darkest shadows, contains only 64 levels.

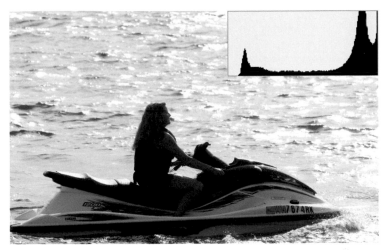

2.8 The histogram inset in this picture shows the pixels crowded against the right side of the histogram, indicating that the image is overexposed in the highlights. Severe overexposure obliterates detail in the highlight areas, such as the waves in this image.

This means that with RAW images, you should expose toward the right side of the histogram to get the maximum levels from a capture. In other words, check the histogram to ensure both that the exposure maintains highlight detail (pixels should be close to, but not pushed against, the right side of the graph), and that there is no empty space between the right edge of the histogram and where the pixels begin.

During image playback, you can press the DISP button twice to display the image with a histogram. This display also has a highlight alert that flashes to show areas of the image that are overexposed (or areas that have no detail in the highlights). If you're shooting RAW capture, be aware that although the histogram is based on the JPEG image, you can use it to evaluate the exposure. If necessary, you can retake the picture if the highlights are blown or shadow areas are solid black (the pixels are pushed against the left side of the scale).

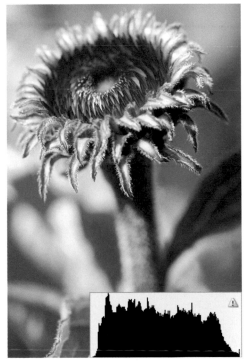

2.9 In the histogram inset in this picture, pixels fill the tonal range, and the image maintains good detail in both the shadow and highlight areas.

Focus and Autofocus Modes

In addition to achieving good exposure, the success of a picture also depends on getting crisp focus. In turn, provided that you keep the camera steady when you take the picture, getting tack-sharp focus depends on three factors: the resolving power of the lens (its ability to render fine details sharply), the resolution of the image sensor, and, if you print the image, the resolution of the printer.

Autofocus speed figures into the final image sharpness as well, especially for fleeting moments such as a child's expression or the flight of an elusive eagle. Autofocus speed depends on factors that include the size of the lens and the speed of the lens-focusing motor, the speed of the autofocus sensor in the camera, and how easy or difficult it is for the camera to focus on the subject.

For most shooting situations, the Digital Rebel XTi/400D's wide-area AI (artificial intelligence) AF (autofocus) system — a system that is tied closely to the camera's drive modes — is fast and reliable. The camera automatically chooses one of three focusing modes:

✦ **One-Shot AF, for still subjects.** In Basic Zone modes, the camera chooses the AF point and does not detect whether the subject is in motion. In Creative Zone modes, you select the AF point.

✦ **AI Servo AF for moving subjects.** When the subject is moving and you are taking single shots, the camera tracks the subject and predicts the focusing distance just before you take the picture. If the AF point is automatically selected, the camera uses the center AF point and tracks the subject as it moves across AF points. If you manually select the AF point, then the camera uses the selected AF point to track the subject.

✦ **AI Focus AF, for still subjects and subjects that may begin to move.** In this mode, the camera automatically switches from One-shot AF to AI Servo AF if it detects subject movement.

In Creative Zone modes, you can select among these AF modes. In Basic Zone modes, you cannot manually select a focus mode. Table 2.2 shows which mode is selected in each drive and exposure mode.

To change AF modes in Creative Zone modes, ensure that the lens is set to autofocus, press the AF (right cross key) button on the back of the camera, and then press the left or right cross key to change the AF mode. Then press the Set button.

Table 2.2
Autofocus and Drive Modes

Drive Mode	Autofocus Mode		
	One-Shot AF	**AI Servo AF**	**AI Focus AF**
Single Shooting	In One-Shot AF mode, the camera must confirm accurate focus before you can take the picture. Once focus is achieved, it is locked as long as the Shutter button is halfway pressed. Exposure is locked as well. This is the best mode for still subjects.	In AI Servo AF, the focus tracks a moving subject, and exposure is set when you take the picture. This mode is used in the Sports Basic Zone mode.	The camera automatically switches between One-Shot AF and AI Servo AF, based on the subject's movement or lack of movement.
Continuous Shooting	Same as single shooting during continuous shooting.	Same as single shooting, with autofocus continuing during shooting at 3fps.	

Understanding Autofocus Point Selection

The EOS Digital Rebel XTi/400D uses a wide-area AI (artificial intelligence) AF (Autofocus) system with nine AF points. An AF point determines the point in the image that will be in sharpest focus.

In Basic Zone modes, the camera automatically selects the AF point. You can select the AF point in all Creative Zone modes, except A-DEP mode.

When no focus point is selected, the camera automatically determines the focus point by analyzing the scene and determining which AF point is over the closest part of the subject. The camera shows the selected AF point in the viewfinder.

While the autofocus system is reliable, it can fail if subjects are in low light, are low in contrast or monotone in color, or when other objects overlap the main subject. For this reason, if you're shooting in Basic Zone modes, be sure to confirm in the LCD that the camera has selected the best AF point. If you still can't get sharp focus, remember that you can quickly switch the lens to MF (manual focus) and turn the focusing ring manually to focus on low-contrast, dim, or monotone subjects.

With autofocus, the camera most often focuses on the object that is nearest the lens. This may or may not be the area of the scene or subject that you want to focus on. For example, if you're taking a portrait, the model's nose is closest to the lens, but the nose isn't where you want to focus. Instead, you want to focus on the model's eyes. The same situation can occur with close-up shots where you want to focus on the center of a

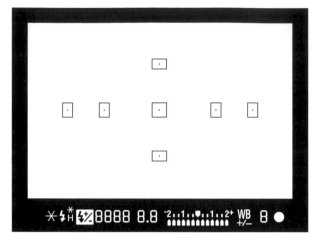

2.10 Nine AF points are shown on the focusing screen on the Digital Rebel XTi/400D.

flower, but in Basic Zone modes, the camera focuses on the part of the flower nearest the lens. In Basic Zone modes with AF-point selection, getting the camera to choose a different AF point is difficult and sometimes impossible. Switching to manual focus is helpful, but not foolproof. For that reason, you may want to switch to a Creative Zone mode so that you can select the AF point manually.

In One-Shot AF, you cannot release the shutter until focus is established. In AI Servo AF, you can release the shutter whether or not the subject is in focus because the focus subsequently catches up with the subject's movement.

You can manually select the AF point by following these steps:

1. **Set the Mode dial to any Creative Zone mode except for A-DEP.**

2. **Press the AF Point Selector button on the upper-right area on the back of the camera.** The AF Point Selector button has an icon, a magnifying glass with a plus sign in it, below the button. The currently selected AF point appears in the viewfinder in red and on the LCD panel.

3. **With the camera to your eye, turn the Main dial until the AF point that you want is highlighted in the viewfinder.** You can also use the cross keys to select an AF point.

4. **Press the Shutter button halfway down to focus on the subject, and continue to hold it to lock focus.** The focus is locked as long as you hold down the Shutter button.

5. **If you want to recompose the image, continue to hold the Shutter button halfway down, move the camera to recompose the shot, and then take the picture.**

Tip *In close focusing situations, and at times when the subject can't be reliably focused on using the AF system, you can switch to MF by sliding the switch on the side of the lens to the MF position. Then you can focus by turning the lens focus ring.*

Using Drive Modes

Drive modes determine how many shots the camera takes at a time. The Digital Rebel XTi/400D has three Drive modes that are appropriate in different shooting situations: Single-shot, Continuous, and Self-timer/Remote control. In Basic Zone modes, the camera automatically chooses the Drive mode.

You can select the Drive mode in all Creative Zone modes.

Single-shot mode

As the name implies, Single-shot means that the Digital Rebel XTi/400D takes one picture each time you press the shutter-release button. In this mode, you can shoot three frames per second (fps), depending on shutter speed.

Continuous mode

The Continuous drive mode allows continuous shooting of three sequential images, or a continuous burst of 27 JPEG Large/Fine images, 10 RAW, or 8 RAW + JPEG Large/Fine images. You initiate image bursts

Setting a Custom Function on the Digital Rebel

On the Digital Rebel XTi/400D, 11 Custom Functions allow you to set your favorite preferences and use them when you're shooting in Creative Zone modes. For example, in Custom Function 1 (C.Fn-1), you can choose to change the function of the Set button and cross keys. You can also choose to have the Set button display the Picture style menu, the image Quality menu, and the Flash Exposure Compensation screen, or to playback images. Other handy functions allow you to set long exposure with noise reduction, determine exposure compensation increments, set shutter curtain sync, and enable mirror lock-up.

To set a Custom Function on the Digital RebelXTi/400D, follow these steps:

1. **Press the Menu button on the back of the camera, and then select the Tools 2 tab.** The Set-up 2 menu appears.

2. **Press the down cross key to select Custom Functions (C.Fn), and then press the Set button.** The Custom Function screen appears.

3. **Press the left or right cross key to select the Custom Function number, and then press the Set button.** The Custom Function options are activated.

4. **Press the up or down cross key to select the setting that you want, and then press the Set button.** Repeat steps 3 and 4 to set other Custom Functions.

5. **Press the Menu button to return to the menu.**

A complete list of Custom Functions, along with their options, is provided in Appendix A.

by pressing and holding the Shutter button all the way down.

 Note *In AI Servo AF mode, the burst rate may be less, depending on the lens and subject.*

When the buffer is full from a continuous shooting burst, you can't shoot until some of the images are offloaded to the CF card. Thanks to Canon's smart-buffering capability, you don't have to wait for the buffer to empty all of the images to the media card before you can continue shooting. After a continuous burst sequence, the camera begins offloading pictures from the buffer to the card. As offloading progresses, the camera indicates in the viewfinder when there is enough buffer space to continue shooting. When the buffer is full, a "busy" message appears in the viewfinder, but if you keep the Shutter button pressed, the number of pictures that you can take is updated in the viewfinder. This is where it is useful to have a fast CF card, which speeds up image offloading from the buffer.

Note *If the AF mode is set to AI Servo AF, the Digital Rebel XTi/400D focuses continually during continuous shooting. However, in One-Shot AF mode, the camera only focuses once during the burst.*

Viewing and Playing Back Images

The ability to see the picture immediately after you take it is one of the crowning jewels of digital photography. On the Digital Rebel XTi/400D, you can not only view images after you take them, but you can also magnify images to verify that the focus is sharp, display multiple images that you have stored on the memory card, display the image with a brightness or RGB histogram, display images as a slide show, and display the image along with its exposure settings.

The following sections describe viewing options and offer suggestions for using each option.

Single-image playback

Single-image playback is the default playback mode, and it briefly shows the image on the LCD after you take the picture. Canon sets the initial display time to two seconds, hardly enough time to move the camera from your eye and to see the image preview. The display time is intentionally set to two seconds to maximize battery life, but given the excellent performance of the battery, a longer display time of four or even eight seconds is more useful. You can also choose to set the Hold option to display the image until you dismiss it by lightly pressing the Shutter button.

To turn on image review, press the Playback button on the back of the camera. If you have multiple pictures on the CF card, you can use the left and right cross keys, or the Main dial to move forward and back through the images.

If you want to change the length of time that images display on the LCD, follow these steps:

1. **Press the Menu button on the back of the camera.**

2. **Press the right cross key to select the Playback tab, then press the down cross key, and then select Review time.**

3. **Press the Set button.** The Review time options are activated.

4. **Press the down cross key to select Off, 2, 4, 8, or Hold.** The numbers indicate the number of seconds that the image displays. Off disables image display, while Hold displays the image until you dismiss it by pressing the Shutter button. Because image display tends to be a power-hungry task, you should use the Hold option with caution.

5. **Press the Set button to confirm your settings, and then press the Shutter button to return to shooting.**

Index Display

The Index Display is an electronic version of a traditional contact sheet. Index Display shows thumbnails of the images on the CF card, with nine images displayed at a time on the LCD. This display is handy when you need to ensure that you have a picture of everyone at a party or event, and it's also a handy way to quickly select a particular image on the media card when the card is full of images.

Tip *Anytime you want to see images on the LCD, just look for the buttons with blue icons or text on the back of the camera. These buttons display images or enable you to move among or magnify them.*

To turn on the Index Display, follow these steps:

1. **Press the Playback button on the back of the camera.**

2. **Press the AE/FE Lock button on the back of the camera.** This button has an asterisk displayed above it.

3. **Press the cross keys to move among the images.** The selected image has a green border.

4. **Press the Enlarge button one or more times to magnify the image.** A rectangular cursor displays in this view. You can move the cursor using the cross keys in order to view different areas of the magnified image.

Tip *You can press the Jump button and the cross keys to move forward or back 10 or 100 images in the Index Display. In full image display, you can press the Jump button and the left or right cross key to move to the first or last image on the card, respectively.*

5. **Press the Shutter button to cancel the display.**

Tip *If you have many images on the CF card and you are viewing images in Index Display, you can press the Jump button to select all nine images as a group. You can then use the left and right cross keys to move to the next group of nine images, and so on, to quickly move through many images on the card.*

Auto Playback

When you want to sit back and enjoy all of the pictures on the CF card, the Auto Playback option plays a slide show of images on the card, displaying each one for three seconds. This is a great option to use when you want to share pictures with the people that you're photographing, or as a review to verify that you've taken all of the shots that you intended to take during a shooting session.

You can turn on Auto Playback by following these steps:

1. **Press the Menu button on the back of the camera, and then press the right cross key to select the Playback tab.**

2. **Press the down cross key to select Auto play.**

3. **Press the Set button.** Images display sequentially and in a continuous loop until you press the Shutter button to stop the slide show. You can pause the display by pressing the Set button. A Pause icon appears in the upper-left area of the image preview. Press the Set button again to resume Auto play.

The DISP button

During image playback, one of the most helpful features is the DISP button. Whether you're in Single-image, Index, or Auto play mode, you can press the DISP button to display all of the exposure settings and see the image's histogram. As you learn to evaluate histograms, you'll appreciate this feature, and it will likely become an often-used playback option.

> **Note** In these playback displays, you can use the Jump button to move forward and back among images. A bar at the bottom of the LCD indicates the position of the image relative to all images on the CF card. When you use the Jump button along with the left and right cross keys, the display jumps ten images either way.

The DISP button sequences through different displays. In single-image playback mode, press DISP once to display basic shooting information overlaid on the image preview. Press DISP again to display shooting information, a small image preview, and the image histogram. Press it once more to return to an image display with no shooting information. You can use the cross keys to move forward and back through pictures in this display.

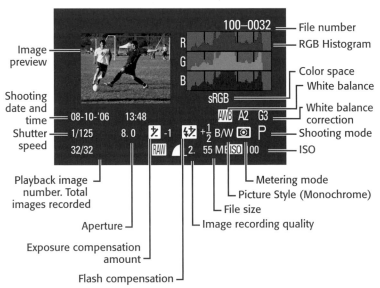

2.11 This is an image preview displaying the RGB (Red, Green, Blue) histogram, date and time, and shooting information.

Another useful playback option is the ability to magnify an image. Magnification helps to verify everything, from focus to signs of digital noise. You cannot magnify images in Auto Playback mode, but you can use it in Index Display.

To magnify an image in Single-image or Index playback displays, press the Enlarge button on the back of the camera. You can magnify from 1.5x to 10x, and use the cross keys to scroll to different parts of the image.

To reduce the magnification, press the Reduce button. You can also use the Main dial to scroll to the next image while maintaining the same image position and magnification level.

Erasing Images

Erasing images is useful only when you know without a doubt that you don't want the image that you're deleting. From experience, however, I know that some images that appear to be mediocre on the LCD can very often be salvaged with some judicious image-editing on the computer. For that reason, you should erase images with caution.

If you want to delete an image, follow these steps:

1. **Press the Playback button on the back of the camera and press the left and right cross keys to select the picture that you want to delete.**

2. **Press the Erase button, and then use the left and right cross keys to select Erase (only the displayed image), All (all images on the CF card), or Cancel.**

3. **Press the Set button to erase the image or images.** When the access lamp stops blinking, lightly press the Shutter button to continue shooting.

Protecting Images

On the other end of the spectrum from erasing images is the ability to ensure that images that you want to keep are not accidentally deleted. When you have that perfect or once-in-a-lifetime shot, you can protect it to ensure that it is not erased.

Setting protection means that no one can erase the image when they use the Erase or Erase All options.

 Caution *Even protected images are erased if you or someone else formats the CF card.*

You can protect an image by following these steps:

1. **Press the Playback button on the back of the camera.** The last image that was taken is displayed on the LCD.

2. **Press the left or right cross key to move to the image that you want to protect.**

3. **Press the Menu button on the back of the camera, and then press the right cross key to select the Playback tab.**

4. **Press the down cross key to select Protect, and then press the Set button.** A small key icon appears at the top of protected images. You can use the left and right cross keys to scroll to other images that you want to protect, and then press the Set button to add protection to the images.

Why Flash-sync Speed Matters

Flash-sync speed matters because, if it isn't set correctly, only part of the image sensor has enough time to receive light while the shutter is open. The result is an unevenly exposed image. The Digital Rebel XTi/400D doesn't allow you to set a shutter speed higher than the 1/200-second flash-sync speed, but in some modes, you can set shutter speeds slower than the flash-sync speed, as shown in the tables in this section.

Using a Flash

Some people shy away from using an external or built-in flash because the light emitted by the flash tends to produce harsh, unnatural-looking illumination on the subject — or even worse, dark shadows behind the subject. Others avoid flash because it can often overexpose the subject, or, more commonly, produce the dreaded red-eye effect in people and pets.

Either the Digital Rebel XTi/400D's built-in flash or an external Canon EX flash unit can help to solve many of the common problems associated with flash photography. In addition, they both offer greater control to allow you to avoid problems that you may have experienced with other cameras. The tables in this section describe the use of the flash in Creative Zone modes as well as in Basic Zone exposure modes that automatically activate the flash.

If you routinely use the built-in flash, then you should know its range and capabilities. The range depends on both the type of lens that you use and the ISO. In general, the longer the focal length, the shorter the distance that the flash covers, and the higher the ISO, the farther the distance the flash illumination covers.

In regard to the dreaded red-eye, the high position of the flash unit, combined with the

Red-eye reduction option, helps to counteract but not eliminate this effect. Red-eye reduction is discussed in more detail later in this chapter.

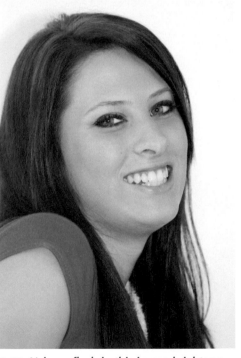

2.12 Using a flash in this image brightens the subject's face and adds catch lights to her eyes. This image was taken using Portrait mode with Red-eye reduction turned on. The exposure was ISO 400, f/4 at 1/60 second.

In fast-action scenes, be sure to not shoot faster than the flash can recycle — approximately two seconds. The built-in flash is sufficient to cover a 28mm field of view, and the closest flash-to-subject distance is one meter, or about three feet, three inches. The maximum flash-sync speed on the Digital Rebel XTi/400D is 1/200 second, which the camera sets automatically, although in some exposure modes, you can set a slower shutter speed.

To ensure correct subject illumination, Canon has a Flash-exposure (FE) lock that's available in Creative Zone exposure modes. The camera calculates and locks the correct exposure for any part of a subject that you choose so that the subject's face, for example, isn't overexposed. FE lock is discussed in more detail later in this chapter.

In addition to the built-in flash, the Digital Rebel XTi/400D has a hot shoe for external Canon EX flash units. While the built-in flash is handy and performs well, an external flash offers creative options that include bouncing and feathering the flash to produce flattering and soft lighting effects, fill-flash to reduce harsh shadows caused by bright overhead light, and fill light for areas in shadow.

| Note | *When you use the built-in flash, be sure to remove the lens hood first to prevent obstruction of the flash coverage. Also, if you use a fast, super-telephoto lens, the built-in flash coverage may be obstructed.* |

Tables 2.3 and 2.4 describe the behavior of the flash and the options in various exposure modes, the ranges of the flash, and Flash-sync speed and aperture settings. Also, you can set Custom Function 3 (C. Fn-3), Flash-sync Speed in Av mode, to option 1 to set the Flash-sync speed to 1/200 second fixed. This option helps to ensure a fast enough shutter speed to prevent blur when you handhold the camera.

Table 2.3
Built-in Flash Range with the EF-S18-55mm Lens

ISO	18mm	55mm
100	1 to 3.7m (3.3 to 12.1 ft.)	1 to 2.3m (3.3 to 7.5 ft.)
200	0.7 to 5.3m (3.3 to 17.4 ft.)	1 to 3.3m (3.3 to 10.8 ft.)
400	0.7 to 7.4m (3.3 to 24.3 ft.)	1 to 4.6m (3.3 to 15.1 ft.)
800	0.7 to 10.5m (3.3 to 34.4 ft.)	1 to 6.6m (3.3 to 21.7 ft.)
1600	0.7 to 14.9m (3.3 to 48.9 ft.)	1 to 9.2m (3.3 to 30.5 ft.)

Table 2.4
Flash-sync Speeds and Aperture Settings

Exposure Mode	Shutter Speed	Aperture
P & A-DEP	Auto (1/60 to 1/200 second)	Auto
Tv	Manual (30 seconds to 1/200 second)	Auto
Av	Auto (30 seconds to 1/200 second)	Manual
M	Manual (Bulb or 30 seconds to 1/200 second)	Manual

Red-eye reduction

Long the bane of photographers of all skill levels, the red-eye effect has ruined many, many pictures. This ghoulish appearance of the eyes occurs when the light from the flash reflects off the back of the retina, making the eyes appear red. Red-eye reduction fires a pre-flash that helps to decrease the diameter of the pupil and lessen the effect; however, it does not eliminate it entirely.

You can use Red-eye reduction in all exposure modes except for Landscape, Sports, and Flash-off modes. To turn on Red-eye reduction, follow these steps:

1. **Press the Menu button on the back of the camera and select the Shooting 1 menu.**

2. **Press the down cross key to select Red-eye On/Off.**

3. **Press the Set key, and then press the down cross key to select On.** Repeat this process to turn off Red-eye reduction; otherwise, it remains selected when the camera is turned off.

Tip
To reduce the appearance of red eyes, ask the subject to look slightly away from the camera and turn on additional lights. If you're using Red-eye reduction, ask the subject to look at the pre-flash lamp on the front of the camera, and then take the picture while the Red-eye reduction lamp indicator in the viewfinder is lit.

FE lock

When you want precise flash exposure for a particular area of the subject, switch to a Creative Zone exposure mode and use FE lock. You can also use FE lock to increase or decrease flash intensity. For example, to decrease flash intensity, point the camera at a white object or a subject that is closer to the camera. To increase flash intensity, point the camera at a dark or farther-away subject.

To use FE lock, follow these steps:

1. **Set the camera to a Creative Zone mode, and then press the Flash button to pop up the built-in flash.**

2. **Focus on the subject by pressing the Shutter button halfway down.**

3. **Position the selected AF point over the area of the subject where you want to lock flash exposure, and then press the AE/FE Lock button.** The AE/FE Lock button has an asterisk icon above it. A pre-flash should fire and the FE Lock icon should display in the viewfinder.

4. **Reposition the camera to compose the shot, press the Shutter button halfway to focus, and then take the picture.**

In Manual mode, you can experiment with shutter speeds (1/200 second and slower) to lighten or darken the scene. The shutter speed controls the overall scene exposure, and the aperture controls the flash exposure. Try experimenting with one or both settings to get the effect that you want.

Using the EOS Integrated Cleaning System

Keeping the image sensor and, subsequently, images clean and dust-free has been a challenge to digital photographers for years. Each time you change the lens on the camera, dust can filter into the lens chamber and eventually settle on the low-pass filter in front of the image sensor. Dust spots on the image sensor inevitably appear as dark spots on your images. With the Digital Rebel XTi/400D, Canon offers a two-step automated cleaning system to address both small, light particles and sticky particles that adhere to the low-pass filter in front of the image sensor.

The first step in the system is automatic cleaning that uses ultrasonic vibrations, driven by a piezoelectric element in the camera, to shake off dust from the first low-pass filter in front of the image sensor. Dust that falls off is captured by sticky material that surrounds the low-pass filter. Each time you turn the camera on and off, the self-cleaning unit operates for one second, barely enough time to notice its operation. You can suspend automatic cleaning by pressing the Shutter or Menu button. In this way, shooting takes priority over sensor cleaning. In addition, you can initiate the self-cleaning unit manually.

The second step of the camera's Integrated Cleaning System addresses larger, sticky particles that can't be shaken off by vibration. This step, called Dust Delete Data, identifies the size and position of large dust particles from a picture that you take of a white piece of paper. The camera then appends the dust data to all upcoming JPEG and RAW images. To delete the dust, you use Canon's Digital Photo Professional v. 2.2's Copy Stamp tool and apply the Dust Delete Data. The program detects the locations that are specified by the Dust Delete Data and erases the spots if they can be effectively erased. Dust Delete Data can be updated at any time, and you can stop the camera from appending the data to images if you want.

You can also use the mirror lock-up feature if you want to clean the sensor using traditional methods such as a blower, brush, or cleaning fluids.

Automatic sensor cleaning

Automatic sensor cleaning can be initiated and turned off at any time. Because the cleaning system requires little power, it does not measurably reduce battery life. To reduce the risk of overheating the cleaning element, self-cleaning can't be operated more than five consecutive times in a ten-second period.

To manually initiate sensor cleaning, follow these steps:

1. **Press the Menu button, and then select the Tools 2 tab.**

2. **Press the down cross key to select Sensor cleaning: Auto.**

3. **Press the Set key.** The Sensor cleaning: Auto screen appears with the Clean now option selected.

4. **Press the Set button.** The sensor-cleaning screen appears for one second during cleaning.

You can turn off automatic sensor cleaning, although I do not recommend it. To turn off automatic cleaning, follow the steps above, but in step 4, select Set up, press the Set button, and then press the right cross key to select Disable. Then press the Menu button twice.

Obtaining Dust Delete Data

For larger, sticky dust particles, you can determine the size and location of dust by taking a picture of a white piece of paper. Although you take a picture of the paper, no image is recorded to the CF card. From the picture, the Digital Rebel XTi/400D maps the coordinates of dust particles that are stuck to the low-pass filter and creates a tiny data file that is appended to future images. To erase the dust, you use Canon's Digital Photo Professional v. 2.2, an image-viewing and editing program that is included on the Canon EOS Digital Solution Disk that comes with the Digital Rebel XTi/400D.

Appending dust data does not increase the image file size, and it does not affect the continuous shooting speed or maximum burst rate of the Digital RebelXTi/400D. It is a good idea to update Dust Delete Data periodically.

Before you begin, ensure that you

✦ **Have a clean piece of white paper that will fill the viewfinder if you position it approximately one foot from the lens.** Ensure that the paper is evenly lit by any light source.

✦ **Set the lens focal length to 50mm or longer.** On a zoom lens, the focal-length settings are displayed on the lens ring. Turn the lens ring to a focal length of 50 or higher.

✦ **Set the lens to manual focus by turning the switch on the side of the lens to MF.**

✦ **With the camera facing forward, set the focus to infinity by turning the lens-focusing ring all the way to the left.**

To obtain Dust Delete Data, follow these steps:

1. **Press the Menu button, and then select the Shooting 2 tab.**

2. **Press the down cross key to select Dust Delete Data, and then press the Set button.** The Dust Delete Data screen appears.

3. **Press the left cross key to select OK, and then press the Set button.** The camera initiates the automatic sensor self-cleaning. A message then appears, telling you to press the Shutter button completely when you're ready to shoot.

4. **With the camera approximately one foot from the white paper and the paper filling the viewfinder, press the Shutter button completely to take a picture of the paper.** The camera automatically sets the camera to Av mode, f/22, 1/2 second or faster, with ISO 800. The flash does not fire. The Digital Rebel XTi/400D captures the Dust Delete Data and displays a message confirming the capture.

5. **Select OK by pressing the Set button.** The Shooting 2 menu appears.

6. **Lightly press the Shutter button to return to shooting.**

Applying Dust Delete Data

After you've acquired Dust Delete Data, you can use Canon's Digital Photo Professional program to apply the data to images. Be sure that you have installed Digital Photo Professional v. 2.2 from the Canon EOS Digital Solution Disk that comes with the camera. You can apply Dust Delete Data to either JPEG or RAW images.

To apply Dust Delete Data in Digital Photo Professional v. 2.2, follow these steps:

1. **Start Digital Photo Professional v. 2.2 or higher, and then navigate to the folder that contains images with Dust Delete Data appended.**

2. **Select an image, and then click in the Edit image window in the toolbar.** The image-editing window appears.

3. **On the menu, click Tools, and then click Start Stamp tool.** A new window appears with the image and a tool palette on the right side.

4. **Click Apply Dust Delete Data.** A progress pane appears, and then a confirmation message that tells you that the data has been applied.

5. **Click OK.**

You can repeat these steps to apply the Dust Delete Data to the remaining images in the folder.

Creating Great Photos with the Digital Rebel XTi/400D

PART II

◆ ◆ ◆ ◆

In This Part

Chapter 3
Photography Basics

Chapter 4
Let There Be Light

Chapter 5
The Art and Science of Lenses

Chapter 6
Composition Basics

Chapter 7
Techniques for Great Photos

Chapter 8
Downloading and Editing Pictures

◆ ◆ ◆ ◆

Photography Basics

✦　✦　✦　✦

In This Chapter

The four elements of exposure

Sensitivity: the role of ISO

Intensity: the role of the aperture

What is depth of field?

Time: the role of shutter speed

Equivalent exposures

Putting it all together

✦　✦　✦　✦

Maybe you purchased the Digital Rebel XTi/400D to gain more creative flexibility than is offered by other cameras. And maybe you're still stuck in the Basic Zone exposure modes, but you're anxious to move into the Creative Zone modes to take advantage of the camera's creative options. This chapter offers you a good start in understanding basic photographic concepts — concepts that are the foundation for making the most of the creative potential that the camera offers.

If you've used a film SLR, this chapter may be a refresher for you. If you haven't used an SLR, this chapter will help you build a foundation from which you can expand your skills. Either way, you can learn quickly with the Digital RebelXTi/400D because you can see the results immediately. Instant feedback from the camera lets you determine whether you're on target or you need to make adjustments.

Whether you use the Basic or the Creative Zone modes, you can get better pictures with the Digital Rebel XTi/400D when you understand the basics of exposure. As you read this chapter, don't worry about remembering everything at once. Take your time and enjoy the process of learning.

The Four Elements of Exposure

Think of exposure as a precise combination of four elements — all of which are related to light. Each element depends on the others to create a successful result. If the amount of one element changes, then the other elements must be increased or decreased proportionally to get a successful result.

The four elements are:

✦ **Scene light.** The starting point of exposure is the amount of light that's available in the scene to make a picture. In some cases, the amount of available light in a scene can't easily be changed. For now, consider the amount of light in the scene as fixed for the purposes of this chapter.

✦ **Sensitivity.** Sensitivity refers to the amount of light that the camera's image sensor needs to make an exposure — in other words, the sensor's sensitivity to light. Sensitivity is measured by the ISO rating. In digital photography, choosing an ISO setting determines how sensitive the image sensor is to light.

✦ **Intensity.** Intensity refers to the strength or amount of light that reaches the image sensor. Intensity is controlled by the aperture, or f-stop, which is an adjustable opening on the lens that allows more or less light to reach the sensor.

✦ **Time.** Time refers to the length of time that light is allowed to reach the sensor. This is controlled by the shutter speed.

3.1 Whether you're shooting outdoors or indoors, understanding and adjusting exposure will give you creative control. The exposure for this image was ISO 100, f/8, at 1/250 second.

3.2 In reasonably bright light, you can set a low ISO, such as 100, to get excellent image quality. This image was taken in afternoon sunlight at ISO 100, f/9, at 1/400 second.

Sensitivity: The Role of ISO

ISO, which stands for International Organization for Standardization, sets the image sensor's sensitivity to light. The higher the ISO number, the less light that's needed to make the picture because the signals coming from the photosites are amplified.

In digital photography, the ISO sequence usually encompasses ISO 100, 125, 160, 200, 250, 320, 400, 800, and up to 1600. The lower the ISO number, the more light the sensor requires, and the higher the ISO number, the less light the sensor needs for the exposure. Photographers refer to ISO as being slow (under ISO 200), fast (ISO 400 to 800), and very fast (over ISO 800).

Tip *An easy way to think about ISO is that each ISO setting is twice as sensitive to light as the previous setting. For example, ISO 400 is twice as sensitive to light as ISO 200. As a result, the sensor needs half as much light to make an exposure at ISO 400 as it does at ISO 200.*

Low ISO settings provide high-quality images with good sharpness, saturation, and contrast. On the other hand, because more light is needed to make the exposure, a longer shutter speed is needed. Longer shutter speeds limit your ability to handhold the camera and still get a sharp picture.

In low-light scenes, you can switch to a fast (high) ISO setting. The greater sensitivity of the sensor to light allows faster shutter speeds that help reduce the risk of blur if

the subject moves or if you move as you hold the camera and press the Shutter button. As a result, during a short exposure time, blur from movement does not have enough time to register in the image.

A drawback to increasing the ISO setting is that it amplifies the analog signal, thus increasing the risk of introducing *digital noise*. Digital noise is analogous in some ways to film grain. In digital photography, noise is comprised of luminance noise and color noise — also called chroma noise. Luminance noise looks similar to grain in film. Chroma noise, which varies by color channel, appears as mottled color variations, depending on the frequency texture of the noise. Chroma noise appears in images as colorful pixels that are scattered, particularly in the shadow areas of the image. Digital noise degrades overall image quality. To avoid it, it's a good idea to set the ISO as low as possible.

Regardless of whether it is luminance noise or chroma noise, digital noise degrades overall image quality by overpowering fine detail, reducing sharpness and color saturation, and giving the image a mottled look. Digital noise increases with high ISO settings, long exposures, underexposure, and when the sensor becomes warmer than normal.

Note

You can use noise-reduction programs to reduce digital noise, but reducing noise also tends to reduce image detail. This is another good reason to avoid ISO settings that are higher than 400. You can also enable a Custom Function (C.Fn-2: Long exposure noise reduction) to reduce digital noise in Bulb exposures of 30 seconds or longer at ISO 100 to 800, and at 1 second or longer at ISO 1600.

In addition to the potential for digital noise, high ISO settings can also reduce sharpness, detail, and color saturation, as well as increase file size.

On the Digital Rebel XTi/400D, ISO settings are 100, 200, 400, 800, and 1600. In the Basic Zone modes, the camera automatically sets the ISO between 100 and 400. The camera also chooses the ISO number based on whether you use the built-in flash or a Canon Speedlite, which is an external flash that you can buy separately. In the Creative Zone modes, you can choose an ISO setting of 100, 200, 400, 800, or 1600.

Checking for Digital Noise

If you choose a high ISO setting, you can check for digital noise by zooming the image to 100 percent in an image-editing program. Look for flecks of color in the shadow and midtone areas that don't match the other pixels, and for areas that resemble the appearance of film grain.

Programs such as Noise Ninja, from www.picturecode.com, NeatImage, from www.neatimage.com, and NIK Software's Dfine, from www.niksoftware.com, can reduce noise with a minimum of detail softening. If you shoot in RAW-image format, programs such as Adobe Camera Raw offer noise reduction during RAW conversion.

To change the ISO, follow these steps:

1. **Choose a mode in the Creative Zone.**

2. **Press the ISO button on the back of the camera.** The ISO menu appears.

3. **Press the up or down cross key to select the ISO that you want.**

3.3 Selecting a high ISO, such as 400 or even 1600, means that you can use faster shutter speeds in low-light scenes and still handhold the camera to get sharp results. This image was taken at ISO 1600 at f/4.0, at a shutter speed of 1/25 second.

Intensity: The Role of the Aperture

The lens aperture (the size of the lens opening) determines the amount, or intensity, of light that strikes the image sensor. Aperture is shown as f-stop numbers, such as f/2.8, f/4, f/5.6, f/8, and so on.

Wide aperture

Smaller f-stop numbers, such as f/2.8, set the lens to a large opening that lets more light reach the sensor. A large lens opening is referred to as a wide aperture. At wide apertures, the amount of time the shutter needs to stay open to let light into the camera decreases.

Narrow aperture

Larger f-stop numbers, such as f/16, set the lens to a small opening that allows less light to reach the sensor. A small lens opening is referred to as a narrow aperture. At narrow apertures, the amount of time the shutter needs to stay open to allow light into the camera increases.

Aperture in Basic Zone modes

The Digital Rebel XTi/400D automatically sets the aperture (and ISO and shutter speed) in Basic Zone modes, based on available light in the scene and the type of picture that you want to take. For example, in Portrait mode, the camera automatically chooses a wide aperture to blur the background. However, in Landscape mode, the camera chooses a narrow aperture to render the detail from foreground to background with acceptable sharpness.

Aperture in Creative Zone modes

In the Creative Zone modes, you can control the aperture by switching to Aperture-priority AE or Manual mode. Just turn the Mode dial to Av or M, respectively, to change to these modes.

In Aperture-priority AE mode, you set the aperture, and the camera automatically sets the correct shutter speed. In Manual mode, you set both the aperture and the shutter speed, based on the reading from the

3.4 A narrow aperture of f/8 provides excellent sharpness throughout an image unless you are close to a foreground object. This image was taken at ISO 100 at a shutter speed of 1/800 second.

Choosing an aperture

Your choice of aperture depends on several factors. If you want to avoid blur from camera shake or subject motion in lower light, choose a wide aperture (smaller f-number) so that you get the faster shutter speeds.

If you're using a telephoto (long) lens and you want to handhold the camera, choosing a wide aperture such as f/2.8 or f/4.0 helps achieve the fast shutter speed that you need to handhold longer lenses.

Of course, an important consideration in choosing an aperture is to control the depth of field — which is discussed in the next section — in your images.

In the Creative Zone modes, you can control the aperture by switching to Aperture-priority AE, Manual, or Program AE mode. Just turn the Mode dial to Av, M, or P, respectively, to change to these modes. In Aperture-priority AE mode, you set the aperture, and the camera automatically sets the correct shutter speed. In Manual mode, you set both the aperture and the shutter speed based on the reading from the camera's light meter. The light meter shows a scale, the exposure level indicator, in both the viewfinder and the LCD panel. This scale indicates over-, under-, and correct exposure based on the aperture and shutter speed combination. In Program AE mode, you can change the aperture, and the camera automatically sets the shutter speed.

3.5 A wide aperture of f/2.8 provides a limited zone of sharpness that focuses attention on the daisy. This image was taken at ISO 100 at a shutter speed of 1/400 second.

camera's light meter. The light meter shows a scale in both the viewfinder and the LCD panel that indicates over-, under-, and correct exposure, based on the aperture and shutter speed combination.

Cross-Reference *You can learn more about exposure and exposure modes in Chapter 1.*

To set the aperture on the Digital Rebel XTi/400D, follow these steps:

1. **Turn the Mode dial to Av (Aperture-priority AE mode), M (Manual mode) or P (Program AE mode).** In P mode, the camera also adjusts the shutter speed to achieve an equivalent exposure.

2. **In Av mode, turn the Main dial until the f-stop that you want appears in the viewfinder or on the LCD.** The camera automatically sets the correct shutter speed. The aperture values displayed differ, depending on the lens that you're using.

 In M mode, hold the Av button as you rotate the Main dial to select the aperture. Then rotate the Main dial to set the appropriate shutter speed. The maximum aperture value depends on the lens that you're using.

 In P mode, rotate the Main dial to change the aperture. The Digital Rebel automatically adjusts the shutter speed to maintain an equivalent exposure.

Note *If "30" blinks in the viewfinder, turn the Main dial to select a wider aperture (lower f-number) to avoid underexposure. If "4000" blinks in the viewfinder, turn the Main dial to select a narrow aperture (larger f-number) to avoid overexposure.*

What is Depth of Field?

Depth of field is the zone of acceptably sharp focus in front of and behind a subject. Aperture is the main factor that affects depth of field, although camera-to-subject distance and focal length also affect depth of field. Depth of field is as much a practical matter—based on the light available to make the picture—as it is a creative choice to enhance the content of the image.

Shallow depth of field

Images where the background is a soft blur and the subject is in sharp focus have a shallow depth of field. Shallow depth of field is traditional for many formal portraits, for some still-life images, for most food photography, for low-light sports, and for some stadium venues. To get a shallow depth of field, choose a wide aperture such as f/2.8, f/4, or f/5.6. The subject will be sharp, and the background will be soft and non-distracting.

Extensive depth of field

Pictures with reasonably sharp focus from front to back have extensive depth of field. To get extensive depth of field, choose a narrow aperture, such as f/8, f/11, or narrower. For images such as landscapes or large groups of people, extensive depth is a good choice.

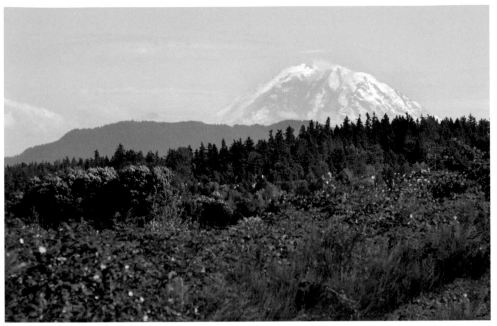

3.6 Good foreground-to-background sharpness in this picture of Mt. Rainier resulted from using a narrow aperture of f/8. This image was taken at ISO 100 at a shutter speed of 1/800 second.

3.7 Using a wide aperture of f/4.0 blurs the background for this portrait. This image was taken at ISO 100 at a shutter speed of 1/13 second.

If it's difficult to remember which f-stop to choose, just remember that large f-numbers enlarge the depth of field and small f-numbers shrink the depth of field. In other words, large f-numbers, such as f/22, enlarge the range of acceptably sharp focus. Small f-numbers, such as f/4, shrink the range of acceptably sharp focus.

When you choose a narrow aperture such as f/16, a longer shutter speed is required to ensure that enough light reaches the sensor for a correct exposure. With slower shutter speeds, be sure to use a tripod, or switch to a faster (higher) ISO setting to get a faster shutter speed.

While aperture is the most important factor that affects the range of acceptably sharp focus in a picture, other factors also affect depth of field, including:

✦ **Camera-to-subject distance.** At any aperture, the farther you are from a subject, the greater the depth of field will be. If you take a scenic photo of a distant mountain, the foreground, middle ground, and background will be acceptably sharp. If you take a portrait and the camera is close to the subject, only the subject will be acceptably sharp.

✦ **Focal length.** Focal length, or angle of view, is how much of a scene the lens "sees." From the same shooting position, a wide-angle lens takes in more of the scene than a telephoto lens and produces more extensive depth of field. A wide-angle lens may have a 110-degree (wide) angle of view, while a telephoto lens may have only a 12-degree (narrow) view of the scene.

 Cross-Reference *For more information on focal length, see Chapter 5.*

Time: The Role of Shutter Speed

Shutter speed controls how long the "curtain" in the camera stays open to allow light from the lens to strike the image sensor. The longer the shutter stays open, the more light reaches the sensor (at the aperture that you set). Shutter speed affects your ability to get a sharp image in low light while handholding the camera, as well as your ability to either freeze motion or to show it as blurred in a picture.

When you increase or decrease the shutter speed by one full setting, it doubles or halves the exposure, respectively. For example, twice as much light reaches the image sensor at 1/30 second as at 1/60 second.

Shutter speeds are indicated in fractions of a full second in the viewfinder and on the LCD. Common shutter speeds (from slow to fast) are: Bulb (the shutter stays open until you close it by releasing the Shutter button), 1 second, 1/2, 1/4, 1/8, 1/15, 1/30, 1/60, 1/125, 1/500, 1/1000, and so on.

Shutter speed determines whether you can freeze a moving subject or allow it to be blurred in the picture. For example, you can adjust shutter speed to freeze a basketball player in midair, or to show the motion of water cascading over a waterfall. As a general rule, to stop motion, set the shutter speed to 1/60 second or faster. To show motion as a blur, try 1/30 second or slower, and use a tripod.

3.8 To show motion as a blur in this image the shutter speed was set to 1/25 second. This image was taken at ISO 100 at f/20.

If you shoot in Basic Zone modes, the camera automatically sets the shutter speed, which gives you less creative control in showing or freezing motion.

To set the shutter speed when shooting in the Creative Zone, follow these steps:

1. **Turn the Mode dial to Tv (Shutter-priority AE) or M (Manual).**

2. **Rotate the Main dial until the shutter speed that you want appears in the viewfinder.** In Tv mode, the camera automatically sets the aperture based on the shutter speed that you choose.

3. **In M mode, rotate the Quick Control dial to set the correct shutter speed** based on the exposure level indicator shown in the viewfinder.

Tip *As a guideline, never handhold a camera at a shutter speed slower than the inverse of the focal length of the lens. For example, with a 100mm lens, don't handhold the camera at shutter speeds slower than 1/100 second. Also, with long telephoto lenses, it's a good idea to always use a monopod or tripod.*

3.9 To freeze motion in this image of a young skateboarder, the shutter speed is set to 1/1250 second. This image was taken at ISO 100 at f/4.0.

Equivalent Exposures

Cameras require a very specific amount of light to make a good exposure. As you have seen, after you set the ISO, two factors determine the amount of light that makes the exposure: the size of the lens opening (aperture or f-stop) and the shutter speed. When you set a wide aperture, you can use a fast shutter speed given ample light in the scene. However, when you switch to a narrow aperture, you must use a slower shutter speed.

Many combinations of aperture and shutter speed produce exactly the same exposure; in other words, the same amount of light exposes the image. For example, an exposure setting of f/22 at 1/4 second is equivalent to f/16 at 1/8 second, f/11 at 1/15, f/8

at 1/30, and so on. The exposures are the same because you decrease the amount of exposure time as you change to the next larger aperture.

The camera's light meter measures the amount of light that is reflected from the subject. The meter uses this information to calculate the necessary exposure, depending on the ISO, aperture size, and shutter speed. If you change the aperture, the camera recalculates the amount of time needed for the exposure. If you change the shutter speed, the camera's meter determines what aperture is required for a correct exposure.

3.10 You can practice using aperture, shutter speed, and ISO combinations to get both classic results as well as creative effects. The exposure settings for this picture of several flags were ISO 100, f/5.6 at 1/1000 second.

Tip

Shoot in a semiautomatic mode such as Aperture-priority AE (Av) mode. This mode gives you creative control over depth of field and eliminates the need to constantly make manual adjustments to the shutter speed. Also, if you want to control the shutter speed for freezing or blurring motion, you can use Shutter-priority AE (Tv) mode instead.

Putting It All Together

ISO, aperture, shutter speed, and the amount of light in a scene are the essential elements of photographic exposure. On a bright, sunny day, you can select from many different f-stops and still get fast shutter speeds to prevent image blur. You have little need to switch to a high ISO for fast shutter speeds at small apertures.

As it begins to get dark, your choice of f-stops becomes limited at ISO 100 or 200. You need to use wide apertures, such as f/4 or wider, to get a fast shutter speed. Otherwise, your images show some blur from camera shake or subject movement. However, if you switch to ISO 400 or 800, your options increase and you can select narrow apertures, such as f/8 or f/11, for greater depth of field. The higher ISO allows you to shoot at faster shutter speeds to reduce the risk of blurred images, but it increases the chance of digital noise.

Let There Be Light

In This Chapter

Color hues

The colors of light

Metering light

Additional
characteristics of light

To get stunning images, you need to understand the basic characteristics of light and how you can use light to your advantage. For some readers, this chapter is a refresher, and for others, it provides a basic foundation for exploring the use and characteristics of light.

Light has fascinated photographers since the inception of photography, and this fascination is no less compelling today than it was then. In general, think of light as a painter thinks about a color palette. You can use the qualities of light to set the mood; to control the viewer's emotional response to the subject; to reveal or subdue the subject's shape, form, texture, and detail; and to render scene colors as vibrant or subdued.

Color Hues

Few people think of light as having color until the color becomes obvious, such as at sunrise and sunset when the sun's low angle causes light to pass through more of the earth's atmosphere, creating visible and often dramatic color. However, regardless of the time of day, natural light has color, and each color of sunlight renders subjects differently. Likewise, household bulbs, candlelight, flashlights, and electronic flashes also have distinctive colors.

4.1 This image was taken during late afternoon as the sun creates a golden glow across the trees. The exposure for this image was ISO 100, f/6.3 at 1/200 second.

The human eye automatically adjusts to the changing colors of light so that white appears white, regardless of the type of light in which we view it. Digital image sensors are not, however, as adaptable as the human eye. When you set the Digital Rebel XTi/400D to Daylight (or auto white balance), it renders color in a scene most accurately in the light at noon on a sunny day. However, at the same setting, it does not render color as accurately at sunset or sunrise because the *color temperature* of the light has changed.

Different times of day and sources of light have different color temperatures. Color temperature is measured on the Kelvin scale and is expressed in degrees K. For the camera to render color accurately, the white-balance setting must match the specific light in the scene.

When learning about color temperatures, keep this general principle in mind: The higher the color temperature is, the cooler (or bluer) the light; the lower the color temperature is, the warmer (or yellower/redder) the light.

Table 4.1 shows Kelvin scale ranges for a sunny, cloudless day. These are, of course, general measures. The color temperature of natural light is affected by atmospheric conditions such as pollution and clouds. An overcast day shifts the color of light toward the cool end of the scale, measuring between 6,000 and 7,000 K.

> **Cross-Reference** *If you use RAW capture, you can adjust the color temperature precisely using Canon's Digital Photo Professional RAW conversion program. See Chapter 8 for details on using this program.*

On the Digital Rebel XTi/400D, setting the white balance tells the camera the general range of color temperature of the light so that it can render white as a neutral in the final image. The more faithful you are in setting the correct white-balance setting or in using a custom white balance, the less color correction you have to do later on the computer.

Table 4.1
Selected Light Color Temperatures

Time of Day	Range in Kelvin	Digital Rebel XTi/400D Setting and Approximate Corresponding Temperature
Sunrise	3,100 to 4,300	Auto (AWB): 3,000 to 7,000 or specify the temperature in degrees Kelvin (K)
Midday	5,000 to 7,000	Daylight: 5,200
Overcast or cloudy sky	6,000 to 8,000	Cloudy, twilight, sunset: 6,000
Sunset	2,500 to 3,100	AWB or cloudy, twilight, sunset: 6,000

Color Temperature isn't Atmospheric Temperature

Unlike air temperature, which is measured in degrees Fahrenheit (or Celsius), light temperature is based on the spectrum of colors that is radiated when a black body is heated. Visualize heating an iron bar. As the bar is heated, it glows red. As the heat intensifies, the metal changes to yellow, and with even more heat, it glows blue-white. In this spectrum of light, color moves from red to blue as the temperature increases — this is the opposite of atmospheric temperature.

Color temperature becomes confusing because we think of "red hot" as being significantly warmer than someone who has turned "blue" by being exposed to cold temperatures. However, in the world of color temperature, blue is, in fact, a much higher temperature than red. This also means that the color temperature at noon on a clear day is higher (bluer) than the color temperature during a fiery red sunset. And the reason that you care about this is because it affects the color accuracy of your pictures.

The Colors of Light

Like an artist's palette, the color temperature of natural light changes throughout the day. By knowing that the predominant color temperature shifts throughout the day, you can adjust settings to ensure accurate color, to enhance the predominant color, and, of course, to use color creatively to create striking photos.

Sunrise

In predawn hours, the cobalt and purple hues of the night sky dominate. However, as the sun inches over the horizon, the landscape begins to reflect the warm gold and red hues of the low-angled sunlight. During this time of day, the colors of grass, tree leaves, and other foliage are enhanced, while earth tones take on a cool hue. Landscape, fashion, and portrait photographers often use the light available during and immediately after sunrise.

Although you can use the AWB setting, you get better color if you set a custom white balance. If you are shooting RAW images, you can also adjust the color temperature precisely in Canon's Digital Photo Professional RAW conversion program.

> **Cross-Reference** *Chapter 1 describes how to set custom white balance.*

Midday

During midday hours, the warm and cool colors of light equalize to create a light that the human eye sees as white or neutral. On a cloudless day, midday light is often

4.2 Bright backlight on a sunny afternoon provides a transparent look to the petals and deep shadows. The exposure for this image was ISO 100, f/8 at 1/200 second.

considered too harsh and contrasty for many types of photography, such as portraiture. However, midday light is effective for photographing images of graphic shadow patterns, flower petals and plant leaves that are translucent against the sun, and images of natural and man-made structures.

For midday pictures, the Daylight white balance setting on the Digital Rebel XTi/400D is a reliable choice. If you take portraits during this time of day, consider using the built-in flash or an accessory flash to fill in dark shadows. You can set flash exposure compensation in 1/3- or 1/2-stop increments to get just the right amount of fill light using either the built-in flash or an accessory Speedlite.

 Cross-Reference *For more details on flash exposure compensation, see Chapter 2.*

Sunset

During the time just before, during, and just after sunset, the warmest and most intense color of natural light occurs. The predominantly red, yellow, and gold light creates vibrant colors, while the low angle of the sun creates soft contrasts that define and enhance textures and shapes. Sunset colors create rich landscape, cityscape, and wildlife photographs.

For sunset pictures, the Cloudy white balance setting is a good choice. If you are shooting RAW images, you can also adjust the color temperature precisely in Canon's

Digital Photo Professional RAW conversion program.

Cross-Reference *See Chapter 8 for details on using the Digital Photo Professional program.*

Diffused light

On overcast or foggy days, the light is diffused and tends toward the cool side of the color temperature scale. Diffusion spreads light over a larger area, making it softer and usually reducing or eliminating shadows. Several things can diffuse light: clouds; an overcast sky; atmospheric conditions including fog, mist, dust, pollution, and haze; objects such as awnings; or shade from trees or vegetation.

Even in bright light, you can create a diffuse light by using a *scrim*, a panel of cloth such as thin muslin or another fabric, stretched tightly across a frame. The scrim is held between the light source (the sun or a studio or household light) and the subject in order to diffuse the light.

Diffused light creates saturated color, highlights that are more subdued than in open light, and shadows that are softer. Diffused light is an excellent light for portraits.

Because overcast and cloudy conditions commonly are between 6,000 and 8,000 K, the Cloudy, twilight, sunset white-balance setting on the Digital Rebel XTi/400D is a good choice for overcast and cloudy conditions.

4.3 This fall farm scene was illuminated by cloudy, late-day light. The exposure for this image was ISO 100, f/4.0 at 1/50 second.

Electronic flash

Most on-camera electronic flashes are balanced for the neutral color of midday light, or 5,500 to 6,000 K. Because the light from an electronic flash is neutral, in the correct intensities, it reproduces colors accurately.

Flash is obviously useful in low-light situations, but it is also handy outdoors where fill-flash eliminates shadow areas that are caused by strong top lighting. It also provides detail in shadow areas for backlit subjects.

On the Digital Rebel XTi/400D, the Flash white-balance setting, which is set to 6,000 K, is the best option because it reproduces colors with high accuracy.

Tungsten light

Tungsten is the light that is commonly found in household lights and lamps. This light is warmer than daylight and produces a yellow/orange cast in photos that, in some cases, is valued for the warmth that it lends to images.

Setting the Digital Rebel XTi/400D to the Tungsten white-balance setting retains a hint of the warm color of tungsten light while rendering colors accurately. If you want neutral color, you can set a custom white balance.

Fluorescent and other light

Commonly found in offices and public places, fluorescent light ranges from a yellow to a blue-green hue. Fluorescent light produces a green cast in photos when the white balance is set to daylight or auto.

Other types of lighting include mercury-vapor and sodium-vapor lights found in public arenas and auditoriums that have a green/yellow cast in unfiltered or uncorrected photos. For accurate color in these types of light, set a custom white balance.

Under fluorescent light, set the camera to the White fluorescent light setting (4,000 K). In stadiums, parking lots, and similar types of light, you may want to set a custom white balance.

Light from fire and candles creates a red/orange/yellow cast. In most cases, the color cast is warm and inviting and you can modify it to suit your taste on the computer.

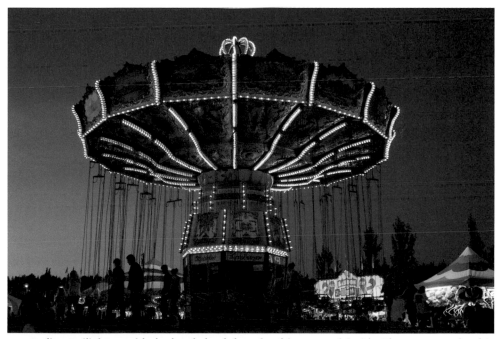

4.4 Fading twilight provided a lovely backdrop for this county fair ride. The exposure for this image was ISO 100, f/4 at 1/15 second.

Metering Light

Your camera's reflective light meter only sees gray. Objects that you see as neutral gray, an even mix of black and white, reflect 18 percent of the light falling on them and absorb the rest of the light. In a black-and-white world, objects that you see as white reflect 72 to 90 percent of the light and absorb the remainder. Objects that you see as black absorb virtually all of the light. All other colors map to a percentage or shade of gray. Intermediate percentages between black and white reflect and absorb different amounts of light.

In color scenes, the light and dark values of color correspond to the swatches of gray on the grayscale. A shade of red, for example, has a corresponding shade of gray on a grayscale. The lighter the shade, the more light it reflects.

The camera's reflective light meter (which measures light that is reflected back to the camera from the subject) assumes that everything is 18 percent gray. The meter expects to see an average scene, which is one that contains a balance of dark and light tones. In average scenes, the camera's meter produces an accurate rendition of what the human eye sees. However, in scenes with large expanses of snow, white sand, and black objects, you often get pictures with gray snow, or gray graduation gowns that should have been black.

Colored surfaces reflect some color onto nearby objects. For example, if you photograph a person sitting in the grass, green is reflected onto the subject. The closer the subject is to the grass, the more green is reflected on the subject's face. Similarly, photographing a subject under an awning or near a colored wall also results in that color reflecting onto the subject. The amount of reflectance depends on the proximity of the subject to the color and the intensity of the color. As a result, you must be aware not only of the color of the primary light, but also of surrounding structures that reflect onto the subject. Reflected color, of course, can make it difficult to achieve the correct color in the image. To avoid or minimize corrections, move the subject away from the surface that is reflecting onto the subject.

Additional Characteristics of Light

Photographers often describe light as harsh or soft. Harsh light creates shadows with well-defined edges, while soft light creates shadows with soft edges. There are traditional uses for each type of light, and before you begin shooting, you should understand the effect of each type of light to use both types of light — and variations in between — effectively.

Hard/harsh light

Hard light is created when a distant light source produces a concentrated spotlight effect — such as light from the sun in a cloudless sky at midday, an electronic flash, or a bare light bulb. Hard light creates dark, sharp-edged shadows as well as a loss of detail in highlights and shadows. For example, portraits taken in harsh overhead light

4.5 Hard light provides bold contrasts and rich color in this image. The exposure for this image was ISO 100, f/8 at 1/800 second.

create dark, unattractive shadows under the eyes, nose, and chin. This type of light is also called *contrasty* light. Contrast is measured by the difference in exposure readings (f-stops) between highlight and shadow areas; the greater the difference, the higher the contrast. Because hard light is contrasty, it produces well-defined textures and bright colors. Hard light is best suited for subjects with simple shapes and bold colors, and for patterns and shadow images.

If you need to shoot in hard light, you can soften it by adding or modifying light on the subject by using a fill flash or a reflector to bounce more light into shadow areas. In addition, you can move the subject to a shady area, or place a scrim (diffusion panel) between the light and the subject. For landscape photos, you can use a graduated neutral density filter to help compensate for the difference in contrast between the darker foreground and brighter sky.

Soft light

Soft light is created when clouds or other atmospheric conditions diffuse a light source, such as the sun. Diffusion not only reduces the intensity (quantity) of light, but it also spreads the light over a larger area (quality). In soft light, shadow edges soften and transition gradually, texture definition is less distinct, colors are less vibrant than in harsh light, detail is apparent in both high-lights and shadow areas of the picture, and overall contrast is reduced.

When working in soft light, consider using a telephoto lens and/or a flash to help create separation between the subject and the background. Soft light is usually well suited for portraits and macro shots, but it is less than ideal for travel and landscape photography. In these cases, look for strong details and bold colors, and avoid including an overcast sky in the photo.

4.6 Diffused and dappled light created pleasing soft light for this image. The exposure for this image was ISO 100, f/7.1 at 1/50 second.

Directional light

Whether natural or artificial, the direction of light can determine the shadows in a scene. Dark shadows on a subject's face under the eyes, nose, and chin result from hard, top light. You can use both the type and direction of light to reveal or hide detail, add or reduce texture and volume, and help create the mood of the image.

✦ **Front lighting.** Front lighting is light that strikes the subject straight on. This lighting approach produces a flat effect with little texture detail and with shadows behind the subject, as seen in many snapshots taken with an on-camera flash.

✦ **Side lighting.** Side lighting places the main light to the side of, and at the same height as, the subject. One side of the subject is brightly lit, and the other side is in medium or deep shadow, depending on the lighting setup. This technique is often effective for portraits of men, but it is usually considered unflattering for portraits of women.

✦ **Top lighting.** Top lighting, as the term implies, is light illuminating the subject from the top, such as what you'd find at midday on a sunny, cloudless day. This lighting produces strong, deep shadows. Top lighting is suitable for some subjects, but it usually is not appropriate for portraits unless you add fill light using a flash or reflector.

In addition, backlighting often produces lens flare that displays as bright, repeating spots or shapes in the image. Lens flare can also appear in the image as a dull haze or unwanted rainbow-like colors. The lens flare spots in the image also have muted color and minimal detail. Occasionally, you can get flare that adds a creative element to the image, but generally, flare degrades image quality. To avoid lens flare, use a lens hood to help prevent stray light from striking the lens, or change your shooting position.

Although you may not be able to control the light, especially natural outdoor light, you can try these solutions to improve your shot:

✦ Move the subject.

✦ Change your position.

✦ Use a reflector or scrim.

✦ Use a filter or change white-balance settings to balance color for or enhance the light.

✦ Wait for better light or a light color that enhances the subject or message of the picture.

4.7 Directional early-morning light illuminated this rose bud. The exposure for this image was ISO 100, f/5.6 at 1/250 second.

✦ **Backlighting.** Backlighting is light that is behind the subject. This technique creates a classic silhouette, and, depending on the angle, it can also create a thin halo of light that outlines the subject's form. Although a silhouette can be dramatic, the contrast obliterates details in both the background and subject unless you use a fill flash.

The Art and Science of Lenses

✦ ✦ ✦ ✦

In This Chapter

Lens choices

Understanding zoom and single-focal-length lenses

Understanding the focal-length multiplication factor

Using wide-angle lenses

Using normal lenses

Using telephoto lenses

Using macro lenses

Extending the range of any lens

✦ ✦ ✦ ✦

One of the biggest advantages to owning the Canon Digital Rebel XTi/400D is the ability to use EF- and EF-S-mount interchangeable lenses. By simply changing lenses, you can transform a boring scene into a compelling and interesting composition.

The lens is the "eye" of the camera, so don't underestimate the importance of high-quality lenses. With a high-quality lens, pictures have stunning detail, high resolution, and snappy contrast. Conversely, low-quality optics produce marginal picture quality.

This chapter takes a look at the lenses available so you can feel comfortable when making decisions about which additional lenses you would like to have for the type of photography you most enjoy.

Lens Choices

Lenses range in focal lengths (the amount of the scene that is included in the frame) from fish-eye to super telephoto and are generally grouped into three main categories: Wide angle, normal, and telephoto. There are also macro lenses that serve double-duty as either normal or telephoto lenses in addition to their macro capability.

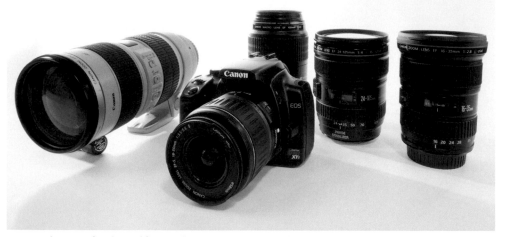

5.1 Having a selection of lenses increases your creative options with the Digital Rebel XTi/400D.

Wide angle

Wide-angle lenses offer a wide view of a scene. Lenses that are shorter than 50mm are commonly considered to be wide angle on full-frame, 35mm image sensors — 16mm and 24mm are examples of wide-angle lenses. A wide-angle lens also offers sharp detail from foreground to background, especially at narrow apertures such as f/22. The amount of reasonably sharp focus from front to back in an image is referred to as *depth of field*.

 Cross-Reference *Depth of field is discussed in more detail in Chapter 3.*

Normal

Normal lenses offer an angle of view and perspective very much as your eyes see the scene. On full 35mm-frame cameras, 50mm to 55mm lenses are considered normal

lenses. Normal lenses provide extensive depth of field (particularly at *narrow apertures*) and are compact and versatile.

Telephoto

Telephoto lenses offer a narrow angle of view, and enable close-up views of distant scenes. On full-frame 35mm cameras, lenses with focal lengths that are longer than 50mm are considered to be telephoto lenses — 80mm and 200mm lens are examples of telephoto lenses. Telephoto lenses offer shallow depth of field and provide a softly blurred background — particularly at wide apertures — and a closer view of distant scenes and subjects.

Cross-Reference *For a complete discussion on aperture, see Chapter 3.*

5.2 A telephoto lens brings distant scenes closer. This image was taken with a 70-200mm lens set to 145mm, equivalent to 232mm on the Digital Rebel XTi/400D. Because of the focal-length multiplication factor, the image includes less of the scene than would be included on a full-frame sensor.

Macro

Macro lenses are designed to provide a closer lens-to-subject focusing distance than non-macro lenses. Depending on the lens, the magnification ranges from half-life size (0.5x) to 5x magnification. Thus, objects as small as a penny or a postage stamp can fill the frame, revealing breathtaking details that are commonly overlooked or invisible to the human eye. By contrast, non-macro lenses typically allow maximum magnifications of about one-tenth life size (0.1x). Macro lenses are single-focal-length lenses that come in normal and telephoto focal lengths.

Understanding Zoom and Single-Focal-Length Lenses

In addition to the basic lens categories, you can also choose between zoom and single-focal-length lenses (also called *prime* lenses). As you add lenses to your system, knowing the advantages and disadvantages of each type of lens helps you to choose the lens that you need for the situations that you photograph most often.

5.3 A zoom lens offers a range of focal lengths so that you can quickly change composition on the fly. The Canon EF 70-200mm f/2.8L IS USM lens is shown here.

Zoom lens advantages

The obvious advantage of a zoom lens is the ability to quickly change focal lengths without changing lenses. In addition, you only need two or three zoom lenses to encompass the focal range that you use most often for everyday shooting.

Most mid-priced and more expensive zoom lenses offer high-quality optics that produce sharp images with excellent contrast.

Zoom lens disadvantages

Although zoom lenses allow you to carry around fewer lenses, they tend to be heavier than their single-focal-length counterparts. Mid-priced, fixed-aperture zoom lenses tend to be *slow*, which means that with maximum apertures of only f/4.5 or f/5.6, they need slower shutter speeds that limit your ability to get sharp images when handholding the camera.

Some zoom lenses have variable apertures. A variable-aperture f/4.5 to f/5.6 lens has a maximum aperture of f/4.5 at the widest focal length, and a maximum aperture of f/5.6 at the telephoto end. Unless you use a

tripod or your subject is completely still, your ability to get a crisp picture in lower light at f/5.6 is questionable.

 Cross-Reference *For a complete discussion on aperture, see Chapter 3.*

More expensive zoom lenses offer a fixed and fast maximum aperture. This means that with maximum apertures of f/2.8 or f/4.0, they allow faster shutter speeds that enhance your ability to get sharp images when handholding the camera. However, the lens speed comes at a price; the faster the lens is, the higher the price.

Single-focal-length lens advantages

Unlike zoom lenses, single-focal-length (prime) lenses tend to be fast with maximum apertures of f/2.8, f/4.5 or wider. Wide apertures allow fast shutter speeds, and this combination allows you to handhold the camera in lower light and still get a sharp image. Compared to zoom lenses, single-focal-length lenses are also lighter and smaller.

5.4 Single-focal-length lenses, such as the Canon EF 100mm f/2.8 Macro USM lens shown here, serve double-duty as a telephoto lens that is ideal for portraits, as well as being a superb macro lens.

In addition, many photographers believe that single-focal-length lenses are sharper and provide better overall image quality than zoom lenses.

Single-focal-length lens disadvantages

Most prime lenses are lightweight, but you need more lenses to cover the range of focal lengths that you need for everyday photography (although some famous photographers used only one prime lens). Single-focal-length lenses also limit the options for on-the-fly composition changes that are possible with zoom lenses.

Understanding the Focal-Length Multiplication Factor

The image sensor of the Digital Rebel XTi/400D is 1.6 times smaller than a traditional 35mm film frame. It is important to know the sensor size because it not only determines the size of the image, but it also affects the angle of view of the lenses that you use. A lens's angle of view is how much of the scene, side-to-side and top-to-bottom, the lens includes in the image.

5.5 This image shows the approximate difference in image size between a 35mm film frame and the Canon Digital RebelXTi/400D. The smaller image size represents the Digital Rebel XTi/400D's image size.

The angle of view for all lenses that you use on the Digital Rebel XTi/400D is narrowed by a factor of 1.6 times at any given focal length. This creates an image equal to that of a lens with 1.6 times the focal length. This means that a 100mm lens on a 35mm film camera is equivalent to a 160mm lens on the Digital Rebel XTi/400D. Likewise, a 50mm normal lens is equivalent to an 80mm lens, which is equivalent to a short telephoto lens on a full 35mm frame size.

> **Note** The EF-S 18-55mm lens is usable only on the smaller-image-size cameras, including the Digital Rebel XTi/400D due to a redesigned rear element that protrudes back into the camera body.

This focal-length multiplication factor works to your advantage with a telephoto lens because it effectively increases the focal length of the lens. Also, because telephoto lenses tend to be more expensive than other lenses, you can buy a shorter and less expensive telephoto lens and get 1.6 times more magnification at no extra cost.

The focal-length multiplication factor works to your disadvantage with a wide-angle lens because the sensor sees less of the scene when the focal length is magnified by 1.6. However, because wide-angle lenses tend to be less expensive than telephoto lenses, you can buy an ultra-wide 14mm lens to get the equivalent of an angle of view of a 22mm lens.

Because telephoto lenses provide a shallow depth of field, it seems reasonable to assume that the conversion factor would produce the same depth-of-field results on the Digital Rebel XTi/400D that a longer lens gives. However, this isn't the case. While an 85mm lens on a full-frame 35mm camera is equivalent to a 136mm lens on the Digital Rebel XTi/400D, the depth of field on the Digital Rebel XTi/400D matches the 85mm lens, not the 136mm lens.

This depth-of-field principle also holds true for enlargements. The depth of field in the print is shallower for the longer lens on a full-frame camera than it is for the Digital Rebel XTi/400D.

Using Wide-Angle Lenses

A wide-angle lens is great for capturing a range of scenes, from large groups of people to sweeping landscapes, as well as for taking pictures in places where space is cramped.

When you shoot with a wide-angle lens, keep these lens characteristics in mind:

✦ **Extensive depth of field.** Particularly at small apertures such as f/8 or f/11, the entire scene, from front to back, is in reasonably sharp focus. This characteristic gives you slightly more latitude for pictures with a less-than-perfect focus.

✦ **Narrow, fast apertures.** Wide-angle lenses tend to be faster (meaning that they have wide apertures) than telephoto lenses. These lenses are good candidates for everyday shooting, even when the lighting conditions are not optimal.

5.6 Wide-angle lenses provide excellent front-to-back sharpness, especially at narrow apertures, such as f/10, which was used for this picture.

✦ **Distortion.** Wide-angle lenses can distort lines and objects in a scene, especially if you tilt the camera up or down when shooting. For example, if you tilt the camera up to photograph a group of skyscrapers, the lines of the buildings tend to converge and the buildings appear to fall backward (this is called *keystoning*). You can use this wide-angle lens characteristic to creatively enhance a composition, or you can avoid it by moving back from the subject and keeping the camera parallel to the main subject. Some wide-angle lenses can also produce images that tend to be soft along the edges.

Tip *To avoid keystoning, you can insert a small bubble level on the hot shoe to ensure that the camera is level. Keystoning and other lens distortions can often be corrected during photo editing; however, it is always better to avoid problems when shooting than fix problems on the computer.*

✦ **Perspective.** Wide-angle lenses make objects close to the camera appear disproportionately large. You can use this characteristic to move the closest object farther forward in the image, or you can move back from the closest object to reduce the effect. Wide-angle lenses are generally not used for close-up portraits because they exaggerate the size of facial features that are closest to the lens.

If you're shopping for a wide-angle lens, look for aspherical lenses. These lenses include a non-spherical element that helps reduce or eliminate optical flaws to produce better edge-to-edge sharpness and to reduce distortions.

Using Normal Lenses

A normal lens is a great walk-around lens for everyday shooting. A 50mm lens is a normal lens on a 35mm film camera, but on the Digital Rebel XTi/400D, a 35mm lens is closer to normal with the focal-length conversion factor. Normal lenses are lightweight and offer fast apertures. In addition, normal lenses seldom have issues with optical distortion, and they produce pictures with a pleasing, "normal" perspective. Normal lenses are reasonably priced and offer sharp images with excellent contrast.

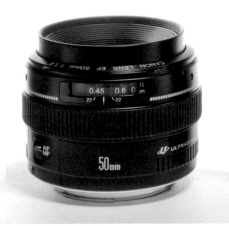

5.7 A normal lens is small and light. It provides an angle of view similar to that of the human eye.

Using Telephoto Lenses

Choose a telephoto lens to capture portraits, and distant subjects such as birds, buildings, wildlife, and landscapes. Telephoto lenses such as 85mm and 100mm are perfect for portraits, while longer lenses (200mm to 800mm) allow you to keep a safe distance while photographing wildlife.

When you shoot with a telephoto lens, keep these lens characteristics in mind:

✦ **Shallow depth of field.** Telephoto lenses magnify subjects and provide a very limited range of sharp focus. At wide apertures, such as f/2.8 or f/4, you can reduce the background to a soft blur. Because of the extremely shallow depth of field, pay attention to careful focus. Canon lenses include full-time manual focusing, which you can use to fine-tune the camera's autofocus.

✦ **Narrow coverage of a scene.** Because the angle of view is narrow with a telephoto lens, much less of the scene is included in the image. You can use this characteristic to exclude distracting scene elements from the image.

✦ **Slow lenses.** Mid-priced telephoto lenses tend to be slow; the widest aperture is often f/4.5 or f/5.6, and this limits your ability to get sharp images without a tripod in all but the brightest light. Also, because of the magnification factor, even the slightest movement is exaggerated.

✦ **Perspective.** Telephoto lenses tend to compress perspective, making objects in the scene appear stacked together.

5.8 Telephoto lenses are larger and heavier than other lenses, but a good telephoto zoom lens is indispensable for photographers. This image was made with the Canon EF 24-105mm f/4.0L IS USM lens set to 105mm.

If you're shopping for a telephoto lens, look for those with low-dispersion lens elements that help to reduce distortion and improve sharpness. Image Stabilization is a feature that further counteracts blur that is caused by handholding the camera.

Using Macro Lenses

Macro lenses open a new world of photographic possibilities by offering an extreme level of magnification. In addition, the reduced focusing distance allows beautiful, moderate close-ups as well as extreme close-ups of flowers and plants, animals, raindrops, and everyday objects.

Normal and telephoto lenses offer macro capability. Because you can use these lenses both at their normal focal length and for macro photography, they do double-duty.

Canon offers macro lenses in the following focal lengths:

✦ EF 50mm, f/2.5 Compact Macro (0.5x magnification)

✦ EF-S 60mm f/2.8 Macro USM (1:1 magnification)

✦ EF 100mm f/2.8 Macro USM (1:1 magnification)

✦ EF 180mm f/3.5L Macro USM (1:1 magnification)

✦ MP-E 65mm f/2.8 Macro Photo (1x-5x magnification)

Note *A Life-size Converter EF is also available for the EF 50mm Compact Macro lens.*

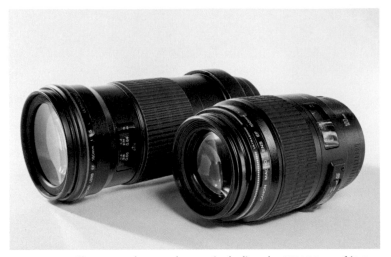

5.9 Canon offers several macro lenses, including the EF 100mm f/2.8 Macro USM and the EF180mm f/3.5L Macro USM that offer 1x (life-size) magnification and a minimum focusing distance of 0.48m/1.6 ft—great for where a longer working distance is desirable.

When you shoot with a macro lens, keep these characteristics in mind:

✦ **Extremely shallow depth of field.** At 1:1 magnification, the depth of field is less than 1mm at maximum aperture. The shallow depth of field makes focusing critical; even the slightest change to the focusing ring can throw the picture out of focus.

✦ **High magnification.** With extremely high magnification, any movement causes blur. It's best to always use a tripod and a cable release or remote to release the shutter.

If you're buying a macro lens, you can choose lenses by focal length or by magnification. If you want to photograph moving subjects such as insects, choose a telephoto lens with macro capability. Moving subjects require special techniques and a lot of practice.

Cross-Reference *For ideas on using macro lenses, see Chapter 7.*

Based on focal length and magnification, choose the lens that best suits the kinds of subjects that you want to photograph.

5.10 This macro image was made using the Canon EF 100mm f/2.8 Macro USM lens.

Extending the Range of Any L-Series Lens

For relatively little cost, you can increase the focal length of any lens by using an *extender*. An extender is a small ring mounted between the camera body and a regular lens. Canon offers two extenders, a 1.4x and 2x, which are compatible with L-series Canon lenses. You can also combine extenders to get even greater magnification. For example, using the Canon EF2xII extender with a 600mm lens doubles the focal length of the lens to 1200mm before applying 1.6x. Using the Canon EF1.4xII extender increases a 600mm lens to 840mm.

> **Tip** *At longer focal lengths, it is imperative that you stabilize the camera on a tripod for sharp focus and to avoid blur from handholding the camera.*

Extenders do not change camera operation in any way, but they do reduce the light that reaches the sensor. The EF1.4xII extender decreases the light by one f-stop, and the EF2xII extender decreases the light by two f-stops. In addition to being fairly lightweight, the obvious advantage of extenders is that they can reduce the number of telephoto lenses that you need to carry.

5.11 Regardless of the lenses that you have, the key is to use them creatively. This image was made using the Canon EF 100mm f/2.8 Macro USM lens.

Composition Basics

While the technical aspects of an image are important, image content and composition carry equal or greater weight. After all, a technically questionable image with a compelling subject and composition can ace a technically perfect image with a mundane subject and uninteresting composition. In this section of the book, you can brush up on composition guidelines and principles.

✦ ✦ ✦ ✦

In This Chapter

Understanding composition

Using the rule of thirds

Symmetry

Composing with color

Controlling the focus and depth of field

Defining space and perspective

✦ ✦ ✦ ✦

6.1 Composition is a skill that intrigues and challenges even the most experienced photographers. Taken at ISO 100, f/5.6, 1/800 second using a Canon EF 100mm, f/2.8 Macro USM lens.

Understanding Composition

Composition is the aspect of photography that many photographers strive to master. Mastering composition, however, remains an ongoing challenge for most photographers. While composition principles can help you design an image, in the end, your personal aesthetic is the final judge. After all, for every rule of composition, there are galleries filled with pictures that break the rules, and they succeed famously.

Most photographers would agree that, when in doubt, it's best to stick with a simple composition. Simple compositions offer the advantage of being easy for the viewer to "read," and that characteristic often makes these images stronger than more complex compositions.

As a photographer, your eyes, your thinking, and your heart reveal and interpret each scene for the viewer. It's your job to combine your visual and emotional perceptions of a scene with the objective viewpoint of the camera. For practice, begin by standing

6.2 Composition can range from strikingly simple, as shown in this abstract image, to complex compositions with layers of content and meaning. Taken at ISO 100, f/4.0, 1/640 second using a Canon EF24-105mm, f/4.0L IS USM lens.

back and evaluating all of the elements in the scene. Gradually narrow your view to see as the camera sees. With this exercise, you learn to see isolated vignettes within the scene. Continue this exercise by looking closely within the vignette to identify dominant elements, colors, patterns, and textures, and think about how you can use them to organize the visual information in the picture.

Before you begin shooting, ask and answer for yourself these questions:

✦ Why am I taking this picture?

✦ What do I want to 'tell' the viewer with this picture — in other words, what is the story?

If you don't ask and answer these questions, you run the risk of taking a picture that is visually difficult to read and that has no message or content. Distilling the image into the message that you want to convey is the first and most important step in creating a well-composed image.

When you know the message or story of the image, some of the traditional composition guidelines that are detailed here can help you to complete the picture.

Using the Rule of Thirds

A standard composition technique in photography is the rule of thirds. Imagine that a tic-tac-toe grid is superimposed on the viewfinder. The grid divides the scene into thirds, providing an asymmetrical composition. Visually dynamic compositions are those that place the subject or the point of interest on one of the points of intersection, or along one of the lines on the grid.

Of course, if you find that placing the subject at one of the intersection points or along one of the lines leaves too much space on the opposite side of the frame, then you can move the subject closer to the center; however, you should avoid placing the subject dead center in the frame.

If you're taking a portrait, you might place a subject's eyes at the upper-left intersection point. In an outdoor photo, you can place the horizon along the top line to emphasize the foreground detail, or along the bottom line to emphasize a dramatic cloud formation. Using this type of grid also helps to create a sense of dynamic imbalance and visual interest in the picture.

In practice, you can use the following tips when composing different images:

✦ If your main point of interest is a static spot, try placing the main point of interest at any one of the points where the dividing lines intersect.

✦ If the main point of interest is horizontal, or if it is a horizon, try placing it along one of the horizontal dividing lines.

✦ If the main point of interest is vertical, try placing it along one of the vertical dividing lines.

6.3 This image roughly shows the grid that is described by the rule of thirds.

Symmetry

The human eye seeks balance in an image. But how do you balance the composition of an image? Is it by composing a perfectly symmetrical image? And while symmetry is a defining characteristic in nature, are symmetrical images visually interesting to viewers? Considering these kinds of questions and concepts help you make composition decisions as you shoot.

Is symmetry good or bad?

Does symmetry really make a picture more or less interesting? Perfectly symmetrical compositions — images that are balanced from side to side or top to bottom — create a sense of balance and stability, but they are also often viewed as boring compositions. This is because while the human eye seeks symmetry and balance, once it finds it, the interest in the composition diminishes. Symmetrical compositions also usually offer less visual impact and intrigue than asymmetrical photos.

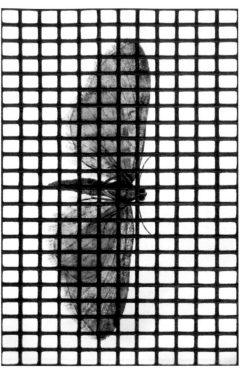

6.4 This image illustrates symmetry, and for many people the composition is too symmetrical to be interesting. The exposure for this image was ISO 100, f/5.6, 1/90 second using a Canon EF 100mm, f/2.8 Macro USM lens.

Create a sense of balance

Balance is a sense of "rightness" or harmony in a photo. A balanced photo appears to be neither too heavy (lopsided) nor too off-center. To create balance, you should evaluate the visual "weight" of colors and tones (dark is heavier than light), the shape of objects (large objects appear heavier than smaller objects), and their placement (objects placed toward an edge appear heavier than objects placed at the center of the frame) in the scene. You can then arrange the elements to create a visual balance.

Tone

The eye is drawn to the lightest part of an image. Further, light tones advance or come forward in an image, while dark tones recede. As a result, if the subject is a darker tone, then light areas on the edges of the frame pull the viewer's eye away from the subject. In an image with a light background, the subject is usually darker than the background. In this case, the contrast of the subject against the light background draws the eye. In short, the subject should be the center of interest due to either the subject's tone or contrast. You can use contrast — the difference in light and dark tones in a photograph — to set off your subject. For example, a small white flower appears more distinct against a large, dark wall than it does against a bright, light-colored wall.

Direction

Placing the subject off-center also gives the image a sense of direction. Generally, there should be space in front of, or to the side of, where the subject is looking or positioned. For example, in a portrait, if a person is looking or positioned in a right-facing direction or angle, then leave more space on the right side of the frame. Also, if a subject is moving, then leave space in the frame in the direction of the subject's movement. This gives the subject a visual space to move into.

6.5 This image leaves space to the front and left of the carriage for it to move into the frame. The exposure for this image was ISO 100, f/2.8 at 1/1500 second using a Canon EF 24-70mm, f/2.8L USM lens.

What lines convey

Because lines have symbolic significance, you can use them to bolster communication, to direct focus, and to organize visual elements. For example, you can place a subject's arms in a way that directs attention to the face. You can use a gently winding river to guide the viewer's eye through a landscape photo. You can use a strong diagonal beam in an architecture shot to bolster the sense of the building's strength. When planning the composition, keep in mind that images have both real and implied lines. Examples of implied lines would be the bend of a leaf or a person's hand.

You can use naturally occurring lines in an image to lead the viewer's eyes from the foreground to the background. This technique is often used in landscape photos, for example, where the lines of a railroad track converge on a distant horizon, or a gracefully curving river meanders into the distance. This technique is also useful in portraits and other types of photography. For example, in a portrait, you can position the subject's arms and hands so that they lead the viewer's eyes to the subject's face.

The key is to not compose the image in such a way that the real lines divide the image into halves, either vertically or horizontally. Rather, use a rule-of-thirds grid to locate the lines at the left, right, bottom, or top. Lines should also lead the viewer's eye toward the subject, rather than away from it and out of the frame.

Lines traditionally convey these meanings:

✦ Horizontal lines imply stability and peacefulness.

✦ Diagonal lines create strength and dynamic tension.

✦ Vertical lines imply motion and strength.

✦ Curved lines symbolize grace.

✦ Zigzag lines convey a sense of action.

✦ Wavy lines indicate peaceful movement.

✦ Jagged lines create tension.

Fill the frame

Just as an artist would not leave part of a canvas blank or filled with extraneous details, you should try to fill the full image frame with elements that support the message. If you ask the questions from earlier in this chapter, the answers will help you to decide how much of the scene you want to include in the frame. Every element you include should support and reveal more about the subject.

Check the background

In any picture, the elements behind and around the subject become as much a part of the photograph as the subject, and occasionally more so because the lens tends to compress visual elements. As you compose the picture, check all areas in the viewfinder or LCD for background and surrounding objects that, in the final image, seem to merge with the subject, or that compete with or distract from the subject.

6.6 This image demonstrates how filling the frame focuses attention on the subject without surrounding elements that create distraction. The exposure for this image was ISO 100, f/7.1 at 1/60 second.

A classic example of failing to use this technique is the picture of a person who appears to have a telephone pole or tree growing out of the back of his or her head. To avoid this type of background distraction, try moving the subject or changing your position.

Frame the subject

Photographers often borrow a technique from painters—putting a subject within a naturally occurring frame, such as a tree that is framed by a barn door or a distant building that is framed by an archway in the foreground. The frame may or may not be in focus, but to be most effective, it should add context or visual interest to the image.

Composing with Color

Depending on how colors are used in a photo, they can create a sense of harmony, visual contrast, or they can make bold, stimulating visual statements. To use colors in composition, remember that complementary colors are opposite each other on a color wheel—for example, green and red, and blue and yellow. Harmonizing colors are adjacent to each other on the color wheel, such as green and yellow, yellow and orange, and so on.

If you want a picture with strong visual punch, use complementary colors of approximately equal intensity in the composition. If you want a picture that conveys peace and tranquility, use harmonizing colors.

6.7 Bold color creates visual interest and strength in this image. The exposure for this picture was ISO 100, f/8, 1/400 second.

The more that the color of an object contrasts with its surroundings, the more likely it is that the object will become the main point of interest. Conversely, the more uniform the overall color of the image, the more likely that the color will dictate the overall mood of the image.

The type and intensity of light also strongly affect the intensity of colors, and, consequently, the composition. Overcast weather conditions, such as haze, mist, and fog, reduce the vibrancy of colors. These conditions are ideal for creating pictures with harmonizing, subtle colors. Conversely, on a bright, sunny day, color is intensified and is ideal for composing pictures with bold color contrasts.

Controlling the Focus and Depth of Field

Because the human eye is drawn first to the sharpest part of the photo, be sure that the sharpest point of focus is on the subject, or the part of the subject that you want to emphasize, for example, a person's eyes. This focus establishes the relative importance of the elements within the image.

Differential focusing controls the depth of field, or the zone (or area) of the image that is acceptably sharp. In a nutshell, differential focusing works like this: the longer the focal length (in other words, a telephoto lens or zoom setting) and the wider the aperture (the smaller the f-stop number), the less the depth of field (or the softer the background). Conversely, the shorter the focal length and the narrower the aperture, the greater the depth of field.

You can use this principle to control what the viewer focuses on in a picture. For example, in a picture with a shallow depth of field, the subject stands in sharp focus against a blurred background. The viewer's eyes take in the blurred background, but they return quickly to the much sharper area of the subject. With a very shallow depth of field, you can virtually eliminate distractions behind the subject.

To control depth of field, you can use the following techniques separately or in combination with each other.

6.8 In this image, the foliage provides a frame for the child that is playing at a park on a summer day. The exposure for this image was ISO 200, f/9, 1/320 second.

6.9 Changing your point of view can mean getting a new perspective by moving above the subject, shifting to a very low position, or moving to a side-angle position. The exposure for this image was ISO 100, f/4, 1/25 second.

Table 6-1
Depth of Field

To Decrease the Depth of Field (Blur the Background)	To Increase the Depth of Field (Sharpen the Appearance of the Background)
Choose a telephoto lens or zoom setting.	Choose a wide-angle lens or zoom setting.
Choose a wide aperture, for example, f/1.4 to f/5.6.	Choose a narrow aperture, for example, f/8 to f/22.
Move closer to the subject.	Move farther away from the subject.

Tip *Instead of routinely photographing subjects at eye level, try changing the viewpoint. For example, if you photograph a subject from a position that is lower than eye level, the subject seems powerful, while a position that is higher than eye level creates the opposite effect.*

Defining Space and Perspective

Some ways to control the perception of space in pictures include changing the distance from the camera to the subject, selecting a telephoto or wide-angle lens or zoom setting, changing the position of the light, and changing the camera position.

For example, camera-to-subject distance creates a sense of perspective and dimension so that when the camera is close to a foreground object, background elements in the image appear smaller and farther apart. A wide-angle lens also makes foreground objects seem proportionally larger than mid-ground and background objects.

While knowing the rules provides a good grounding for well-composed pictures, Henri Cartier-Bresson summed it up best when he said, "Composition must be one of our constant preoccupations, but at the moment of shooting it can stem only from our intuition, for we are out to capture the fugitive moment, and all the interrelationships involved are on the move. In applying the Golden Rule, the only pair of compasses at the photographer's disposal is his own pair of eyes." (From *The Mind's Eye* by Henri Cartier-Bresson, with a preface by Gerard Mace, published by Aperture.)

Techniques for Great Photos

◆ ◆ ◆ ◆

In This Chapter

Intro

Privacy notes

Architectural photography

Action and sports photography

Black-and-white photography

Business photography

Candid photography

Child photography

Environmental portrait photography

Event photography

Fine-art photography

Flower and macro photography

Landscape and nature photography

Low-light and night photography

Panoramic photography

Pet and animal photography

Photojournalism

Portrait photography

Still-life photography

Stock photography

Street photography

Sunset and sunrise photography

Travel photography

Weather and seasonal photography

Wedding photography

◆ ◆ ◆ ◆

Now is a good time to do some serious shooting with your Digital Rebel XTi/400D. In this section of the book, you can explore a wide variety of specialty areas and subjects in photography.

There is no right way to use this chapter. You can skip around and try only the photography subjects that appeal to you, or you can try all of them. Some sections present several techniques, all of which are suitable for the subject. Feel free to experiment creatively with these techniques to create your own unique effects. You know that the approach is successful when that one special picture seems to jump off the screen or leaves you with a feeling of deep satisfaction and pride.

While most of these techniques are straightforward and easy, some may take practice to perfect. The pictures that you take for photo subjects vary, depending on the scene and subject that you are shooting. You can use the information in the book as a starting point, and as you shoot your pictures, think about how the scene that you're capturing differs from the examples in this chapter. You can then use what you've learned in other sections of this book to adjust your technique. Creative problem-solving is part of the fun of photography, and it helps you to integrate all of the elements of photography into your own shooting.

Remember, the best way to get great pictures is to take a lot of them.

Privacy Notes

The majority of this chapter discusses specific photography subjects. Before going further, it's important to add a note about privacy concerns. In general, as a photography enthusiast, you can photograph people and buildings that are in public places. However, you should always be aware of privacy concerns when taking images of strangers and of commercial property. Some people and many corporate facilities do not want to be photographed or to allow photographs of their facilities.

You should also be aware of whether you are shooting on public or private property. For example, most shopping malls are private property. You should not photograph in private malls, stores, or on any other private property without the consent of the owner or management company. It is not permissible to enter private property to take a person's picture without the person's permission. Most important, you should always avoid photographing children, even in public places, without the consent of the parents. Even if the photo does not identify the child, common courtesy dictates the wisdom of getting parental permission before you make a picture.

> **Note** *If you sell your photographs, additional considerations apply. I recommend reading* The Law in Plain English for Photographers, *by Leonard D. DuBoff.*

Architectural Photography

Architecture mirrors the culture and sensibilities of each generation. New architecture reflects the hopeful aspirations of the times, while older structures are often valued for the nostalgic memories that they evoke. For photographers, photographing both new and old architecture provides rich photo opportunities to update portfolios with interesting new images.

Architectural photography involves photographing a sense of place and space. The challenge with the Digital Rebel XTi/400D, given the smaller sensor size, is capturing the scope of the exterior or interior. Canon offers a range of wide-angle lenses, including the ultra-wide 14mm prime lens (equivalent to approximately 22mm on the EOS XTi/400D) to wide-angle zoom lenses such as the EF-S 10-22mm f/3.5-4.5 USM (designed for the smaller sensor size) or the L-series 16-35mm f/2.8 USM lens (equivalent to 25-56mm on the Digital Rebel XTi/400D). It is always important to watch for edge sharpness, and so if you routinely allow extra space on the left and right edges, the widest-angle lenses are your best choices for architectural and interior photography.

> **Tip** *When foreground elements mirror the architecture, be sure to use them in the composition to lead the viewer's eye. For example, if a nearby metal sculpture echoes the glass and steel design of the building, you should include all or part of the sculpture for foreground interest.*

Whether or not architecture is your primary photographic interest, even a brief foray into architectural photography will help to hone your eye for how lines, masses, and spaces work together to create a definable presence.

If you're new to architectural shooting, you should choose a building and spend time studying how light transforms the character of the building at different times of the day. Look for structural details and visual spaces that create interesting shadow plays, reflections, and patterns as they interact with other subsections of the structure.

Most buildings are built for people, and people contribute to the character of the buildings. In terms of composition, people provide a sense of scale in architectural photography, but more importantly, they imbue the building with a sense of life, motion, energy, and emotion.

The umbrella of architectural photography includes interior photography of both commercial and private buildings and homes. Light also plays a crucial role in creating compelling interior images. As you thumb through a few pages of *Architectural Digest* or a similar publication, it is clear that well-planned lighting, whether artificial or natural, can make or break the shot.

7.1 This image shows a shared courtyard of two office buildings and the striking difference in architectural design between the two buildings. Taken at ISO 100, f/11, 1/200 second, using the Canon EF 24-105mm f/4.0L IS USM lens set to 24mm.

About Wide-Angle Distortion

Both wide-angle and telephoto lenses are staples in architectural photography. When you use a wide-angle lens at close shooting ranges, and especially when you tilt the camera upward, the vertical lines of buildings converge toward the top of the frame. You can correct this distortion in an image-editing program, or you can use a tilt-and-shift lens, such as the Canon TS-E 24mm f/3.5L, which corrects perspective distortion and controls focusing range. Because shifting raises the lens parallel to its optical axis, it can correct the wide-angle distortion that causes the converging lines. Tilting the lens allows greater depth of focus by changing the normally perpendicular relationship between the lens's optical axis and the camera's sensor.

To use a tilt-and-shift lens, you first set the camera so that the focal plane is parallel to the surface of the building wall. As the lens is shifted upward, it causes the image of the wall's surface to rise vertically, thus keeping the building shape rectangular.

Inspiration

A great source of inspiration is to go inside buildings and look for interior design elements that echo the exterior design. Create a series of pictures that explain the sense of place and space. Find old and new buildings that were designed for the same purposes, for example, courthouses, barns, cafés and restaurants, libraries, or train stations. Create a photo story that shows how design and use have changed over time. As you shoot, study how the building interacts with surrounding structures. See if you can use juxtapositions for visual comparisons and contrasts.

As you consider buildings and interiors, always try to verbalize what makes the space distinctive. When you talk about the space, you can begin to think about ways that will translate your verbal description into visual terms.

Many new structures include distinctive elements such as imported stone, crystal abstract displays, and so on. Be sure to play up the unique elements of exteriors and interiors. Very often, you can use these features as a theme that runs throughout a photo story.

7.2 This image emphasizes the perpetual rush of modern business life by showing the blurred bus passing under the office building's large clock. The exposure for this image was ISO 100, f/8 at 1/50 second using the Canon EF 24-105mm f/4.0L IS USM lens set to 47mm.

Taking architectural and interior photographs

7.3 The striking architectural design and reflected buildings in the mirrored exterior make this office complex striking.

Table 7.1
Architectural and Interior Photography

Setup	**In the Field:** For the image in figure 7.3, I was looking for a building that symbolized strong, bold design but that echoed the density of structures in a typical metropolitan downtown area. This building met the requirements for bold lines, and the reflections of nearby office buildings served the secondary purpose of showing other complexes. The challenge was to find a shooting position that allowed me to show the entire structure and to capture good, vivid reflections in the mirrored surface of the building.
	On Your Own: Study the building or space and look for the best details. Will details be best pictured straight on or from the side? Can you isolate repeating patterns that define the style? Consider contrasting ultra-modern buildings with older, nearby buildings. Frame architectural images carefully to include only the detail or structures that matter in the image.
Lighting	**In the Field:** Mid-afternoon sunlight served well to show the strong lines of this building against a blue sky. This light also provided clean and clear reflections of nearby office structures.
	On Your Own: While bright, midday light works well for modern structures, older buildings often look best when photographed in golden sunset light.
Lens	**In the Field:** Canon EF 24-105mm f/4.0L IS USM lens set to 32mm.
	On Your Own: Zoom lenses are very helpful in isolating only the architectural details that you want while excluding extraneous objects such as street signs. If you use a wide-angle lens and want to avoid distortion, keep the camera on a level plane with the building—avoid tilting the camera up or down.
Exposure	**In the Field:** ISO 100, f/8, 1/250 second, Aperture-priority AE mode, Standard Picture Style, RAW capture mode.
	On Your Own: In scenes with a high dynamic range—where there is a wide difference between the highlight and shadow exposures—try taking multiple exposures. For example, one image can be metered for highlights, another for the midtones, and another for the shadows. Then you can composite the images in Photoshop to get a higher dynamic range than the sensor can provide.
Accessories	A polarizing filter is an excellent way to reduce or eliminate glare from glass and mirrored building surfaces. In addition, it also enhances color contrast.

Architectural photography tips

✦ **Emphasize color and lines.** If the building you're photographing features strong, vivid colors, emphasize the colors by shooting in bright midday sunlight. Find a shooting position that allows you to show off the dynamic lines and shapes of the building or interior.

✦ **Use surrounding elements to underscore the sense of place and space.** For example, a university building's design that incorporates gentle arches might be photographed through an archway leading up to the entrance. Or if the area is known for something such as an abundance of dogwood trees, try including a graceful branch of blossoms at the top and side of the image to partially frame the structure. Keep surrounding elements to a minimum to avoid distraction from the main subject.

✦ **Try A-DEP mode.** If your photograph shows a succession of buildings from an angle that puts them in a stair-stepped arrangement, use A-DEP mode to get the best depth of field.

✦ **For low-light and night exterior and interior shots, turn on long-exposure noise reduction using C.Fn-2.** Immediately after the initial exposure, the camera creates a dark frame to reduce noise. Using this feature slows down the shooting process, but it provides the best insurance against objectionable levels of digital noise in images.

Action and Sports Photography

With a burst rate of approximately 27 JPEG frames with smart buffering in Continuous Drive mode, the EOS XTi/400D allows for fast-action shooting. The focal length multiplication factor of 1.6x also brings the action close in with telephoto lenses. For example, using the Canon EF 70-200mm f/2.8L IS USM lens effectively provides a 112-320mm equivalent focal length. With shutter speeds ranging from 1/4000 to 30 seconds, the camera offers ample opportunity to either freeze or show the action of any subject that you choose, whether it's an athlete, a child, or a car.

Of course, the difference between showing and freezing motion is primarily a result of the shutter speed that you choose. Fast shutter speeds freeze motion, and slow shutter speeds show motion as a blur. In addition, with a slow shutter speed, if you move the camera to follow the subject, you can blur background elements while keeping part of the subject in reasonably good focus. This is called *panning*.

Creative Zoom Effects

You can use your zoom lens to do more than change the focal length. For example, you can use your zoom lens during a long exposure to create an effect similar to the one shown in this image.

©2006 Bryan Lowrie

In this image, the photographer used a Canon EF-S 18-55mm lens and rotated the zoom ring on the lens during a 1/10-second exposure. The result is a sharp point of focus on number 44's jersey and a gradual outward blur to the edges of the frame. The image was taken at ISO 400 at f/5.6.

©2006 Bryan Lowrie

7.4 This shot captures the action of an opening play of a high-school football game and shows the complexity of player interaction. The exposure for this image was ISO 400, f/7.1 at 1/250 second.

Inspiration

Sports photography encompasses the entire range of sports activities, from volleyball and skiing to car racing. Action subjects cover an even broader range—everything from children playing to puppies romping in the yard to people walking on the street.

As you take sports and action photos, you need to master the techniques of freezing or blurring motion as well as capture the emotion and sense of being "in the moment." If you photograph sports that you play or are interested in, your passion or enthusiasm for the sport is often conveyed in your images.

7.5 Panning, or moving the camera with the motion of the biker, blurs the background and creates a sense of speed in the image. The exposure for this image was ISO 100, f/16 at 1/40 second using a Canon EF 24-105mm f/4.0L IS USM lens set to 60mm.

Taking action and sports photographs

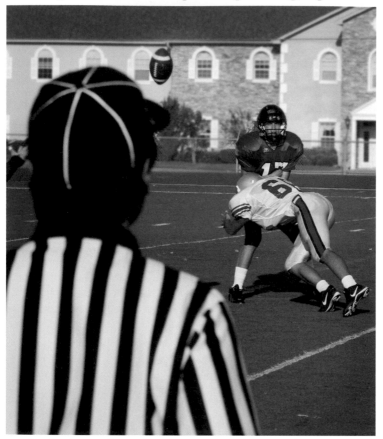

7.6 Getting interesting action shots such as this one takes good timing on the part of the photographer. Note the football in the air between the referee and players.
©2006 Bryan Lowrie

Table 7.2
Action and Sports Photography

Setup	**In the Field:** The image in figure 7.6 was taken at a high-school football game. When taking action shots, you can set the camera to Continuous Drive mode to ensure that you get the fast frame rate offered by the Digital Rebel XTi/400D. In bright light, setting a negative exposure compensation of -1 or -2 Exposure Values (EV) can help to avoid blowing out detail from highlight areas in the image.
	On Your Own: Find a good shooting position with a colorful, non-distracting background. If you are shooting athletes, set up the camera and pre-focus on a spot where they will pass. Then, as the athletes enter the frame, press the Shutter button. Or you can pan, or move, the camera with the athlete's motion to blur the background.
Lighting	**In the Field:** This image was taken in afternoon sunlight with a narrow aperture to freeze the motion of the football players.
	On Your Own: Moderate light is ideal for showing action blur, although motion blur shows in bright light as well.
Lens	**In the Field:** Canon EF 75-300mm III USM f/4-5.6 lens set to 75mm.
	On Your Own: The lens you choose depends on the subject you're shooting. If a telephoto lens is appropriate for the shot, it provides a greater softness to the background and to the blur if you're panning.
Camera Settings	**In the Field:** JPEG capture, Aperture-priority AE mode with the white balance set to Daylight, Continuous Drive mode.
	On Your Own: To control shutter speeds, use Shutter-priority AE mode and set the shutter speed to 1/60 second or faster to freeze motion, or 1/30 second or slower to show action as a blur. In mixed-light situations, I recommend using AWB or setting a custom white balance.
Exposure	**In the Field:** ISO 400, f/9, 1/1600 second, Aperture-priority AE mode.
	On Your Own: You may need to experiment to get the shutter speed that shows motion blur and the f-stop that gives you the depth of field you want. You can generally show motion blur at 1/30 second and slower shutter speeds.
Accessories	At slower shutter speeds, consider using a tripod to ensure that the subject of the image is sharp. It may also be a good idea to use the Canon Extender EF 1.4x II or the Canon Extender EF 2x II on L-series lenses for times when you don't have a close-in shooting position. The 1.4x extender results in the loss of one f-stop of light, and the 2x extender results in two f-stops of light.

Action and sports photography tips

✦ **Capture the thrill.** Regardless of the technique that you choose to shoot action photos, set a goal of showing the emotion, thrill, speed, or excitement of the scene in your pictures. You want the kind of picture where people look at it and say "Wow!"

✦ **Take a high shooting position.** Instead of choosing a front-row seat at a sports event, move back to the fourth or fifth row and use the additional height to your advantage. Be sure to stake out room enough for your monopod or tripod, and if you have a lens extender, take a few test shots with and without the extender to see whether the loss of light is worth the extended focal length. If this loss of light means that you can't get a fast enough shutter speed to freeze motion, then you may want to opt out of using the extender.

✦ **Find a well-lit spot and wait.** If lighting varies dramatically across the sports field and you find it difficult to continually change the exposure or white balance, find the best-lit spot on the playing field or court, set the exposure for that lighting, and then wait for the action to move into that area.

✦ **Experiment with shutter speeds.** To obtain a variety of action pictures, vary the shutter speed between 1/30 and 1/1000 second. At slower shutter speeds, part of the subject will show motion, such as a player's arm swinging.

✦ **Practice first.** Practice your action photography between events by photographing children and pets in motion. As you practice, develop your eye for quick composition and hone your reflexes.

✦ **Shoot locally.** If you're new to shooting sports, consider photographing high school and local amateur events. These are good places to hone your reflexes and composition. You will usually be under fewer restrictions, be able to get closer to the athletes, and have fewer fans to contend with.

Black-and-White Photography

In 100-plus-year-old tradition, black-and-white photography remains one of the most popular renderings for images, whether film or digital. The popularity of black-and-white extends to fine-art, wedding, and portraiture photography. And as a photographer, the draw of black-and-white is compelling as a creative option as well.

7.7 Some subjects work better than others as black-and-white images. This close-up of a magnolia blossom lends itself well to black-and-white rendering. The exposure was ISO 100, f/2.8 at 1/50 second, and I used a Canon EF 100mm f/2.8 Macro USM lens.

For the uninitiated, creating black-and-white photos would seem to be as easy as desaturating a color image. However, creating black-and-white images requires a different way of viewing a scene. Instead of looking at color, the photographer who aims for classic black-and-white images must judge scenes in terms of textures, tonal ranges, forms, and shapes, while remaining oblivious to the distraction of colors. And light acts like brushes to heighten or subdue the form, shape, and substance of the subject.

You can use the excellent Monochrome Picture Style on the EOS Digital Rebel XTi/400D. Or, thanks to RAW processing, you can create extremely high-quality black-and-white images using conversion programs such as Canon's Digital Photo Pro, Adobe Camera Raw, or Adobe Lightroom. If you use the Monochrome Picture Style, or if you shoot RAW capture and use Canon

Digital Photo Professional, then you can apply the look of traditional black-and-white filters such as red, yellow, orange, green, and blue. You can use these filters to enhance and distinguish among colors in the image; for example, using a green filter lightens green in the image.

Traditionally, you could use deep red or deep yellow color filters, and if you want a deeper effect for the filter on the Monochrome Picture Style, you can set a plus contrast setting to increase the effect of the filter. Here are the filter options from which you can choose:

✦ **Yellow.** Use this filter with virtually all subjects, including landscapes, portraits, architecture, and sunsets. This filter makes the blue sky look more natural and provides brighter clouds.

✦ **Orange.** Use this filter with landscapes, sunsets, and marine scenes. This filter effect darkens a blue sky and adds brilliance to sunset images.

✦ **Red.** Use this filter with landscapes, sunsets, architecture, stone, wood, sand, and snow. This filter effect dramatically darkens a blue sky and makes colorful fall leaves look crisp and bright. This filter adds brilliance to sunsets and enhances the rendering of textures.

✦ **Green.** Use this filter to enhance outdoor Caucasian portraits and nature images that include foliage. This filter effect brightens leaves and foliage, making them look natural.

If you shoot RAW images, you can convert to the Monochrome Picture Style during the conversion and apply the filter effects or toning effects at the same time. Toning effects include Sepia, Blue, Purple, and Green.

Cross-Reference *To learn how to select a Picture Style, see Chapter 1.*

Inspiration

If you want to emphasize the impression of texture, be certain that the focus is tack sharp by using a narrow aperture and a tripod. To emphasize contrast in black-and-white images, look for scenes where there is excellent tonal contrast between the subject and the background.

In black-and-white photography, you can't rely on color to create the mood of an image. Instead, rely on strong lighting and control over the tonal range. Black-and-white photography is uniquely suited for rendering both high-key and low-key images with stunning effect. (High-key images have the majority of tones at the light end of the gray scale, and vice versa for low-key images.)

7.8 Rustic subjects such as this barn window make appealing black-and-white images. The exposure for this image was ISO 100, f/8 at 1/60 second, and I used a Canon EF 24-105mm f/4.0L IS USM lens set to 24mm.

Taking black-and-white photographs

7.9 Portraits often work very well as black-and-white images.

Table 7.3
Black-and-White Photography

Setup	**In the Field:** The portrait in figure 7.9 was taken with a seamless white background that provided an entirely non-distracting, crisp background.
	On Your Own: If you have distracting background elements, you can use a wide aperture to blur the background while maintaining reasonable sharpness on the subject. In addition, you can move the subject farther from the background to blur the background more.

Continued

Table 7.3 *(continued)*

Lighting	**In the Field:** The subject was lit by continuous modeling lights on two studio strobe systems, with a large silver reflector to camera right. The lights added small but effective catch lights to the subject's eyes.
	On Your Own: Take a meter reading on the brightest highlights in the scene, and then use that exposure to shoot. A good method is to use the AE Lock button to set the exposure on the brightest highlight. You can learn about using AE lock in Chapter 2.
Lens	**In the Field:** Canon EF 24-105mm f/4L IS USM set to 105mm.
	On Your Own: A zoom lens is indispensable for scenes where you need to change the zoom setting to vary the composition. The Canon EF 24-105mm f/4.0L IS USM lens offers a great range for portraits, ranging from a single person to groups of people.
Camera Settings	**In the Field:** JPEG capture, Aperture-priority AE mode with the Picture Style set to Monochrome.
	On Your Own: Many photographers agree that capturing images in color and rendering them as black-and-white in either a RAW conversion program or in Photoshop provides the highest-resolution final image.
Exposure	**In the Field:** ISO 400, f/4, 1/60 second.
	On Your Own: Even in good light, it is important to use a tripod to ensure that you get tack-sharp focus on the subject's eyes.

Black-and-white photography tips

✦ **Natural forms, including the human body, lend themselves well to black-and-white photography.** The abstractness of these subjects allows a great deal of latitude in creative lighting approaches, viewpoints, and framing.

✦ **For striking black-and-white images, look for scenes that have a strong division of tones.**

✦ **To emphasize texture in a monochrome image, shoot into the light.** Because this technique produces underexposure in shadow areas, you can make two images, one exposed for the highlights and another exposed for the shadows, and then composite the images in Photoshop.

Business Photography

Given a choice between reading business correspondence that is a solid block of text or reading correspondence that includes illustrative photos, most people would choose the correspondence with photos, and with good reason. Well-placed photos not only illustrate and explain the text, but they lend credibility and interest to many types of business documents.

"The true portrait... reflects the personality."

Henri-Cartier Bresson

Photography by: Charlotte Lowrie
Available for Corporate, Editorial, & Stock Assignments
Editorial, nature, people, & still-life stock photos available.
Portfolio: http://wordsandphotos.org/Portfolio_Main.htm
555.788.0667 | charlotte@wordsandphotos.org

7.10 Images can be used effectively for all types of business documents, such as this self-promotion piece for a mailer.

Photos that represent a company's branding or that are used in advertising are best made by a professional photographer. However, for routine business correspondence, you can create images that enhance your business and documents.

Inspiration

At the office, photograph new employees; employee milestone events such as anniversaries and retirements; informal company parties; products or projects for internal or external newsletters; and new business or internal project proposals. You can also use pictures to illustrate employee-training materials.

http://wordsandphotos.org
professional writing and photography

Charlotte K. Lowrie
888.0666
688.0555
780 NE 85th St.
Wood, WA 98077

7.11 I used this image of a vintage camera to add interest to my business card.

If you are in sales, you can photograph customers with a product that they purchased, and then use the image in thank-you promotion pieces such as calendars or cards. Small businesses can use and reuse product images for print and Web promotions, as well as for documenting processes such as product manufacturing.

The most important aspect of business photography is to get a clean, uncluttered shot that shows the subject, whether it is a person or a product, in the best light and with true-to-life color. For small object backgrounds, you can buy folding poster boards at a craft store and set them up on a desk or conference table. For images of people and large objects, find a neutral-color wall with enough space to move the subject 5 to 6 feet away from the wall. This helps lessen dark background shadows if you use the built-in flash.

Taking business photographs

7.12 The image here was a product shot for a small business that was launching Web-based sales.

Table 7.4
Business Photography

Setup	**In the Field:** A white seamless background, such as the one shown in figure 7.12, allows you to include text and logos for either print or online use. It's a good idea to shoot both vertical and horizontal orientations so that you have a choice based on how you want to use the images.
	On Your Own: Simple setups and compositions are the best place to start with business images. You can't go wrong with white or black backgrounds for small objects such as this. Plan how much space you will need at the top, bottom, or sides of the frame to insert text and other graphics, and then shoot accordingly.
Lighting	**In the Field:** This shot was lit by modeling lights with a silver umbrella. A large silver reflector to camera right filled in the shadows. The background was then lightened in Photoshop during image editing.
	On Your Own: Window light or continuous studio lighting systems can be effective for making this type of picture. For a warmer effect, you can use a gold umbrella or gold reflector on the right.
Lens	**In the Field:** Canon EF 50mm f/1.4 lens. I chose this lens for its excellent contrast and sharpness.
	On Your Own: Your lens choice depends on the subject. For small objects, a normal lens, such as the EF-S 60mm f/2.8 Macro USM, is a good choice. If you want to blur the background, choose a telephoto lens, and for large displays, use a wide-angle lens. If you photograph a group of objects or a production process, consider a medium wide-angle lens such as the Canon EF 24-70mm f/2.8L USM lens. For portraits, a short telephoto lens such as the Canon EF 100mm f/2.8 Macro USM gives you a nice head-and-shoulders shot.
Camera Settings	**In the Field:** RAW capture, Aperture-priority AE mode with a custom white balance.
	On Your Own: Setting a custom white balance for the type of light in the scene gives you the most accurate color. This is important when shooting products for businesses, and it significantly reduces time spent correcting the color on your computer.
Exposure	**In the Field:** ISO 100, f/22, 1/125 second.
	On Your Own: Set a narrow aperture, such as f/8 or f/16, if you want front-to-back sharpness. If the background is distracting, use a wider aperture, such as f/5.6 or f/4.0. Set the ISO to 100 or 200, depending on the amount of light available.
Accessories	Silver reflectors are invaluable, especially when you have limited options for controlling existing light. Affordable silver reflectors come in a variety of sizes.

Business photography tips

✦ **Compensate for shadows.** If you're doing a head-and-shoulders shot of a person, such as a new employee, ask the subject to hold a silver reflector at waist level and tilted to throw light upward slightly to fill in shadows that are created by overhead lighting. Ask the subject to adjust the reflector position slightly, as you watch for the position that best fills shadow areas under the person's eyes, nose, and chin.

✦ **Adjust the setup for the photograph, based on its intended use.** For example, if you're taking photos to use on a Web site, keep the composition and the background simple to create a photo that is easy to read at the small image sizes that are used on the Web. Brighten small-size images just slightly for use on the Web.

✦ **Maintain the same perspective in a series.** In a series of photos, be sure to keep the perspective the same throughout. For example, if you are photographing several products, set up the products on a long table and use the same lens and shooting position for each shot. Also be sure to keep lighting consistent though the succession of shots.

✦ **Look at the colors as a group.** As you set up a photo, consider all the colors in the image. If they do not work well together, change backgrounds or locations to find a better background color scheme for the subject, or use a neutral-color background such as a white wall or a poster board.

✦ **Turn off the flash.** If you're photographing small objects, turn off the flash. It is very difficult to maintain highlight detail at close working ranges using a flash. You can supplement light on the object with a desk lamp, if necessary.

Candid Photography

Few photographers can resist the urge to capture pictures of people just as they are — unposed and acting naturally. Good candid pictures often become the prize images in your portfolio because, unlike posed portraits, you catch subjects unaware, preoccupied with their private world of thoughts and activities and without their "camera" faces. Capturing candid photos means that you need to fade quietly into the background.

To disappear into the surroundings, you need a lens — preferably a zoom lens — that allows you to change focal length while maintaining your distance. You also need to be able to shoot quickly to capture the subject's expression or activity as it changes. Therein lays the importance of being prepared and patiently staying with the subject to capture the truest expressions and reactions.

7.13 Catching people as they go about their daily routine creates some of the best candid shots. Here, a salesman, distracted by a telephone call from a friend, created a great opportunity to photograph him from a distance. Taken at ISO 100, f/4 at 1/15 second using a Canon EF 24-105mm f/4.0L IS USM lens set to 105mm.

Tip

While it may seem that family members are great candidates for candid photography, they are often the ones who are most alert to and aware of your presence. You may have better luck shooting family candid shots when family members are in large groups and are distracted by activity around them.

Inspiration

Downtown streets filled with people going about their daily routines also offer endless opportunities for candid photography. You can find other excellent opportunities at concerts, parades, airports, and parks.

Very often, you can take images that express a concept without showing a person's face. Some examples are a small child being led by a parent's hand, a silhouetted couple holding hands as they walk away from the camera, or an older person sitting quietly on a park bench.

7.14 This image was captured as women were chatting after a lavish Russian wedding reception. The exposure for this image was ISO 1600, f/4 at 1/100 second using a Canon EF 24-105mm f/4.0L IS USM lens set to 105mm.

Taking candid photographs

7.15 These two boys in matched clothing were engrossed in watching the waves come in. This was just too good of a picture to pass up.

Table 7.5
Candid Photography

Setup	**In the Field:** As with all images, a clean background is the best background. For the image in figure 7.15, I zoomed in close to eliminate some nearby ducks from the frame.
	On Your Own: If possible, choose a shooting position that provides a clean background, shoot using a wide aperture to blur background distractions, or frame tightly. If you must change positions, be quiet to avoid distracting the subject or giving away your candid shooting.
Lighting	**In the Field:** Bright sunlight provided vivid color in both of the boys' clothing and in the water.
	On Your Own: Lighting for candid shots can run the gamut. Watch for highlight areas on the subject's face, and use Auto-exposure lock to ensure that highlights are not blown out if there's time to use it without missing the shot. AE lock is discussed in Chapter 2.

Lens	**In the Field:** Canon EF 70-200mm f/2.8L IS USM with the lens set to 110mm.
	On Your Own: A zoom lens is indispensable for candid shots. Typically, a telephoto zoom offers the focal range necessary for you to remain at a distance, yet fill the frame with the subject.
Camera Settings	**In the Field:** RAW capture, Aperture-priority AE mode with white balance set to Daylight.
	On Your Own: To control the depth of field, choose Aperture-priority AE mode. However, if the light is low, switch to Shutter-priority AE mode and keep the shutter speed at 1/60 second or faster. Be sure to set the white balance to match the type of light in the scene.
Exposure	**In the Field:** ISO 100, f/7.1, 1/320 second.
	On Your Own: In low-light scenes, switch to Shutter-priority AE mode and set the shutter to 1/30 or 1/60 second. At 1/30 second, you may get some blur if the subject moves, which can add interest to the image. In good light, switch to Aperture-priority AE mode, set the ISO at 100, and select a moderate to wide aperture.

Candid photography tips

✦ **Be patient and be prepared to shoot quickly.** Patience is a hallmark of candid photography. Also be sure to carry a spare, charged battery with you.

✦ **Choose your lenses after you survey the overall look of the scene.** For example, if the background is busy and distracting, choose a telephoto lens to help blur the background. Have alternate lenses nearby and easy to grab for quick lens changes.

✦ **Because using a flash gives away your candid shooting, try switching to wide apertures in low-light scenes.** Set the camera to Aperture-priority AE mode, and turn the Main dial to set the aperture to f/3.5 or f/2.8.

Child Photography

Perhaps no specialty area is as satisfying and challenging as child photography. It is satisfying because it is a singular opportunity to capture the innocence, fun, and curiosity of unspoiled (so to speak) kids, and it is challenging because success depends on engaging the child so that you can reveal the child's sense of innocence, fun, and curiosity. Even more important than having the right camera is having the right props, toys, personality, and patience — all of which are key to making a location or studio session successful.

Of the many factors that figure into making successful pictures of children, the single critical factors are the child's mood or state of mind and how good of a rapport you establish with the child early on. A tired, hungry, bored, or out-of-sorts child will not put up with your attempts to pose and re-pose them for long. Encourage parents to bring children when they are well rested, fed, and in a happy frame of mind. Without this, a photo shoot can quickly degrade into a struggle of historic proportions. And if you skip the important first moments of connecting with the child, the images will ultimately mirror the missing emotional connection.

The goal of child photography is to capture the essence of the child or children. Children are incredibly bright: By the end of their first year of life, most babies have perfected a cheesy "camera smile." This likely is not the smile you want. In fact, not all child pictures must depict a child smiling. The better that you are able to connect with the child, the greater your chances are of capturing genuine expressions of happiness, interest, or concentration.

Tip
With young children who are walking, many of the tips in the Action and Sports section of this chapter apply. Because they move fast and often sit still only for milliseconds rather than minutes, setting the camera Drive mode to Continuous to capture image sequences is often a necessity.

It's also a good idea to have games and toys that the children enjoy either nearby during shooting or even to use as part of the picture. And because children feel more comfortable in familiar surroundings, it's often possible to photograph them in a playroom, bedroom, living area, or at an outdoor playground. If you're in an area where you can't control background elements, you can use a wide aperture, such as f/4.0 or wider, to reduce distracting background objects to a soft blur. As you shoot, always focus on the child's eyes.

7.16 This is an unusual pose, but, as with many photo sessions with kids, they create new poses and angles, and the photographer is well advised to go with the flow of the child's antics. Taken at ISO 100, f/11 at 1/125 second, using a Canon EF 24-105mm, f/4.0L IS USM lens.

Inspiration

7.17 This detail shot from a five-generation family photo session shows the hands of the 100-year-old great-great grandmother and her six-day-old great-great-granddaughter. Taken at ISO 100, f/2.8 at 1/60 second using a Canon EF 100mm f/2.8 Macro USM lens.

Child photography is one of the areas where you can let the child inspire you. Because so much of the session depends on the disposition of the child, if you can establish a good rapport with the child and allow yourself to go with the flow of the child's activity, you can often get much better images than if you try to pose the child. In other words, let the child do what comes naturally as long as the child remains safe.

Not all child portraits have to show a sunny, smiling child, although at least some should. Emotions can also make compelling images that parents can identify with and cherish in years to come.

Taking child photographs

7.18 With infants, such as this six-day-old girl, it is a good idea to include the parent in the picture.

Table 7.6
Child Photography

Setup	**In the Field:** The image in figure 7.18 was part of a five-generation photo shoot. It was taken in a small apartment, and because of distractions on the walls, I later cloned out the distractions and warmed the background color.
	On Your Own: Work hard to find an area where the background is clean or at least complimentary to the subjects. This work not only creates a better picture, but it saves you time editing the image on your computer. Also be sure to move the subject well away from the wall to avoid shadows and unnecessary background detail.
Lighting	**In the Field:** The lighting for this picture included late afternoon light that filtered from a large window to camera right, as well as overhead fluorescent light and a Tungsten lamp. In short, this was a lighting nightmare.
	On Your Own: Regardless of where you photograph children, be sure that they have room to move and interact with parents and with you. Nearby windows provide lovely light, but be sure to set up a large silver reflector to throw light into the shadow side of the subject.
Lens	**In the Field:** Canon EF 24-70mm f/2.8L USM lens.
	On Your Own: A short or long telephoto lens and wide aperture provide the soft background that you want. The versatile Canon EF 70-200mm f/2.8L IS USM is a perennial favorite. The Canon EF 100mm f/2.8 Macro USM and the EF 85mm f/1.2 II USM lenses are also good candidates for child and adult portraiture.
Camera Settings	**In the Field:** RAW capture, Aperture-priority AE mode with the white balance set to AWB. I used AWB because the scene had three kinds of light and a tight shooting schedule. If there had been time, the ideal approach would be to set a custom white balance.
	On Your Own: As the light fades, switch to Shutter-priority AE mode to help ensure subject sharpness. Image stabilization (IS) lenses give you approximately one to two more f-stops — based on lower shutter speed for handheld images — than non-IS lenses, and these f-stops are very often worth the premium prices on IS lenses.
Exposure	**In the Field:** ISO 100, f/6.7, 1/8 second using a tripod.
	On Your Own: As with all portraits, control the depth of field to suit the rendering that you want. Very fast lenses, such as the EF 50mm f/1.4 USM and the EF 85mm f/1.2 II USM, are ideal when you need to control background distractions and shoot in low-light scenes.

Child photography tips

✦ **Less direction is best.** Gaining a child's cooperation can be tricky, and if the child feels over-manipulated, you can lose the child's good humor. Set up a sense of give-and-take, with you giving the most so that the child continues to enjoy the shooting session.

✦ **Have an assistant or baby/child wrangler.** Any photographer who has shot child portrait sessions alone has likely had the sense that these sessions often teeter on the edge of chaos. Having an assistant behind the camera to interact with the child and chat with the parents allows you to concentrate on lighting, composition, and changing camera position.

✦ **Plan before the session.** Be sure to talk to the parents about the clothing that the child will wear and how many changes they want during the session. If you're shooting in the studio, you can plan for backgrounds and props that work well with the clothing. If you're shooting outdoors, the clothing should be appropriate for the setting. Also, learn as much as you can about the child's interests before the session so that you can more quickly engage the child with subjects, toys, or props that interest him.

Environmental Portrait Photography

An environmental portrait, or a portrait taken of a subject in work or leisure-time surroundings, offers several advantages over traditional portraits. With environmental portraits, the work area adds context that helps to reveal more about the subject than is shown in traditional portraits. In addition, the subject is often more comfortable in familiar surroundings, and the work or interest area also gives ample fodder for conversation during the shooting, both of which help the subject to feel relaxed and comfortable.

Environmental portraits borrow elements from both photojournalism and portraiture. With a successful merger of the two techniques, environmental portraits offer insight into the subject that is often associated with photojournalism, while incorporating the techniques that are associated with portraits.

Tip *In portraits, ensure that the subject's eyes are in sharp focus. You can do this by using Autofocus lock. Position the autofocus point in the viewfinder on the subject's eyes, and press the Shutter button halfway down. When the camera beeps to confirm focus, continue to hold the Shutter button as you move the camera to recompose the image. Then take the picture.*

Inspiration

7.20 This miniature Schnauzer collects her toys in her bed. Using a white seamless background and window light, I created a twist on an environmental portrait. Taken at ISO 100, f/4 at 1/80 second using a Canon EF 24-105mm, f/4.0L IS USM lens set to 45mm.

7.19 How much of the environment you include depends on your judgment. Here including more of the background would have repeated background elements that were already there. Taken at ISO 100, f/6.3 at 1/125 second using a Canon EF 24-105mm, f/4.0L IS USM lens set to 75mm.

Because environmental portraiture offers a refreshing and adaptable approach to portraiture, it is worthwhile to learn the basic techniques. And you can use variations of the techniques for pictures of children, elders, and friends — all within the comfort of their everyday surroundings. You can use either the Portrait mode on the Digital Rebel XTi/400D for quick shots, or switch to a Creative Zone mode such as Aperture-priority AE mode to have more control over the depth of field in the final image.

If you want to gain experience shooting environmental portraits, look for opportunities wherever people are in their work or leisure-time surroundings, whether in an office, garage, or studio.

You can successfully apply the concepts of this technique to many types of portraiture, student, and family photography. For example, depending on the person's interests, you might consider making an environmental portrait of a mother or grandmother in the kitchen or gym, a high-school senior proudly posing with a first car, or a football player leaning against a goal post.

Taking environmental portrait photographs

7.21 In this image, I included enough of the surrounding elements to show this baker's everyday work area.

Table 7.7
Environmental Portrait Photography

Setup	**In the Field:** The image in figure 7.21 was taken at a bakery in a large store as the baker prepared apples for dipping in caramel. The work area was not altered for the picture; however, during editing, I cloned out a couple of signs that were attached to the walls.
	On Your Own: Get to know the subject to find out what elements play an important role in his work or avocation. Then set up the scene with some of those elements as part of the composition. When framing environmental portraits, use discretion about how much of the scene you include to avoid a cluttered look. Ultimately, you want the image to be informative, but also easy for viewers to understand.

Lighting	**In the Field:** For this image, overhead fluorescent lighting and track spotlights added a nice spotlight-like appearance to the apples, the subject, and the walls.
	On Your Own: Light from nearby windows can provide soft and flattering light. You can also use an accessory flash and bounce the flash off a wall or ceiling to provide more attractive lighting. Experiment with different levels of flash compensation to get just the right amount of illumination. If you're shooting outdoors, open shade or the light on an overcast day is ideal.
Lens	**In the Field:** Canon EF 24-105mm f/4.0L IS USM lens set to 24mm.
	On Your Own: Shorter focal lengths of 28 to 35mm are ideal when you want to include environmental elements in portraits. In addition, these focal lengths provide extensive enough depth of field to make contextual elements visually distinct without competing with the subject. To avoid wide-angle distortion, do not have the subject close to the camera. You can use a normal or short telephoto lens, as well; just step back a little to include environmental elements.
Camera Settings	**In the Field:** RAW capture, Aperture-priority AE mode.
	On Your Own: To control the depth of field, choose Aperture-priority AE mode to allow the background to be either soft (wide aperture) or sharply defined (narrow aperture). If you're working in mixed light, this is a great time to set a custom white balance or to shoot RAW images. You can then correct the color by click-balancing on a white or gray card that you shot under the scene lighting, which I did in this photo.
Exposure	**In the Field:** ISO 200, f/4.0, 1/25 second.
	On Your Own: Use the lowest ISO setting possible, such as 100 or 200, to avoid introducing digital noise in the image. If the light is low, use an accessory flash and bounce the flash off a wall or ceiling. On the Digital Rebel XTi/400D, use flash exposure compensation to get a natural-looking level of illumination.
Accessories	A tripod is always a good accessory to ensure sharpness when taking portraits.

Environmental portrait photography tips

✦ **Use a shorter focal length.** Normally, a medium telephoto lens is the choice for portraits, but with environmental portraits, a shorter focal length allows you to include surroundings that provide context.

For example, if you're using the Canon EF 24-70mm f/2.8L USM lens, a 35mm setting is a good choice. If you use a wide-angle lens, be sure that the subject is not close to the camera because facial features can be distorted in very unflattering ways.

✦ **Develop a rapport.** Develop a rapport with your subjects to make them feel more comfortable. The most important ingredient for any portrait is the connection that the photographer establishes with the subject. And in an environmental situation, ask the subject to show you what her work involves. As she gets involved in telling you about her work, she becomes less self-conscious and that's when you're most likely to capture her as she is in her work environment.

✦ **Scout locations that offer flattering light.** Natural light is always a good choice, especially gentle light that filters into the room from a nearby window. You can set up a silver reflector on the opposite side of the subject to reflect light into the shadow areas.

✦ **Check the background.** As with any image, be sure to check the background for distracting elements. You can tidy up the area beforehand, or you can use a wider aperture to help blur distractions. However, be careful not to blur away important contextual elements. For example, if you want to leave surrounding elements in reasonably sharp focus, you can use f/5.6 instead of f/3.5 or f/2.8.

✦ **Identify poses.** Because people quickly tire of even informal posing, discuss poses with your subject before you begin shooting. If you have a list of poses, go over them with the subject so that he feels comfortable and can respond to your direction. You can also provide minimal posing direction and go for more natural shots. You should provide breaks during which the subject can go about his work or play; the distraction of the activity provides countless opportunities for additional shots.

Event Photography

Events are an area in photography that present many opportunities, such as at parades, fairs, festivals, races, and traveling exhibits. Everything from Mardi Gras to a local county fair is a candidate for your photographic prowess and for great images to add to your portfolio.

Before you go to the event, think about photographing it as a story that identifies the theme and provides detailed context to give viewers a true sense of being there. You can include overall shots of the event to give a sense of the number of visitors, as well as close-up shots of visitors in traditional, comical, and poignant situations.

Planning is important. For example, if you're shooting a parade, walk the parade route the day before at the same time of day that the parade will occur. Note areas where you might encounter lighting challenges from the shadows of tall buildings or from backlighting.

in deep shade and require slow shutter speeds. Determine ahead of time whether you will use a flash or need to carry a monopod or tripod, especially for late-day and evening shooting.

Inspiration

7.22 A biker heads toward the finish line in this image taken at ISO 100, f/11 at 1/60 second using a Canon EF 70-200mm f/2.8L IS USM lens set to 140mm.

7.23 As part of the event images, be sure to get color shots that help define the event. This state fair image was taken at ISO 100, f/5 at 1/320 second using a Canon EF 24-105mm, f/4.0L IS USM lens set to 105mm.

For festivals, fairs, and other events, check the sponsor's Web site to obtain a schedule of events a day or two beforehand. Also, get a program or map of the event so that you know where the most interesting booths or exhibits are located, and where and when awards or music events will be held. Many event organizers hire photographers long before the event to take shots that will be used for the next year's event promotions. You can easily do a Web search to find the event planners or sponsors to contact them about shooting the activity. In addition, some event shots have resale potential as stock photography images.

If the event is held indoors, check ahead of time to see if there are restrictions on using a flash. Even if the event is outdoors, chances are good that some pictures will be

In a larger sense, popular public events reflect our culture, and the fads and fashions of the time. Consider how the series of photos that you take at an event can become a record of current culture. In the photos, include popular icons that will eventually reflect the era. Fashion, popular foods and activities, cars, and even cell phones are all possibilities. Be sure to include people in typical situations, such as a child holding onto a parent's leg or crying from exhaustion, or adults catching a short nap on the grass.

To capture the ambience of the event, consider close-up and medium-wide portraits of visitors interacting with performers, with vendors, and with each other. If the event is fast-paced and lively, you can use slow shutter speeds to capture motion as a blur.

Taking event photographs

7.24 Juxtaposing elements of the event provides a creative and unusual perspective.

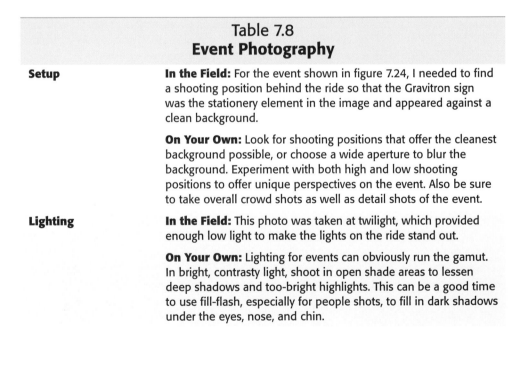

Table 7.8
Event Photography

Setup	**In the Field:** For the event shown in figure 7.24, I needed to find a shooting position behind the ride so that the Gravitron sign was the stationery element in the image and appeared against a clean background.
	On Your Own: Look for shooting positions that offer the cleanest background possible, or choose a wide aperture to blur the background. Experiment with both high and low shooting positions to offer unique perspectives on the event. Also be sure to take overall crowd shots as well as detail shots of the event.
Lighting	**In the Field:** This photo was taken at twilight, which provided enough low light to make the lights on the ride stand out.
	On Your Own: Lighting for events can obviously run the gamut. In bright, contrasty light, shoot in open shade areas to lessen deep shadows and too-bright highlights. This can be a good time to use fill-flash, especially for people shots, to fill in dark shadows under the eyes, nose, and chin.

Lens	**In the Field:** Canon EF 25-104mm f/4.0L IS USM lens set to 24mm.
	On Your Own: Both wide-angle and telephoto zoom lenses are good choices for event photography. Zoom lenses are indispensable because they allow you to change focal length while you are shooting.
Camera Settings	**In the Field:** RAW capture, Aperture-priority AE mode.
	On Your Own: To control the depth of field, switch to Aperture-priority AE mode and set the white balance to the type of light in the scene. If the light is low, switch to Shutter-priority AE mode and set the shutter to 1/30 second or faster.
Exposure	**In the Field:** ISO 100, f/4, 1/8 second.
	On Your Own: In good light, choose ISO 100. In lower-light scenes, choose ISO 200, 400, or even 1600 to get faster shutter speeds. At music concerts or events in low light, it's often effective to allow blur of the performers to show in the image as well as at other events. Experiment with different shutter speeds to get a variety of shots that reflect the pace and mood of the event.
Accessories	Using a polarizer on the lens helps to deepen the colors, and increases the saturation of color throughout the image for outdoor events.

Event photography tips

✦ **Choose multiple location options.** For parades, locate at least two shooting positions — one at street-level and the other from a higher view. Then use the high vantage point to record overall crowd scenes with a wide-angle lens, and use both the wide-angle and a telephoto lens from the street-level shooting position.

✦ **Try creative shooting positions at events.** Don't be afraid to kneel down or even lie down and shoot up. This shooting position makes the subject appear more powerful.

✦ **Ask for permission before photo-graphing children.** Always ask permission from a parent or guardian before photographing a child.

✦ **Plan some shots for the best hours of light.** For most outdoor events, this will be from late afternoon through sunset. Also stake out a shooting position that allows you to take the best advantage of the golden light.

✦ **Arrive early at popular events.** Because crowds gather quickly, an early arrival allows you to record pictures of people preparing race cars, musical instruments, booths, or floats. It also allows you to photograph crowds as they begin coming into the event.

Fine-Art Photography

The defining criteria for fine-art photography are the classic, inspiring, or iconic subject; the artistic rendering of the subject; and the photographer's extraordinary inner vision. It is this combination that draws curators, collectors, and art aficionados to the images. In many ways, fine-art photographers are the keepers of a vision that reveals life in ways that we would otherwise overlook.

Fine-art photography often crosses traditional lines. For example, the spectacular landscapes of Macduff Everton, the classic still-life images of Irving Penn, and the street photography and portraits of Henri Cartier-Bresson cross into the world of fine-art photography.

As a tool for the fine-art photographer, the Digital Rebel XTi/400D offers all of the creative options required to render subjects with the vision that you have in mind. While gallery images are often thought of as being extreme enlargements, the images from the Digital Rebel XTi/400D can also be upsampled to produce larger prints for gallery exhibitions. Many galleries now accept smaller image sizes, so that prints at the camera's native resolution make it a contender in the fine-art arena.

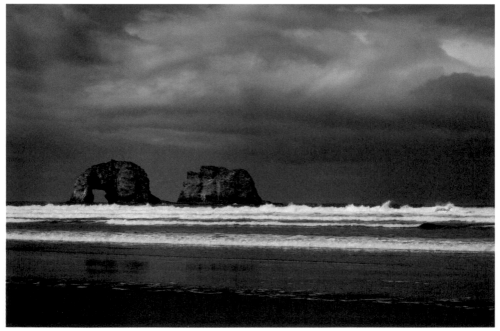

© *Cricket Krengel*

7.25 This image of a stormy sea and sea stacks off the coast of Oregon represents the evocative nature of fine-art photography. Taken at ISO 100, f/7.1, 1/2000 second in Manual mode, using the Canon EF-S 18-55mm f/3.5-5.6 USM lens.

Inspiration

© *Cricket Krengel*

7.26 The flock of sandpipers taking flight makes this a standout landscape and nature image. Taken at ISO 200, f/8, 1/2500 second in Manual mode, using the Canon EF-S 18-55mm f/3.5-5.6 USM lens.

If you're new to fine-art photography, visit local galleries to see what curators and gallery managers are selecting for exhibition. Although many subjects are appropriate for fine-art photography, the most important criterion is your artistic vision. Finding and refining your way of seeing the world so that it inspires others and creates a sense of awe is the foundation of most fine-art photography.

For inspiration, review the classic masters of art. Read the classic and contemporary books to find images, drawings, and text that resonate with you, and then translate the words and concepts into inspiring images. Because other specialty areas of photography cross over into fine art, study the latest trends in graphic and industrial design for themes and approaches that inspire you visually.

Taking fine-art photographs

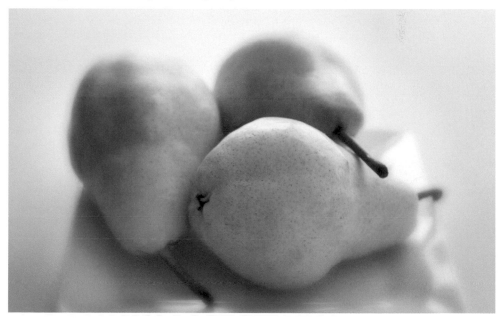

7.27 A simple setup and diffused window light helped to give these pears a soft glow.

Table 7.9
Fine-Art Photography

Setup	**In the Field:** The pears shown in figure 7.27 had been sitting around for a couple of days and had ripened with lovely red coloring in places. I left them as they were and moved them near a window for this shot.
	On Your Own: Fine-art photography leaves much open for viewers to fill in from their imaginations. Artful post-processing is useful, but the importance of getting a good image in the camera is equally important.
Lighting	**In the Field:** The light for this shot was a south-facing window with the blinds pulled down. The blinds diffused the morning light to create a soft look throughout.
	On Your Own: For fine-art images, lighting that is moody and evocative is excellent, and in image editing, the mood can be heightened.
Lens	**In the Field:** Canon EF 24-105mm f/4.0L IS USM set to 50mm.
	On Your Own: The lens that you choose depends on the scene, of course. You can consider using a soft-focus filter, or very fast lenses such as the Canon EF 50mm f/1.4 or the Canon EF 85mm f/1.2L II USM.
Camera Settings	**In the Field:** RAW capture, Aperture-priority AE mode with white balance set to auto (AWB). The Picture Style was set to Standard. I tweaked the white balance during RAW conversion in Adobe Camera Raw.
	On Your Own: For this type of image, try to achieve a shallow depth of field with a selective focus. Choosing a wide aperture often works best.
Exposure	**In the Field:** ISO 100, f/4.0, 1/125 second.
	On Your Own: For images with a high dynamic range, many photographers prefer to take two or three images, one exposed for highlights, one for midtones, and one for shadows; they then composite these images in Photoshop to get a final image at a higher dynamic range than the camera can deliver.
Accessories	If you choose to shoot multiple images to composite in Photoshop (as suggested above), be sure to use a tripod.

Fine-art photography tips

✦ **Build a series of images.** As with other areas of photography, look for a unified series of images on specific subjects that reveal your artistic vision.

✦ **Explore alternative digital processing techniques.** Unlike other areas of photography where a traditionally processed print is the expectation, in fine-art photography, you can exercise creative freedom in processing and rendering images.

Tip Some excellent techniques for processing RAW images are included in Adobe Camera Raw Studio Skills, published by John Wiley and Sons.

✦ **If you are upsampling images to make very large gallery prints, you should either upsample in a RAW conversion program or upsample incrementally.** Upsampling, or increasing an image beyond its native resolution, allows you to print Digital Rebel XTi/400D images at larger sizes. Upsampling can be done in Adobe Camera Raw in the Workflow Options section, or it can be done in Photoshop in the Image/Image Size dialog box using Bicubic interpolation. Most photographers agree that if you upsample in Photoshop, you should do so in successive increments of approximately 10 percent, until you arrive at the size of print that you need.

✦ **If you shoot black-and-white, take advantage of Canon's Monochrome Picture Style and filters.** Canon's Monochrome Picture Style offers color filter effects that simulate traditional color filters for black-and-white photography. You can also achieve similar effects in Adobe Camera Raw by using the Calibrate tab sliders to adjust tint and saturation for individual color channels.

Flower and Macro Photography

Rarely can a photographer resist the temptation to photograph flowers, exotic plants, and gardens. The enticements include the riot of colors, the allure of symmetry and textures, and the intricate design variations. Flowers and gardens offer an appeal that transcends cultural and language barriers, making them a universally captivating subject. As my friend and renowned landscape and nature photographer Terry Livingstone says, "Flowers are sexy."

7.28 Amazing symmetry is a defining characteristic of flowers and creates the center of interest in this image. The exposure for this image was ISO 100, f/2.8 at 1/1000 second, using a Canon EF 100mm, f/2.8 Macro USM lens.

The following guidelines will help you to capture the best images when photographing flowers and gardens. If the garden is a popular attraction for tourists, then it is probably designed with several "best" ways to view it; for example, it may contain arbors, topiaries, fountains, or statues. Get a map at the visitor's center, and look for tips on the best vantage points for the main areas of the garden. Take some overall "establishing" shots of the garden from each main vantage point, and then switch to isolating specific areas of the garden as individual compositions.

Of course, flower and garden images are strongest when you factor in the principles of good composition. The image should have a clear subject, and the composition should first lead the viewer's eye to the main subject and then through the rest of the image. Experiment with compositional elements such as color, shape, texture, lines, and selective focus to create the composition.

Employing a little anthropomorphism is helpful as well. In portraiture, the goal is to capture the subject's personality; you can use the same technique in flower photography to capture the personality of individual blossoms.

Inspiration

Take the idea of anthropomorphism a step further by ascribing human characteristics to flowers, and see where it leads creatively. For example, asking questions such as whether flowers have bad-hair days can help you look at them differently. How do flowers handle the problem of overcrowding? Consider the implied hierarchy in the scene or arrangement, and try to isolate it as the subject. Try using selective lighting to help isolate the hierarchy or order.

7.29 Macro photography can reveal the intricate structures within the subject. The exposure for this image was ISO 200, f/4 at 1/100 second, using a Canon EF 100mm, f/2.8 Macro USM lens.

Both flowers in a bouquet and individual flowers can make striking compositions, especially against a vivid background such as a bright blue sky. Given a little patience, you can also include bees, butterflies, grasshoppers, and other insects as part of the composition. Isolating individual parts of the flower to create a half-round or stair-stepped sequence of blossoms is only one of the many ways in which you can approach floral photography.

When planning your composition, you should also ask yourself these questions: Can you use color to convey your interpretation of the flower or garden as being strong, weak, vibrant, or subdued? What photographic techniques can you use to emphasize the grace, beauty, and tranquility of the garden or flower?

Taking flower and macro photographs

7.30 The dew pattern that remained on this rose bud after an early morning fog lifted provides the center of interest in this image.

Table 7.10
Flower and Macro Photography

Setup	**In the Field:** I took the picture in figure 7.30 in my yard as a heavy fog was lifting. With the Canon EF100mm f/2.8 Macro USM lens, it was easy to show the delicate balance of dewdrops lining the edges of the petals.
	On Your Own: Flowers and plants in outdoor light offer ready-made setup and lighting. If you don't have a garden, local nurseries and greenhouses offer plentiful subjects. Indoors, a single blossom or bouquet makes a good subject. Outdoors, you can compose images ranging from large fields of flowers to smaller groupings and single stems. You can also take a low shooting position, and then shoot upward to use the blue sky as a beautiful backdrop. You can try spraying flowers with water and glycerin to create artificial dew.
Lighting	**In the Field:** Diffuse light from the morning sun breaking through the fog provided soft side-light for this rose bud.
	On Your Own: Outdoor light ranging from overcast conditions to bright sunshine is suitable for photos. Try using reflectors to direct light toward a small group or blossom. Fill-flash is sometimes helpful to create slightly more vibrant color.
Lens	**In the Field:** Canon EF 100mm f/2.8 Macro USM lens.
	On Your Own: For large areas that contain blossoms, plants, or gardens, use a 24 to 35mm lens. For small groupings and single stems, consider a normal focal length or short telephoto lens. You can also use the EF-S 60mm f/2.8 Macro USM or the venerable EF 100mm f/2.8 Macro USM lens.
Camera Settings	**In the Field:** RAW capture, Aperture-priority AE. During RAW image conversion, I warmed up the overall image color temperature, which was initially quite cool.
	On Your Own: Decide on the best depth of field for the scene that you're shooting, and use Aperture-priority AE mode to set the f-stop. To blur the background, start with an f/5.6 aperture. For extensive depth of field, set an f/11 or narrower aperture.
Exposure	**In the Field:** ISO 100, f/5.6, 1/250 second.
	On Your Own: For large fields of flowers or plants, set a narrow aperture such as f/11 or f/16 to ensure maximum sharpness throughout the image. To isolate details of a single stem using selective focus, choose a wide aperture such as f/5.6. If you want maximum depth of field with a macro image at close focusing range, choose a narrow aperture of f/16 or f/22 and use a tripod.
Accessories	A tripod is always a good precaution when you're taking close-up or macro shots and when you're using a telephoto lens. You can also buy plant holders that do not damage the plant, but that hold it steady against outdoor breezes.

Flower and macro photography tips

✦ **Try a high position.** When photographing large gardens, try shooting from a high position. You can even shoot from a ladder to show the overall scope and color patterns of the garden.

✦ **Ensure precise focus for floral shots.** Anything short of razor-sharp detail detracts from floral images. If necessary, switch to manual focus by moving the switch on the Canon lens to the Manual setting. You can then tweak the final focus to perfection.

✦ **Enhance color.** In outdoor pictures, use a polarizer to enhance saturation of the flower colors and the sky.

✦ **Use the sky as a backdrop.** To create striking images, use a low shooting position and tilt the camera up to isolate the flower against a deep blue sky.

✦ **Use lighting to your advantage.** Many flower petals are transparent, and with backlighting, the delicate veins of the petals are visible. The same is true for many plant leaves. Watch for backlighting to create compelling and very graphic images of flowers and plants.

Landscape and Nature Photography

With breathtaking vistas of forests, mountains, and sky, landscapes and nature remain favorite subjects of photographers. From dawn to dusk and sometimes beyond, our environment provides an endless source of inspiration for lovely images. And you don't have to go far. You can choose a single location and return day after day to take entirely different pictures. Seasonal changes to flora and fauna, wildlife, rain, sunshine, fog, and snow all contribute to nature's ever-changing canvas.

Photographing landscapes and nature requires high levels of both creative and technical skills to create compositions that are dynamic and evocative of the mood of the scene, and that adequately capture the extremes of light and shadow.

Tip *The image histogram is a great tool for evaluating whether the camera has successfully captured detail in both light and dark areas. If the pixels are crowded against the left, right, or both sides of the histogram, this means that the camera wasn't able to maintain detail in one or both areas. Filters, such as a graduated neutral-density (NDGrad) filter, can help balance the exposure for bright sky areas and darker foreground areas, thus allowing the sensor to hold detail in both areas.*

7.31 I wanted to include the sense of people going about their daily activity in the shadow of Mt. Rainier, and a golf course provided that opportunity. Taken at ISO 200, f/8 at 1/640 second, using a Canon EF 70-200mm, f/2.8L IS USM lens set to 100mm.

The challenge of outdoor photography is in capturing the essence of a scene without the aid of chirping birds, the smell of clover, and the warm breeze of a late spring day. Compositional techniques including identifying a center of interest, using leading lines, framing, and placing the line of the horizon off-center go a long way in creating interesting nature pictures that help convey the sense of grandeur and beauty that you sense when the scene catches your eye.

The quality of light plays a starring role in nature photography. The low angles of the sun at sunrise and sunset create shadows that add a sense of depth to landscapes, not to mention the beautifully rich hues that characterize these times of day. Fog adds a sense of mystery, overcast light enriches colors, and rain dapples foliage with fascinating patterns of water droplets.

You can set the Picture Style to Landscape to achieve vivid blues and greens with a boost to contrast and sharpness. If you're shooting JPEG images, you can set the Picture Style so that it's applied in the camera, and you can adjust the sharpness, contrast, color saturation, and color tone to your liking. Or, if you're shooting RAW, you can apply the style and adjust contrast and sharpness using Canon's Digital Photo Professional conversion program.

Tip *One of the best tools an outdoor photographer can have is a polarizing filter that not only reduces glare and reflections, but also increases color saturation in the sky.*

Inspiration

7.32 This image is meant as a playful take on the old adage to "have your ducks in a row." Taken at ISO 200, f/11 at 1/50 second using a Canon EF 70-200mm, f/2.8L IS USM lens set to 105mm.

Choose a place that gives you a unique sense of tranquility. Try different positions, focal lengths, and foreground elements to help capture that sense of tranquility. As you take pictures, look both at the overall scene and at the components that make it compelling. Isolate subscenes that make independent compositions or that you can use as a center of interest for the overall scene.

As you look around, ask yourself questions such as whether including more or less of the sky will enhance the scene and the composition. Generally, a gray, cloudless sky adds no value to the image; in these conditions, including less of the sky in the frame is a better choice. Stormy skies, on the other hand, can add both drama and beautiful color to outdoor images.

Watch for naturally occurring elements such as an old wooden fence, a winding road, or a decaying archway to create classic compositions.

Taking landscape and nature photographs

7.33 There is nothing quite like sunrise and sunset light to add depth and brilliance to color such as in this landscape image taken during sunset.

Table 7.11
Landscape and Nature Photography

Setup	**In the Field:** In figure 7.33, an old, abandoned barn is just visible between the branches of a large tree that is just beginning to show fall color. The setup involved finding a shooting location and position that emphasized the tree with a secondary point of interest on the barn.
	On Your Own: Because such a wide variety of scenes are possible with landscapes and nature, the best advice is to trust your eye to set up and compose images. Try to exclude distracting high-line wires, road signs, and trash within the scene. Shoot from a variety of low-, high-, and eye-level positions. For sweeping scenes, include a foreground object, such as a person, a rock, or a fence, to give a sense of scale. As you look through the viewfinder, consider how the elements in the frame will direct the viewer's eye in the final picture.
Lighting	**In the Field:** The sunset light created a scene with a high dynamic range. I was able to open up shadows somewhat during RAW conversion, and I then used the Shadow/Highlight command in Photoshop to open the shadow areas even more.
	On Your Own: A variety of lighting conditions is inherent in landscape and nature photography. Often, the best light occurs just before, during, and just after sunrise and sunset, when the low angle of the sun creates long shadows and enhances the colors of flora and fauna.
Lens	**In the Field:** Canon EF 24-105mm f/4.0L, IS USM lens set to 40mm.
	On Your Own: Both wide-angle and telephoto zoom lenses are good choices for landscape and nature photography. For distant scenes, a wide-angle lens renders some elements too small in the frame. You can use a telephoto lens to bring them closer.
Camera Settings	**In the Field:** Aperture-priority AE mode with white balance set to Daylight. During RAW conversion, I warmed the color slightly.
	On Your Own: A favorite choice among photographers is to use Aperture-priority AE mode with white balance set to match the light. Because some landscape images look better with deeper color, you can use the Landscape Picture Style, which produces higher saturation and color intensity for the greens and blues in nature and landscape images. If you're shooting RAW capture, then you can set the Picture Style in Canon's Digital Photo Professional conversion program.
Exposure	**In the Field:** ISO 100, f/10, 1/60 second.
	On Your Own: Use the lowest ISO possible to avoid digital noise. In most landscape and nature photos, extensive depth of field is the best choice. Meter for the most important element in the scene, and bracket to ensure that at least one frame does not have blown-out highlights.

Landscape and nature photography tips

✦ **Position yourself to take advantage of the colorful or interesting sky as a backdrop.** For pictures of foliage, flowers, and colorful seasonal trees, use a low shooting position and shoot upward if you have a deep blue sky as the backdrop for the subject.

✦ **Get extensive depth of field.** To get extensive depth of field, set the Digital Rebel XTi/400D to Aperture-priority AE mode, and choose a narrow aperture such as f/11 or f/16. Then focus the camera one-third of the way into the scene, lock the focus, recompose, and take the picture.

✦ **Try using a telephoto lens.** Many people associate landscape photography with wide-angle lenses. However, telephoto lenses are indispensable in all types of outdoor photography, and they are very useful for isolating a center of interest in a wide-ranging vista.

✦ **When you shoot landscapes, include a person or object to help provide scale.** For example, to bring home the massive size of an imposing mountain range, include a hiker in the foreground or midground to give the viewer a scale of reference.

✦ **Look for details that underscore the sense of the place.** A dilapidated fence or a rusted watering trough in a peaceful shot of a prairie helps to convey how the land was used.

✦ **Look for interesting light.** For example, when you shoot in a forest or shaded area, try to include streaming shafts of light that are coming through the trees or illuminating a single plant.

✦ **Use exposure compensation in scenes with large areas of light colors.** Large areas of light colors or white, such as snow scenes or white sandy beaches, can fool the camera meter into underexposing the image. To ensure that the snow or sand appears white in the final image, set Exposure compensation on the Digital Rebel XTi/400D to +1 or +2.

✦ **Look for different ways to frame the scene.** Try using a tree as a frame along one side of the image, or a break in the foliage that provides a natural window and reveals a longer view of the scene.

Low-Light and Night Photography

If you're ready to challenge your photography skills, shooting low-light and nighttime images is a great way to do it. Evening and night images not only expand your understanding of exposure, but they also open a new world of creative challenge, enjoyment, and the potential for lovely results. Some events and stock photos also require you to shoot in low-light interiors and at evening and nighttime, so having a good understanding of how to get good results without excessive digital noise is important.

7.34 This twilight scene on a Lake Washington dock was exposed at ISO 100, f/4.5 at 1 second using a Canon EF 70-200mm, f/2.8L IS USM lens set to 78mm.

Table 7.12
Ideal Night and Evening Exposures

Subject	ISO	Aperture	Shutter Speed
City skylines (shortly after sunset)	100 to 400	f/4 to f/8	1/30 second
Full moon	100	f/11	1/125 second
Campfires	100	f/2.8	1/15 to 1/30 second
Fairs, amusement parks	100 to 400	f/2.8	1/8 to 1/15 second (1/30-1/60)
Lightning	100	f/5.6 (f/8)	Bulb; keep shutter open for several lightning flashes
Night sports games	400 to 800	f/2.8	1/250 second
Candlelit scenes	100 to 200	f/2.8 to f/4	1/4 second
Neon signs	100 to 200	f/5.6	1/15 to 1/30 second
Freeway lights	100	f/16	1/40 second

Fireworks Photography

If you want to capture the rocket's red glare, you can use lenses in the range of 28mm to 100mm. Choose an ISO from 200 to 400. Because the camera may have trouble focusing on distant bursts of light, you can pre-focus manually on infinity and get good results. I also recommend using a tripod or setting the camera on a solid surface to ensure sharp images. If you want to keep it simple, you can set the camera to Full Auto and then just point and shoot.

If you want to have more creative control, you should know that capturing fireworks is an inexact science at best. I usually set the camera to ISO 200, use Manual mode, set the aperture to f/11 or f/16, and set the shutter on Bulb; this allows you to experiment to find the best time, usually between one and two seconds. Check the results

on the LCD and adjust the time as necessary. The goal is to get a long enough exposure to record the full burst without washing out the brightest colors.

Don't worry if you miss some good displays at the beginning of the fireworks show, because the finale usually offers the best photo opportunities. Practice during the early part of the display to perfect your timing before the finale.

Sunset and twilight are magical photography times for shooting subjects such as city skylines, harbors, and downtown buildings. During twilight, the artificial lights in the landscape — such as street and office lights — and the light from the sky reach approximately the same intensity. This crossover lighting time offers a unique opportunity to capture detail in a landscape or city skyline, as well as in the sky.

Low-light and night photos are a great chance to use Manual mode on the Digital Rebel XTi/400D. Table 7.12 provides some sample metering recommendations.

In scenes where the subject is stationary and you're shooting with a tripod, turn on Long Exposure Noise Reduction using C.Fn-2. This doubles the amount of the original exposure time, but it also virtually eliminates digital noise, giving you a very high-quality final image without using noise-reduction programs during editing.

Inspiration

Try shooting city skyline shots in stormy weather at dusk, when enough light remains to capture compelling colors in the sky. These scenes also are great opportunities for panoramic images. Busy downtown streets as people walk to restaurants, cafés, and diners; gasoline stations, widely spaced lights on a lonely stretch of an evening highway, the light of a ship coming into a harbor, or an outdoor fountain or waterfall that is lit by nearby streetlights are all potential subjects for dramatic pictures.

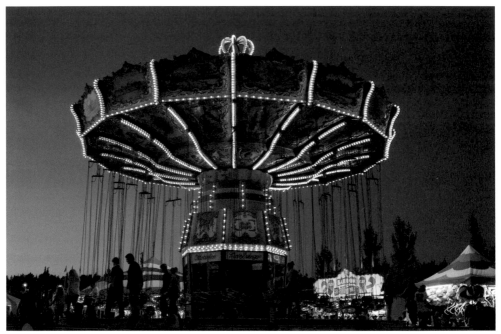

7.35 This longer-exposure image shows people on a ride at the Evergreen State Fair in Washington. The exposure for this image was ISO 100, f/4 at 1/5 second using a Canon EF 24-105mm, f/4.0L IS USM lens set to 24mm.

Taking low-light and night photographs

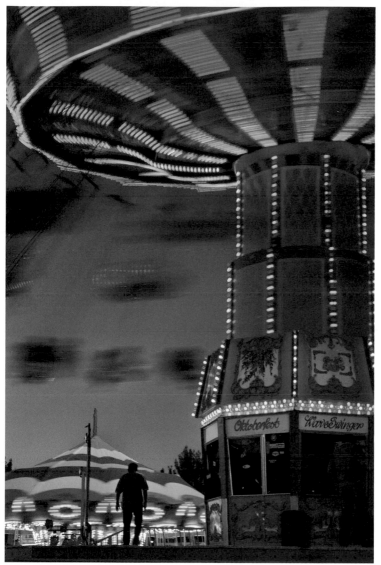

7.36 The inclusion of a carnival worker under one of the rides provides context for the image.

Table 7.13
Low-Light and Night Photography

Setup	**In the Field:** The challenge in figure 7.36 was to find a shooting position that allowed for a clean background with the carnival worker silhouetted against the twilight sky.
	On Your Own: Ensure that your composition has a clear message and isn't visually confusing; you can do this by reducing the number of elements in the frame. If you are photographing a busy outdoor area, find a location that is away from pedestrian traffic and unaffected by the vibration of passing cars. Be aware that passing cars and nearby lights can influence the meter reading on the camera. If this happens, you should try to change your shooting position.
Lighting	**In the Field:** This image was taken at twilight, which allowed for the lights of the ride to be distinct against the sapphire sky.
	On Your Own: To photograph night scenes with floodlit buildings and bridges, begin shooting just after sunset so that the buildings stand out from their surroundings. Check the image histogram on the LCD by pressing the DISP button.
Lens	**In the Field:** Canon EF 24-105mm f/4.0L IS USM lens set to 35mm.
	On Your Own: A wide-angle zoom lens set to 18mm or 24mm allows you to get a broad expanse when you are shooting indoor concerts, as well as evening and night scenes. Although telephoto lenses are great for bringing distant scenes closer, at this time of day, a tripod is a requirement especially if you use a long lens.
Camera Settings	**In the Field:** Aperture-priority AE mode with white balance set to auto (AWB).
	On Your Own: Assuming that you have the camera on a tripod or on a solid support, Aperture-priority AE mode gives you control over the depth of field. In Basic Zone mode, you can turn off the flash and use Landscape mode.
Exposure	**In the Field:** ISO 100, f/4.0, 1/4 second.
	On Your Own: Just past sunset, you can usually rely on the meter to give a good exposure, but you may choose to bracket exposures at 1-stop intervals. However, if bright lights surround the scene, the meter can be thrown off. Use a lens hood and check the image histograms often in the LCD. To reduce exposure time, you can increase the ISO up to 400, or even 1600.
Accessories	Using a tripod or setting the camera on a solid surface is essential in low-light scenes.

Low-light and night photography tips

✦ **Be safe and use common sense.** Night shooting presents its own set of photography challenges, including maintaining your personal safety. Always follow safety precautions when shooting. Be sure to wear reflective tape or clothing, and carry a flashlight and a charged cell phone with you.

✦ **Use a flashlight to trick the focus.** If the camera has trouble focusing, train your flashlight on the subject long enough to focus manually or automatically, and then turn off the flashlight before you take the picture.

✦ **Use a level when using a tripod.** A small bubble level designed to fit on the flash hot-shoe mount is an indispensable piece of equipment that helps you to avoid tilted horizon shots.

✦ **Try the Self-timer mode.** You can, of course, negate the advantage of using a tripod by pressing the Shutter release button with your finger. For example, just pressing the Shutter button with your finger can cause noticeable loss of sharpness. A better solution is to use the Self-timer mode.

Panoramic Photography

When the full, glorious sweep of a scene takes your breath away and makes you wish that you could capture it completely, this scene is a good candidate for panoramic photography. In traditional photography, a panoramic photo is longer and narrower than traditional photos, and it is taken with a panoramic camera. Panoramic cameras vary, from those that scan and gradually record the entire scene to others that capture the scene all at once.

7.37 This panoramic image was stitched together from five images of a farming community in the shadow of the mountains near Carnation, Washington. Taken at ISO 100, f/11, 1/125 second using a Canon EF 16-35mm f/2.8L USM lens set to 24mm.

You can easily create panoramic photos using digital photographs and the PhotoStitch program. PhotoStitch is Digital Rebel XTi/400D software that precisely aligns a series of photos from side to side or top to bottom.

The technique of taking a series of pictures for a panorama is to shoot successive images of a scene from left to right or top to bottom. To make the images consistent, keep the camera exposure and settings the same, and keep the camera level across all of the pictures. Each successive image should include some overlap with the previous image by about one-third of the frame. This overlap helps you to align the images later.

Note Programs such as PhotoStitch help you to merge two or more pictures into a panorama and print the merged image. If you're so inclined, you can create images with a 360-degree wraparound view, and you can also shoot images for the panorama in vertical or horizontal format. The program automatically adjusts for differences in brightness and color. Because the final image is a combination of multiple single images, the panoramic image file size is very large.

Inspiration

Panoramic photography is most often associated with landscape subjects, but residential and commercial interiors, city skylines, and gardens are also good subjects. Try to have one or more foreground objects in the panorama that provide a sense of scale in large sweeps of land or water. Including stormy or colorful skies also adds to the drama of a panoramic image.

7.38 This image of fog-enshrouded mountains and forest at sunset was exposed at ISO 100, f/8, 1/30 second using a Canon EF 70-200mm, f/2.8L IS USM lens set to 190mm.

Taking panoramic photographs

7.39 This sunset panoramic image was stitched from three separate images.

Table 7.14 **Panoramic Photography**	
Setup	**In the Field:** As I looked at the scene in figure 7.39, I determined how much of it I wanted to appear in the final combined image. Then I started shooting from left to right, leaving about a 33-percent overlap in each subsequent shot.
	On Your Own: Identify the composition that you want in advance of shooting. The composition should include a center of interest and follow the traditional composition guidelines. Moving objects such as birds and planes are not good to include in panoramas. Their movement and position through the series of images can make subsequent image stitching more difficult. Technique is also important: Keep the camera level across the series of images.
Lighting	**In the Field:** The sunset color was exceptional and the cloud formations provided a point of reference for stitching together the images.
	On Your Own: Choose a time of day when the lighting remains constant. If you include the sun, try to keep it entirely within one of the images, rather than partly in two or more images to make stitching easier.
Lens	**In the Field:** Canon EF 24-105mm f/4.0L IS USM lens set to 40mm.
	On Your Own: The final panoramic here measures 26.25 inches wide at 300 dpi. You can make nice panoramas from as few as two images or as many as five images; however, you should keep images to a reasonable number, such as three, to make stitching easier. Images taken with telephoto lenses are often easier to stitch than those that are taken with wide-angle lenses.

Continued

Table 7.14 *(continued)*	
Camera Settings	**In the Field:** RAW capture, Aperture-priority AE mode with the white balance set to Daylight. I warmed the color during RAW conversion. **On Your Own:** Use the same exposure for all images in the same panorama; if you use auto exposure, the difference between sections of the panorama may vary, making it more difficult to achieve an even exposure across the images. Good depth of field is preferable with panoramic images. A panorama need not be horizontal. You can also shoot vertical panoramic images. The more the images overlap, the easier it is for the stitching program to combine them seamlessly.
Exposure	**In the Field:** ISO 100, f/7.1, 1/50 second. **On Your Own:** To maintain extensive depth of field, set the aperture to f/8 or f/11. This is also a situation where you want to avoid unnecessary digital noise by setting the ISO to 100 or 200.
Accessories	Definitely use a tripod to keep the camera level across the series of shots.

Panoramic photography tips

✦ **Have a composition in mind before you begin.** This helps you to determine where you want the center of interest to appear in the final image. With the final composition in mind, you can then determine the starting and ending points.

✦ **Use an extensive depth of field.** The aperture that you use should be as narrow as possible to ensure extensive depth of field.

✦ **Include large objects in a single frame.** Try to include large foreground elements such as trees and buildings in a single frame, rather than stitched across multiple frames. If this isn't possible, be very careful to keep the camera level and allow at least a 33-percent overlap between frames.

✦ **Take several series of the same scene.** Take a panoramic series more than once to ensure that one series will stitch together seamlessly.

Pet and Animal Photography

Nothing gets an "awwww" quicker than a cute pet or animal photo. Next to photographing people, pets and animals are some of the most appealing subjects in photography and can be a fun specialty area. As with people photography, the goal is to convey the personality of the pet or animal. Of course, a major difference is that few if any pets and animals smile, and so conveying the animal's mood hinges on eliciting its natural curiosity and interest, and then capturing the responses.

7.40 Pets such as Tiki provide excellent photo opportunities. This image was exposed at ISO 100, f/2.8 at 1/25 second using a Canon EF 100mm, f/2.8 Macro USM lens.

> **Note** *When you photograph pets and animals, keep the welfare of the animal in mind. Never put the animal in danger or expect more of the animal than it is capable of or willing to give.*

Young, untrained pets and animals provide a lot of appeal, but they can be harder to work with because they don't readily respond to verbal commands. In these situations, give the pet a large but confined area and go with the flow, using props, toys, and rewards to entice the behavior that you want. Even with older pets that normally respond to verbal commands, don't be surprised if their response is less predictable when you're photographing them. After all, they can't see your face when it's behind the camera. Instead, establish eye contact with the animal as you set up the camera and talk to the animal throughout the photo session. Of course, you should also be patient with the animal and offer rewards and verbal encouragement.

If you choose an outdoor location, consider an area that limits the animal's ability to roam. Otherwise, you may find yourself trailing behind your pet, trying to get a good shot, when your pet would really rather be chasing birds in the yard.

Like people, pets quickly tire of having flash pictures taken, and some learn to look away from the camera. As an alternative to using a flash, photograph the animal outdoors or by the light of a nearby window. Continuous Drive mode is a good choice for taking successive shots of animals at play.

Inspiration

7.41 If you do not have a pet, many pet stores let you photograph the animals that they have for sale. This image of a gray rabbit was exposed at ISO 100, f/2.8 at 1/8 second using a Canon EF 100mm, f/2.8 Macro USM lens.

Photo opportunities include any new experiences for the animal, such as getting acquainted with another pet, sleeping in odd positions or curled up with other pets, watching out the window for children to come home from school, racing after a ball or Frisbee, or performing in an arena.

Taking pet and animal photographs

7.42 This miniature Schnauzer, Snickers, has long been a model for many images, and for a few biscuits, she will pose for long stretches of time.

Table 7.15
Pet and Animal Photography

Setup	**In the Field:** I set up seamless paper on a stand for the background in figure 7.42 and positioned the Schnauzer on a table, several feet in front of the background.
	On Your Own: Indoor pictures are relatively easy to set up for small pets and animals. If you include a favorite toy, be sure that it doesn't obscure the pet's face. Outdoor setups are easiest and provide a natural background for the animal, but often keeping the animal from wandering off is difficult. Find open areas where grass or natural foliage can be the background. Be sure to focus on the animal's eyes.
Lighting	**In the Field:** Daylight from nearby windows was used for this image, with a large silver reflector to camera right to reflect light into the dog's shadow side.
	On Your Own: Indoors, you can use the basic lighting setup described above, or you can use the light from a nearby window. Outdoors, late afternoon and sunset light provide beautiful light for animal pictures.
Lens	**In the Field:** Canon EF 24-105mm f/4.0L IS USM.
	On Your Own: Your lens choice depends in part on whether you're taking a portrait or full-body picture, as well as the size of the pet or animal. For large animals, the Canon EF 24-70mm f/2.8L USM lens is a good choice. I also often use the Canon EF 50mm f/1.4 USM lens for pet portraits.
Camera Settings	**In the Field:** RAW capture, Aperture-priority AE mode, with a custom white balance setting.
	On Your Own: For outdoor pet portraits, Aperture-priority AE mode allows you to control the depth of field. However, in lower light and if the animal is fidgety, Shutter-priority AE mode may be the best choice to ensure that the shutter speed is fast enough to prevent blur.
Exposure	**In the Field:** ISO 100, f/4.0, 1/6 second.
	On Your Own: If you use Aperture-priority AE mode, watch the shutter speed to ensure that it isn't slower than 1/30 second to avoid motion blur if the animal moves. In general, try to keep the shutter speed at 1/60 second or faster by choosing a wider aperture. If you fear that the animal will move, brighten the lights or add additional lights so that you can use a faster shutter speed. Or you can increase the ISO to 200, or use a wider aperture, such as f/5.6.
Accessories	For more traditional portraits of pets indoors, use a tripod. Outdoors, a tripod may not be practical, so be sure the shutter speed is fast enough to prevent motion blur. Also, have biscuits and toys available to attract the pet's attention.

Pet and animal photography tips

✦ **In most cases, shoot from the pet's eye level.** Occasionally, a high shooting position is effective to show a young animal's small size, but generally you'll get the most expression when you are on the same eye level with the animal.

✦ **Entice the animal with a treat or toy.** To get an animal to look in a particular direction, try holding a favorite toy or treat in your hand and move it in the direction that you want the pet to look.

✦ **Focus on the eyes.** Always focus on the pet or animal's eye that is nearest to the camera. Depending on how you want to render the background, you'll want to have sharpness throughout the animal for more formal portraits.

✦ **Try other techniques.** Use the techniques described in the earlier sections about action and sports photography to photograph animals in action.

Photojournalism

Many people think that editorial shooting and photojournalism is a specialty reserved for working journalists. But the genre of editorial and photojournalism photography has become the style de jour for other specialties including weddings and high-school senior photography. The appeal lies in the documentary aspect of capturing life and events as they happen. There is an essential element of the narrative—visually telling the story as it unfolds in real time with no posing or fabrications in most cases.

Editorial and photojournalistic style includes elements from other types of photography— including environmental portraiture, street, action and sports, and documentary—but with an emphasis on a visual narrative that often supports accompanying text.

7.43 The softly illuminated cross to the left of the pastor, as well as the shadowy audience figures in the foreground, provide the context for this image. Taken at ISO 1600, f/4.0, 1/4 second with the Canon EF 24-105mm f/4L IS USM lens.

Getting shots that define the spirit and character of the person or event goes to the heart of this photographic specialty — without posing or staging the scene. To capture defining shots, you need to understand the event or person. And you need to be there, in position, and ready to shoot when a defining moment happens.

Styles change over time. Depending on the editorial style that is in vogue, photojournalists may produce a classic photo story that is comprised of a series of photos that tell the story of the person or event, or they may distill the essence of the story in one or two shots.

/ **Note** *The Digital Rebel XTi/400D is a durable camera, but it does not have weather-sealing protection that you find on professional* cameras. *As a result, you should be careful when using it repeatedly in inclement weather and you should avoid rough handling. However, if you take precautions to keep it dry and treat it well, the Digital Rebel XTi/400D will serve you well in any situation.*

Inspiration

Look for opportunities to hone your photojournalism and documentary-shooting skills at local rallies, political gatherings, conventions, marches, protests, and elections. As you document these events or events in your family's lives, think of what makes each situation unique to the people involved in it, and try to capture that sense in the images.

7.44 Capturing the emotion and spirit of the activity that you're documenting is part of the goal of both good photojournalism and personal photo stories. Taken at ISO 1250, f/4.0 at 1/15 second using a Canon EF 24-105mm, f/4.0L IS USM lens set to 105mm.

Taking photojournalism photographs

7.45 This is one of a series of images documenting a specific worship service. This image focusing on part of the band provided a fine test of the Digital Rebel XTi/400D's high ISO settings.

Table 7.16
Photojournalism Photography

Setup	**In the Field:** For most photojournalism assignments, setups are not used unless the objective is a portrait for publication or for use in a newsletter. The primary setup for figure 7.45 was to find a shooting position that allowed for a clean shot of the foreground guitarist with the other guitarist in the background.
	On Your Own: For editorial shots, you may commonly work with positioning, lighting, and posing, but all toward the goal of accurately representing the subject. For breaking news shooting, the best strategy is to find an unobstructed view of the unfolding story and stay out of the way of people in the scene.
Lighting	**In the Field:** This image was taken under interior spotlights. A red sign in the background had lights sprinkled throughout, and it provided enough light to open up the shadows at the bottom of the frame.
	On Your Own: In low-light scenes or indoors, and if you're reasonably close, you can use either the built-in flash or an accessory flash — provided that flash photography is allowed and does not disrupt the proceedings. A reflector is also a handy accessory.

Lens	**In the Field:** Canon EF 24-105mm f/4.0L IS USM lens set to 105mm.
	On Your Own: A fast telephoto zoom lens, such as the Canon EF 70-200mm f/2.8L IS USM, is ideal for photojournalism and editorial shooting because in many scenes, you cannot get close to the subject. For weather-related photojournalism pictures, a wide-angle lens is ideal if you want to include the context of bad weather surrounding a person or group that is coping with the weather.
Camera Settings	**In the Field:** Aperture-priority AE mode with white balance set to auto (AWB).
	On Your Own: Always shoot at the highest resolution setting on the camera and maintain high resolution through the editing process so that the image looks good if the editor wants to use it in a large size.
Exposure	**In the Field:** ISO 1600, f/4.0, 1/30 second. The noise level at ISO 1600 on the Digital Rebel XTi/400D is acceptable. In fact, the performance is better at 1600 than at 800, in my opinion.
	On Your Own: Use wide apertures of f/3.5 or f/2.8 to blur distracting backgrounds. If the background adds context to the scene, stop down to f/8 or f/11 if the light allows.

Photojournalism photography tips

✦ **If you're new to photojournalism shooting, review current news images to get a feel for visual storytelling.** Although everyone has grown up seeing news photos, few people study them closely. Take time to carefully study photos in newspapers, news magazines, and consumer magazines to see how the photographers encapsulate the defining moments of a story and its background details through images.

✦ **Consider using photojournalism techniques for scrapbooking and family album photo stories.**

✦ **Capture the defining moment.** Before you begin, think about what the defining moment might be in the scene that you're shooting. You may miss capturing the defining shot by not knowing in advance what it might be. Of course, as the scene develops, the defining shot may change. Be prepared to keep up with the flow of events and anticipate events so that you can be in a good position to get the best pictures.

✦ **Have plenty of battery power.** Often, you can't tell how long an event will last. For this reason, I recommend buying the accessory battery grip so that you have enough battery power to last the duration.

✦ **Get permission.** Be very cautious when photographing private events, and always ask the event organizers for permission to photograph the event.

Portrait Photography

Portraiture is probably the most popular of photographic specialties, and it can provide hours of fun and practice in developing your photographic prowess. The goal of all portraiture is to reveal an individual's personality and spirit.

7.46 A simple, straightforward approach to portraiture is a good way to begin. The exposure for this image was ISO 100, f/4 at 1/10 second using a Canon EF 24-105mm, f/4.0L IS USM lens set to 99mm.

The following sections detail some of the key considerations involved in portraiture.

Lens choices

For head and head-and-shoulders portraits, normal to medium telephoto lenses ranging from 35 to 100mm are excellent choices. With a characteristic shallow depth of field, telephoto lenses help to blur the background and background distractions to make the subject stand out as the center of interest. For full-length and environmental portraits, a moderate wide-angle lens is a good choice. While a wide-angle lens can be used for head and head-and-shoulders portraits, it distorts facial features. For example, the nose appears larger, something that the subject usually does not appreciate.

Backgrounds and props

A portrait should make the subject the center of attention, and that's why a nondistracting or softly blurred backdrop or background is important. If you have trouble finding a good background, you can deemphasize the background by using a wide aperture such as f/4.0 or f/2.8. If you plan to use a flash, be sure to move the subject well away from the background to avoid dark shadows. Alternately, you can use harsh light and let deep shadows outline the subject. You can use props and locations that help to show the subject's areas of interest. For example, a football field is as good a background for a star football athlete as studio muslin or white seamless paper. For a musician, the musical instrument can be incorporated into one or more of the images.

Group Posing Tips

Here are some tips if you are photographing two or more people. The goal of portraiture is to make subjects look their best. You can use a few techniques to achieve this goal.

✦ Think of posing in terms of the lines that the subjects form: diagonal lines, triangles, X shapes, and so on. Posing people along these lines creates more dynamic images than posing them in parallel, horizontal rows.

✦ Coach subjects to place their hands in a neutral, non-expressive position. Placing a hand close to or on the face often puts undue emphasis on the hand.

✦ To avoid having the heads on the same vertical plane as the shoulders, ask subjects to stand with their bodies at a slight angle to the camera and to rest their weight on the rear foot.

✦ A subject's eyes should follow the direction of the nose.

✦ In large groups, whenever possible, keep the depth of people in rows shallow. In other words, use an arrangement that is two people deep rather than three or four people deep. Also use a narrow aperture to keep each person in sharp focus. For example, for a large group, f/11 would provide good depth of field to ensure that each subject is reasonably sharp, provided that you are not standing very close to the group. If you arrange a small group with one person slightly behind the other in stair-step fashion, try using A-DEP mode. This mode produces excellent depth of field for these types of arrangements.

Lighting

Lighting choices differ for portraits of men and women. For men and boys, a strong, directional daylight can be used to emphasize strong, masculine facial features. For women and girls, soft, diffuse light streaming from a nearby window or the light on an overcast day is flattering. To control light, you can use a variety of accessories, including reflectors to bounce light into shadow areas and diffusion panels to reduce the intensity of bright sunlight. These accessories are equally handy when using the built-in flash or an accessory flash for portraits. For the best exposure, take a meter reading from the highlight area of the subject's face, use Auto-exposure lock, and then recompose and take the picture.

Flash

The built-in flash produces nice images, especially if you set a negative flash compensation. However, you often have more flexibility when you use an accessory flash. With accessory flash units, you can soften the light by bouncing it off a nearby wall or ceiling. You can also mount one or more accessory flash units on light stands and point the flash into an umbrella to create studio-like lighting on location.

Tip

Use flash exposure compensation to dial back to the amount of light from the flash that you want. See Chapter 2 for details on setting flash exposure compensation.

Regardless of the light source, be sure that the subject's face is lit so as to bring it to the front of the image. The subject's eyes should have catch-lights, or small, white reflections of the main light. A 2 o'clock catch-light position is classic and makes the subject's eyes look vibrant. Light also affects the size of the subject's pupils — the brighter the light, the smaller the pupil size. A smaller pupil size is preferable because it emphasizes the subject's irises (color part of the eye), making the eyes more attractive.

Posing

Entire books are written on posing techniques for portraits. A quick guideline is that the best pose is the one that makes the subject look both relaxed and natural. In practice, this means posing the subject in a comfortable position and in a way that emphasizes the attractive features while minimizing less-attractive features. Key lines are the structural lines that form the portrait. Posing the subject so that diagonal and triangular lines are formed by the legs, arms, and shoulders creates more dynamic poses. Also, placing the subject's body at an angle to the camera is often more flattering than a static pose that has the head and shoulders on the same vertical plane.

Flash Photography

The Digital Rebel XTi/400D has good flash metering for both indoor and outdoor pictures. As you use the built-in flash or an accessory Speedlite, keep these points in mind.

✦ The distance covered by the flash increases as the ISO increases. In other words, if you set the camera to ISO 200, the flash distance is greater than at ISO 100. Also, to help lessen red-eye, you can increase the amount of room light as much as possible.

✦ You can use Flash-exposure lock in Creative Zone modes to light an off-center subject. Just pop up the flash and verify that the flash icon is lit in the viewfinder. Place the subject in the center of the frame, press the Shutter button halfway down, and then press and hold the Exposure Lock button on the back of the camera. The flash emits a pre-fire to calculate the amount of flash required, and FEL is displayed momentarily in the viewfinder. You can then move the camera to recompose the image, focus, and take the picture.

✦ If you use an accessory flash, such as the Canon Speedlite 550EX, you can consider buying a synch cord or flash bracket so that you can position the flash unit farther away from the lens.

✦ With an accessory flash unit, you can also point the flash head toward a neutral-color (or white) ceiling or wall to bounce the flash. The bounced light is diffused, producing a much softer and more flattering light.

✦ You can use an accessory flash unit to fill shadows, to stop action in lower-light scenes, and to add a point of sharpness in panned shots.

Clothing

Multiple clothing changes provide variety for portraits, and you can coordinate clothing with the overall mood of the photograph that is created by the combination of background, props, and posing. If you are doing portrait shooting for family and friends, discuss with them in advance clothing, props, and location, and be sure to bring with you hairbrushes, makeup, and anything else that the subject may forget to bring.

Rapport

Even if you light and pose the subject perfectly, a portrait can easily fail if you haven't established a positive connection with the subject that is mirrored in the subject's eyes in the image. Every minute that you spend building a good relationship with the subject pays big dividends in the final images.

Inspiration

Before you begin a portrait session, talk to the subject to find out his or her interests. Then see if you can create setups or poses that reflect these interests. Consider using props; for example, big, floppy hats for women can help to inspire improvisation. Alternately, play off the subject's characteristics. For example, with a very masculine subject, use angular props or a rocky, natural setting that reflects his masculinity.

7.47 White photographic paper background is the backdrop for this young man in his motocross jersey and helmet. Taken at ISO 100, f/14 at 1/125 second using a Canon EF 24-105mm, f/4.0L IS USM lens set to 58mm.

For inspiration and ideas for creative portraits, you can browse the latest newsstand magazines and music CD covers.

Taking portrait photographs

7.48 For this image, the young woman wanted a serious look as an alternate to other images of her smiling. This turned out to be one of her favorite images from an afternoon of shooting.

Table 7.17
Portrait Photography

Setup	**In the Field:** For the picture in figure 7.48, the subject was standing next to a south-facing window with a louvered room divider as the backdrop.
	On Your Own: Uncluttered and simple backgrounds are effective for ensuring that the subject is the center of interest in the image. If you don't have white paper or a large white poster board, you can use a plain, neutral-color wall, or plain room divider, and move the subject four to six feet from the background. Moving the subject away from the background and lighting the background separately helps to reduce or eliminate background shadows. If you are just beginning, keep poses simple and straightforward, and allow the subject to assume a natural position; then tweak the pose for the best effect.
Lighting	**In the Field:** This image was lit by late afternoon light from a window at camera left. I also placed a large silver reflector to camera right to fill in the shadow side of the subject.
	On Your Own: You can use window light alone or in combination with one or two silver reflectors. Consider using the built-in flash to add nice catch lights to the subject's eyes.
Lens	**In the Field:** Canon EF 24-105mm f/4.0L IS USM lens set to 88mm.
	On Your Own: Most photographers prefer a focal length of 100 to 105mm for portraits. Canon offers a variety of zoom lenses that offer a short telephoto focal length, such as the EF 24-105mm f/4.0L IS USM and the EF 70-200mm f/2.8L IS USM lenses. Another lens to consider for excellent contrast in portraits is the renowned Canon EF 50mm f/1.4 USM lens (equivalent to 80mm on the EOS Digital Rebel XTi/400D).
Camera Settings	**In the Field:** Aperture-priority AE mode with a custom white balance.
	On Your Own: In the field, you want to control depth of field for portraits. Aperture-priority AE mode gives you the most control.
Exposure	**In the Field:** ISO 100, f/5.6, 1/15 second.
	On Your Own: Avoid digital noise in shadow areas, particularly in portraits — choose the lowest ISO possible. To get a depth of field that ensures facial features that are reasonably sharp, set the aperture no wider than f/5.6 or f/8, depending on your distance from the subject.
Accessories	A tripod is a good accessory for portrait work, although it limits your ability to move around the subject quickly to get different angles. If the light permits, shooting off the tripod frees you to try more creative angles and shooting positions.

Portrait photography tips

✦ **Prepare a list of poses ahead of time.** People often feel uncomfortable posing for the camera. Having a list of poses, or at least a mental idea of the poses that you want, helps you to quickly direct the subject and make him or her feel comfortable with your expertise.

✦ **Flatter the subject.** For adults, ask the subject to lift his or her head and move it forward slightly to reduce the appearance of lines and wrinkles. Watch the change to see if the wrinkles are minimized. If not, adjust the pose further.

✦ **Use natural facial expressions.** It's always nice if the subject smiles, but portraits in which the subject is not smiling can be equally effective.

✦ **Pay attention to hands.** If the shot includes the subject's hands, you can minimize the appearance of veins. To do this, ask the subject to hold his or her hands with the fingers pointed up for a few minutes before you begin shooting.

✦ **Frame the subject.** In general, keep the subject's head in the upper one-third of the frame.

✦ **Focus.** Always focus on the subject's eye that is nearest to the camera.

✦ **Always be ready to take a shot.** When a good rapport is established between you and the subject, be ready to shoot spontaneously, even if the setup isn't perfect. A natural, spontaneous expression from the subject is much more important than fussing to get a perfect setting.

✦ **Take several frames of key poses.** It's entirely possible that something will be amiss with one or more frames. If you take only one picture, you won't have a backup shot of important poses.

✦ **Keep up the chitchat.** Keep up a steady stream of conversation that includes friendly directions for adjusting poses. Friendly chitchat helps to put the subject at ease and allows a natural way for you to provide direction as you're shooting.

Still-Life Photography

Poetic arrangements reminiscent of paintings immediately jump to mind when many people think of still-life photography. Artistic arrangements of pottery, flowers, fruit, and personal mementos are also popular subjects. However, still-life arrangements can also be found in existing scenes in old homes and buildings, along sidewalks, and in stores. Product photography incorporates many of the same aspects of composition, lighting, and exposure that still-life photography uses.

7.49 This image was set up with the nail-polish bottle on an acrylic sheet placed on photographic paper. A window to camera left and a silver reflector at camera right lit the subject. Taken at ISO 100, f/11 at 1/6 second using a Canon EF 100mm, f/2.8 Macro lens.

Although some photographers shy away from still-life and product photography because of their slower pace, both areas offer photographers a chance to expand their creative skills. They also offer ample opportunity to try varied techniques both in the camera and on the computer.

The nature of still-life subjects photography invites you to experiment with dramatic lighting and to think of ways to modify existing light. The goal of lighting and light modification is to enhance the overall mood of the setup so that it complements the subject. For example, you might use a sheer curtain to modify incoming window light for a delicate floral arrangement or for handmade soaps, giving either subject a soft, romantic look.

The choice of lenses for still-life photography depends, of course, on the subject. In general, normal, short telephoto zoom lenses, or moderate wide-angle zoom lenses are ideal for most still-life subjects.

Inspiration

7.50 Sometimes you don't have to set up a still-life image, but you find them in nature, such as this fallen apple in sunset light. Taken at ISO 100, f/8 at 1/60 second using a Canon EF 24-105mm, f/4.0 IS USM lens set to 85mm.

Traditional subjects are a great way to start learning the art of still-life photography. These subjects include fruit, flowers, pottery, antiques, clothing, meal entrées, beverages, bottles, soaps, coins, watch and clock parts, and decorative holiday display items.

Almost anything that catches your eye for its beautiful form, texture, shape, and design is a good candidate for a still-life photo. The same also applies to product photography where you want to enhance the form, shape, and design of the product. Because the success of the image often depends on the setup and arrangement, it's a good idea to study art and design books; these publications can help to spark ideas for creating your own setups.

Taking still-life photographs

7.51 Still-life images abound. I was drawn to this scene by the way the late-afternoon light cut across these piano keys.

Table 7.18
Still-Life Photography

Setup	**In the Field:** Figure 7.51 is a 'found' image that only required thinking about how to frame the scene. **On Your Own:** You can find many existing still-life images around your home or outside the home. Just watch carefully for small, discrete settings that form a composition on their own. Like still-life, product photography can be shot in the context in which the product will be used, or in a studio setting with a plain background.
Lighting	**In the Field:** The lighting for this shot was moderate sunshine from a window to the back of the keyboard. The shadow play on the keys provided a directionality that I liked. **On Your Own:** For small still-life and product shots that you set up on your own, the diffuse light from a nearby window is often the most attractive light. You can modify the existing light using silver reflectors to fill shadow areas, or you can use inexpensive diffusion materials such as tracing paper or a sheer curtain to reduce the harshness of bright light.
Lens	**In the Field:** Canon EF 24-105mm, f/4.0L IS USM lens. **On Your Own:** Your lens choice depends on the scene that you're shooting and your distance from it. Use a telephoto zoom lens to bring distant scenes closer, and a wide-angle lens to capture larger scenes. For minimal product distortion, the Canon EF 50mm f/1.4 USM lens gives great contrast and no lens distortion.
Camera Settings	**In the Field:** RAW capture. Aperture-priority AE mode. **On Your Own:** To control the depth of field, choose Aperture-priority AE mode and set the white balance to the type of light in the scene. If the light is low, switch to Shutter-priority AE mode.
Exposure	**In the Field:** ISO 100, f/5.6, 1/20 second. The wide aperture resulted in a very narrow area of sharpness toward the top of the frame. Another approach would be to use a narrow aperture to get more extensive depth of field. **On Your Own:** If you want background objects to appear as a soft blur, choose a wide aperture such as f/5.6 or wider. This brings the focus to the main object in the scene.
Accessories	Silver reflectors and diffusion panels are handy accessories for still-life and product photography.

Still-life photography tips

✦ **Choose items with the most aesthetic appeal for still-life arrangements.** If you're photographing fruit or other food items, spend time looking for the freshest and most attractive pieces of fruit, or the freshest plate of food. With other subjects, be sure that you clean, polish, or otherwise ensure that the subject is as clean and attractive as possible.

✦ **Try out the Digital Rebel XTi/400D's various Picture Style options.** For example, if you have set up a subject and you want a soft and subdued look, try the Portrait or Monochrome Picture Styles.

✦ **Experiment with focus.** Try adding a soft-focus effect to your still-life shots, either with a filter on the camera or later on the computer.

✦ **Experiment with different backgrounds.** A draped sheer curtain, a black poster board, or a rough adobe wall can make interesting backgrounds.

Stock Photography

At some point, almost everyone who has more than a passing interest in photography toys with the idea of making money from their images. And, for those who do, their short-list of ideas includes stock photography near the top. Stock photos fill the pages of popular newsstand magazines and brochures, and grace posters in public places and billboards along the highways. Stock photography refers to making existing images available for licensing by clients, including advertising agencies, corporations, magazines, book publishers, and others. Existing images can be offered to clients by individual photographers, by cooperatives of multiple photographers, or by stock photo agencies representing multiple photographers.

With more than 1,000 stock photography agencies and organizations to choose from — ranging from the leaders such as Getty and Corbis to grass-roots organizations such as Photographers Direct and the new micro-stock agencies that sell images for as little as a penny or a dollar — your chances of selling images as stock are better than ever before.

Using a traditional stock agency as an example, the agency markets the work of many photographers. They negotiate with and finalize licensing rights with clients, collect payment, and subsequently pay the photographer a percentage of the licensing price. The percentage split between the photographer and the agency varies, but a common split is 50 percent to the photographer, and 50 percent staying with the agency.

7.52 An image similar to this one was licensed for stock photography. It conveys a sense of concern. I left space on the right of the frame to insert text or graphics. Taken at ISO 100, f/18 at 1/125 second using a Canon EF 70-200mm, f/2.8L IS USM lens set to 73mm.

In turn, the agency is responsible for marketing and licensing tasks, which gives photographers more time to make pictures. With the potential to license a single image multiple times, a photo marketed by an agency or cooperative can provide a continuing source of income for months or even years, with no additional work on the photographer's part.

Stock photography represents a potentially lucrative way to use your existing images. Currently, the hottest trends in stock photo subjects are lifestyle images that run the gamut of subject areas from dining to outdoor activities and sports.

Many agencies have a minimum resolution for stock images that ranges from 8" × 10" at 300 dpi to 11" × 14" at 300 dpi. Some stock agencies allow for upsampling to increase native resolution of images to larger printing sizes. If you're new to stock shooting, check the agency requirements for minimum image resolution before requesting a portfolio review.

Inspiration

Over the years, major stock agencies have acquired thousands of images so that they now have more specific subject needs. As a photographer, it pays to consider potential stock use when you are out shooting. For example, if you're shooting landscape images, you may veer slightly to shoot roads leading up to the area because design agencies often look for scenic road shots for automotive clients. Consider shooting landscape images with camper tents in the scene, as well as people rafting, fishing, or swimming. These days, an image has more potential for stock use when it includes people enjoying popular activities.

Conceptual shooting is also a good area to consider. Themes such as "single," "breaking up," and the "tranquility of a spa" are examples of recent stock requests.

7.53 Stock agencies need all kinds of images. An image similar to this one has been licensed twice by stock clients. Taken at ISO 100, f/10 at 1/125 second using a Canon EF-S 18-55mm, f/3.5-5.6 lens set to 18mm.

Taking stock photographs

7.54 This lifestyle image includes the young woman doing a common activity — using a cell phone — and can be used for either specific or conceptual needs.

Table 7.19
Stock Photography

Setup	**In the Field:** For the image in figure 7.54, I used a white, louvered room divider as a background. This is one of several variations in a series of images on this subject. **On Your Own:** White backgrounds are useful because clients often replace the background with a color or other background that fits their needs. Leaving space in the image composition for designers to insert text and other graphics is also a good idea.
Lighting	**In the Field:** This image was lit by late-afternoon window light to camera left and a large silver reflector to camera right. Window light is an excellent light source for portraits, whether they are for stock or your personal use. **On Your Own:** Bright, clean images are preferred by clients and agencies, although stylistic variations can set your images apart from the multitudes of stock images.
Lens	**In the Field:** Canon EF 24-105mm, f/4.0L IS USM lens set to 88mm. **On Your Own:** Your lens choice depends on the scene that you're shooting and your distance from it. Use a telephoto zoom lens to bring distant scenes closer and a wide-angle lens to capture breathtaking sweeps of landscape.
Camera Settings	**In the Field:** Aperture-priority AE mode with a custom white balance. **On Your Own:** Control the depth of field by choosing Aperture-priority AE mode. If the light is low, switch to Shutter-priority AE mode. I used a tripod for this image.
Exposure	**In the Field:** ISO 100, f/5.6, 1/15 second. **On Your Own:** If you need to blur the background details, try adjusting the f-stop to get the results you want. Shoot many variations of stock images, including vertical and horizontal format and from different shooting perspectives such as high, low, and from the side.

Stock photography tips

✦ **Study existing styles.** Over the years, the quality of stock imagery has risen to some of the best images to be found. At a minimum, agencies' expectations are excellent exposure, composition, and subject matter. However, more importantly, agencies look for a personal style that sets your imagery apart from the thousands of images that they already have in their library. Study the images offered by top stock agencies, and determine how you can match and better what's currently being offered.

✦ **Captions and keywords.** In most cases, photographers are responsible for providing clear and accurate captions. In fact, some agencies and clients make go and no-go decisions based on the accuracy of captions.

✦ **Build a sizeable portfolio.** Most stock photo agencies expect potential photographers to have a substantial body of work—images numbering in the hundreds if not thousands. This means that if you only have a dozen or so great images, chances are better than good that a traditional stock agency won't be interested.

✦ **Image content and marketability.** Agencies look for a creative edge, if not creative genius, that makes images stand out. The "stand-out" quality is, of course, judged through the dispassionate eye of a photo editor—someone who reviews hundreds of images from polished photographers every day, and who can quickly cull pedestrian images from star performers.

Street Photography

Henri Cartier-Bresson spoke eloquently and passionately of using the camera to tell picture stories. Making a picture story, in Cartier-Bresson's view, required that "the brain, the eye, and the heart" of the photographer work together to capture an unfolding process. For street photographers, the heart of photography exists most vibrantly in the picture stories that unfold every day on city streets. And whether you consider yourself a street photographer or not, street photography offers the singular ability to capture a broad sweep of our world in action.

Nothing is more important in street shooting than having an acute awareness of what's going on around you at all times. Certainly this awareness helps to ensure your personal safety, but more important, it puts you in touch with the heartbeat of the city—that palpable throb of life in progress that makes street photography both compelling and addictive.

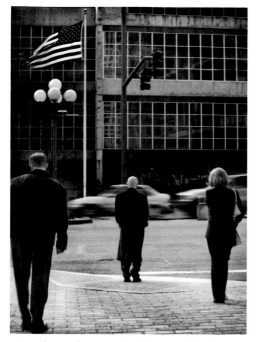

7.55 These three pedestrians waiting for a light to change take on a surreal sense because of their similar posture and clothing. Taken at ISO 100, f/13 at 1/15 second using a Canon EF 70-200mm, f/2.8L IS USM lens set to 70mm.

Many professional photographers began their careers by shooting on city or small-town streets. The subject matter attracts many photographers, and street photography is an excellent venue to develop your skill, by shooting in all sorts of lighting conditions and with a variety of subjects and scenes.

For flexibility, a fast telephoto zoom lens is ideal for street photography. It allows you to get in close to the scene while maintaining a distant, background shooting position. Also, because street shooting varies from bright sunlight to deep shade, a fast f/2.8 lens gives you a better chance of getting sharp, handheld pictures in low-light scenes.

Street shooting is also a great way to hone your skill at composition and using selective depth of field. If you're new to street shooting, you may find that your composition skills improve because you're continually evaluating what scene elements to include and exclude. Likewise, you're also forced to make quick decisions on choosing the aperture and camera-to-subject distance to control depth of field.

Inspiration

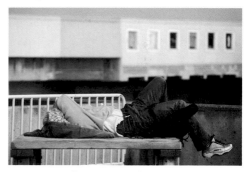

7.56 A Seattle picnic table becomes a place to catch a quick nap. The exposure for this image was ISO 100, f/4.0, 1/750 second using a Canon EF 70-200mm, f/2.8L IS USM lens set to 153mm.

The "Decisive Moment"

When shooting on the street, know that drama can unfold quickly, and you need to be prepared to photograph the story as it unfolds. In a dramatic situation, photographing the decisive moment usually means capturing the moment of peak tension. Getting the picture of critical tension is like adding a period to the last sentence of a novel: Without it, the story isn't complete. The only secret to getting this shot is being there and being ready to shoot if action unfolds.

Certainly not all street photography involves dramatic events; in fact, most street photography centers on telling the story of our collective life and times. However, the principles are the same: Finding a compelling scene, and then waiting for the one person to stride into the scene to complete it, to explain it, to add mystery or intrigue to it. As Cartier-Bresson wrote, "The photographer must make sure while he is still in the presence of the unfolding scene, that he hasn't left any gaps—that he has really given expression to the meaning of the scene in its entirety."

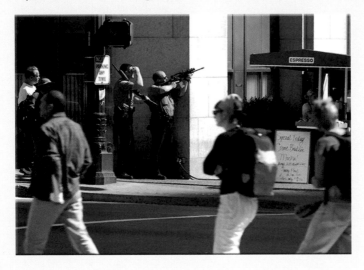

On the street, the initial impulse is to photograph everything you see. But as you become more selective in street shooting, try doing a thematic series. Potential subjects for thematic series abound. For example, you could do a study on how people react to waiting for a traffic light to change, or do a series on life in and around a metropolitan bus terminal.

Or choose a spot that is slated for improvement. Assign yourself to document the reconstruction. You can photograph the area as it is now and capture the "life" of the area. Then you can follow up every week or so to see how the construction changes not only the look of the place, but also the sense of place.

Taking street photographs

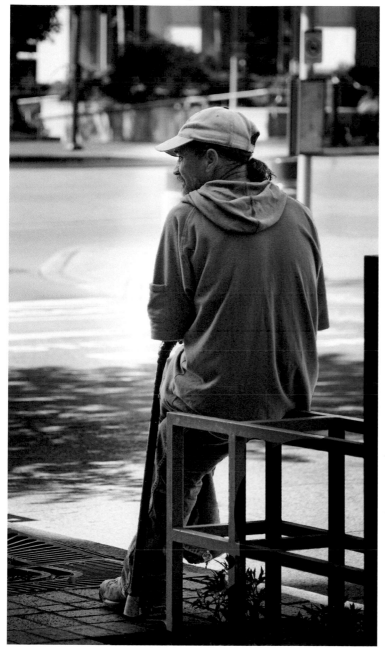

7.57 Street shots can be simple, everyday activities such as this man with a cane who was waiting for a bus. The black-and-white conversion was done in Photoshop during image editing.

Table 7.20
Street Photography

Setup	**In the Field:** The image in figure 7.57 was taken at a metropolitan bus terminal. I quietly moved back from the man to avoid attracting his attention, and zoomed in to 200mm to frame the shot.
	On Your Own: Vary shots by taking a high or low shooting position. Watch for iconic shots that describe our life and culture. Street photography is also a great time to capture humorous scenes of people interacting, or people juxtaposed with background billboards and signs.
Lighting	**In the Field:** The man was sitting in deep shadow with areas of bright sunlight striking his cap and part of his clothing. I exposed for the highlights, knowing that I would have to brighten the image in Photoshop during editing.
	On Your Own: Lighting for street photography can run the gamut. Watch for highlight areas on the subject and use negative exposure compensation or bracketing to ensure that highlights are not blown out.
Lens	**In the Field:** Canon EF 70-200mm, f/2.8L IS USM lens set to 200mm.
	On Your Own: A zoom lens is indispensable for street shots. Typically, a telephoto zoom offers the focal range necessary for you to remain at a distance, while bringing the subjects close to fill the frame. The telephoto lens offers the additional advantage of blurring a distracting background.
Camera Settings	**In the Field:** Aperture-priority AE mode. The white balance was set to Auto. Usually, I don't know until I have the images on the computer whether I want one or more images rendered in black-and-white. This image was converted to black-and-white in Photoshop using the Channel Mixer feature.
	On Your Own: To control the depth of field, choose Aperture-priority AE mode and set the white balance to the type of light in the scene. If the light is low, switch to Shutter-priority AE mode.
Exposure	**In the Field:** ISO 100, f/4.0, 1/320 second.
	On Your Own: In low-light scenes, switch to Shutter-priority AE mode and set the shutter to 1/30 or 1/60 second. At 1/30 second, you may get some blur if the subject moves, which can also make an effective image. If you want sharpness throughout the image to show the surroundings, set a narrow aperture such as f/8 or f/16. To blur the background, choose a wide aperture such as f/5.6 or wider.

Street photography tips

✦ **Watch for photo "stories."** Photo stories involve subjects and sequences that tell the story of a place, building, or group of people. Shoot the photo-story sequence over time, and edit images carefully to include only the photos that follow your story line.

✦ **Use light to your advantage.** There's nothing like the warm light of sunset to make city streets and buildings glow. Set a narrow aperture, such as f/11 or f/8, to ensure extensive depth of field.

✦ **Always keep a spare memory card handy.** If a drama unfolds suddenly on the street, you'll be glad that you have an empty card that you can slip into the Digital Rebel so that you can continue shooting uninterrupted.

✦ **Pack wisely and travel light.** Always carry a fully charged cell phone with you, and carry only the lenses with which you plan to shoot. The lighter load gives you greater mobility and lessens the chance that your equipment might be stolen.

Sunset and Sunrise Photography

The colorful drama that unfolds at the beginning and end of each day has inspired photographers to capture the images of sunrises and sunsets since the dawn of photography. At no other times of day does the sky offer such compelling color, whether you are photographing the sunset itself or scenery or people in the glow of sunrise or sunset light. Whether you shoot weddings, portraits, fashion, or commercial assignments, knowing how to shoot in the magical light of sunrise and sunset will net some of the best shots of the assignment or for your portfolio.

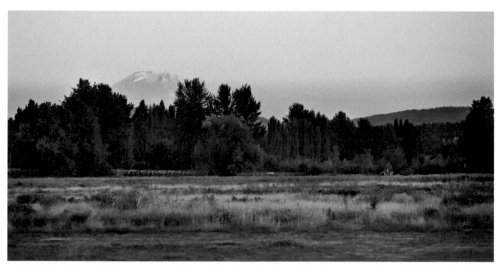

7.58 This image of Mt. Rainier was taken during an early fall sunset. The exposure was ISO 100, f/4.5, at 1/60 second using a Canon EF 70-200mm, f/2.8L IS USM lens set to 200mm.

Tip

To protect your eyesight as well as the image sensor, don't point the Digital Rebel XTi/400D directly at the sun. Instead, shoot the sun at a slight angle and be sure to use a lens hood to avoid flare (reduced contrast when light from outside the intended image strikes the lens).

Choosing a lens depends on the subject that you're shooting and how you want to show the sunrise or sunset within the context of the overall photo. A wide-angle lens provides a large sweep of sky that can lead the eye to the distant horizon, but it also reduces the apparent size of the sun to a small speck on the horizon. By contrast, a telephoto lens gives the sun a more prominent role so that you can isolate an object, such as a sailboat, as it passes in front of the sun.

Because many sunrise and sunset images include the sun, it's important to preserve the color of the sun in the image. If you meter on the sky, the sun will be white — colorless and without detail — in the final image. For this reason (and because sunrise and sunset pictures look great with rich, deep color), use a -1 to -2-stop exposure compensation and also bracket the exposure to be safe.

Cross-Reference

For more information on exposure bracketing, see Chapter 2.

Silhouettes

A solid subject such as a person, tree, or boat that is positioned between the camera and a bright light source such as the setting sun creates a silhouette when you expose the image for the brighter background. Of course, any solid subject that is backlit can produce a silhouette. For example, entire or partial silhouettes are often used in portraits. Because detail in the silhouetted subject will not be visible in the image, choose a subject that has an identifiable shape, and strive to keep the composition clean and simple. In sunset images, silhouettes are especially effective in the light just after the sun sets.

To create a silhouette, select Av (Aperture-priority AE) mode. This mode allows you to control both the depth of field and the part of the scene that the camera meters. Focus on a bright part of the background (which simultaneously sets the exposure), and press the AE Lock button. Then recompose, focus, and take the picture.

Inspiration

Certainly sunrise and sunset photography are a popular genre. But to be successful, these pictures should have more interest than just the glorious colors of the sky. A foreground object or even a distant object can add context and symbolism that makes the picture stand out from run-of-the-mill sunrise and sunset pictures.

7.59 This image combines an exposure for the roses in the foreground and an exposure for the sunset sky in the background. The basic exposure for this image was ISO 100, f/4, at 1/800 second using a Canon EF 24-105mm, f/4.0L IS USM lens set to 58mm.

Taking sunset and sunrise photographs

7.60 The sweep of light falling on the forest and the silhouetted trees to the left of the frame adds depth to this sunset image.

Table 7.21
Sunset and Sunrise Photography

Setup	**In the Field:** The image in figure 7.60 was taken from a second-story window. The main consideration was in framing the scene and determining how many of the foreground silhouetted trees to include at the left of the frame.
	On Your Own: To set your sunset pictures apart from others, compose the image so that the effect of the light is shown, such as on ripples on a lake. Add interest by including objects in the foreground or midground. For scenic, landscape, and seascape images, keep the horizon in the upper or lower third of the image. Sunrises and sunsets happen over a very few minutes of time. Be sure that you are in position well before the time of sunrise or sunset and ready to shoot.
Lighting	**In the Field:** Early sunset light provided superb color to the clouds while yielding a golden hue to the sunlight that was falling on mountainside trees.
	On Your Own: Sunrise and sunset happen within a few minutes of time, and the colors of the sky can change dramatically during those few minutes. The color temperature of sunrise is 3,100 to 4,300 K, and sunset is 2,500 to 3,100 K. Knowing these approximate temperature ranges allows you to fine-tune color when you shoot RAW images and process them in Digital Photo Professional.
Lens	**In the Field:** Canon EF 100mm f/2.8 Macro USM lens.
	On Your Own: Your lens choice depends on the scene that you're shooting and your distance from it. Use a telephoto zoom lens to bring distant scenes closer, and a wide-angle lens to capture breathtaking sweeps of color.
Camera Settings	**In the Field:** RAW capture, Aperture-priority AE mode. The white balance was set to AWB and tweaked during RAW conversion.
	On Your Own: Aperture-priority AE mode is a good choice so that you can control the depth of field. If you want to shoot in a Basic Zone mode, Landscape mode is a good option.
Exposure	**In the Field:** ISO 100, f/6.3, at 1/200 second.
	On Your Own: Light fades quickly during sunrise and sunset. You can set the ISO to 100 to 400, and perhaps even switch from a lower ISO at the beginning of the light change to a higher ISO as the light fades. For expansive scenes, keep good depth of field by using f/8 or f/11. If the shutter speed drops below 1/60 or 1/30 second, set the camera on a solid surface or use a tripod.
Accessories	If you're shooting just before the golden light has begun, you can add simulated sunset light by using a gold reflector to reflect into the subject.

Sunset and sunrise photography tips

✦ **Capture the full range of colors.** The color of the sky before, during, and just after sunset and sunrise changes dramatically. Be sure to use all the time to capture the changes.

✦ **Get in position early.** Be in place and have the camera set up 15 minutes or more before the sunset or sunrise begins. Once sunset or sunrise begins, you have only ten minutes at most to capture the shots you want.

✦ **Use the sky to your advantage.** Clouds help to diffuse sunlight and create colorful and dramatic sunsets. On clear days, the best time to shoot is just before or just after the sun falls below the horizon.

✦ **A tripod or monopod is your friend.** You'll get sharper images by using one.

Travel Photography

The Digital Rebel XTi/400D is lightweight and extremely versatile, making it ideal for traveling. With a set of compact zoom lenses and plenty of memory cards, you'll have everything you need to take high-quality shots to document your travels.

Before you begin any trip, clean your lenses and ensure that the Digital Rebel XTi/400D is in good working condition. Consider buying spare batteries and memory cards. If you're traveling by air, check the carry-on guidelines on the airline's Web site and determine if you can carry the camera separately or as part of your carry-on allowance. An advantage of being a digital photographer is that you do not have to worry about film being fogged by the X-ray machines.

Another pre-trip task is to research the destination by studying brochures and books to find not only the typical tourist sites, but also favorite spots of local residents. When you arrive, you can also ask the hotel concierge for directions to popular local spots. The off-the-beaten-path locations will likely be where you get some of your best pictures.

Here are some additional tips for getting great travel pictures:

✦ **Research existing photos of the area.** At your destination, check out the postcard racks to see what the most-often-photographed sites are. Determine how you can take shots that offer a different or unique look at the site.

✦ **Include people in your pictures.** To gain cooperation of people, always be considerate, establish a friendly rapport, and show respect for individuals and their culture. If you do not speak the language, you can often use hand gestures to indicate that you'd like to take a person's picture, and then wait for his or her positive or negative response.

✦ **Keep the composition simple with a clear center of interest.** This is where a telephoto lens comes in handy. With it, you can eliminate distracting elements on either side of the subject or a dull, overcast sky. In larger scenes, you can use a wide-angle lens.

7.61 This New York City image captures the charms of this famous location. The exposure for this image was ISO 100, f/5.6, 1/200 second.

✦ **Waiting for the best light pays big dividends.** Sometimes this means that you must return to a location several times until the weather or the light is just right. Once the light is right, you can take many photos from various positions and angles.

✦ **Photographing people and landmarks.** If you want to include family or traveling companions in a shot at a famous landmark, use Landscape or Aperture-priority AE mode with an aperture of f/8 or f/11 to keep the foreground and background sharp.

✦ **Add bold, bright color to your images.** Look for colorfully painted storefronts, boats, gardens, cars, buses, apartment buildings, and so on to add interest to your pictures.

Inspiration

If the area turns out to have a distinctive color in the scenery or in the architecture, try using the color as a thematic element that unifies the images that you take in that area. For example, the deep, burnt-orange colors of the southwest U.S. can make a strong unifying color for vacation images.

Watch for details and juxtapositions of people, bicycles, and other objects with backgrounds such as murals and billboards. Also watch for comical or light-hearted encounters that are effective in showing the spirit of a place.

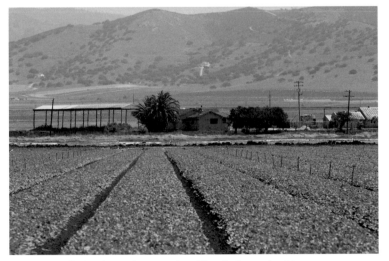

7.62 A road trip through central California is marked by an abundance of lettuce farms, like the one shown in this image. Taken at ISO 100, f/10, 1/200 second using a Canon EF 70-200mm, f/2.8L IS USM lens set to 165mm.

Taking travel photographs

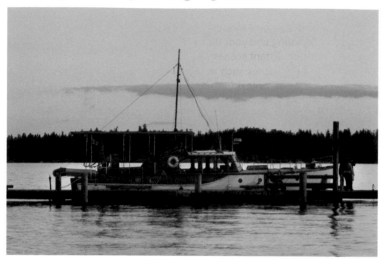

7.63 This fishing boat is an uncommon occurrence on Lake Washington in the Seattle area, which is more commonly associated with hydroplane and sailboat races.

Table 7.22
Travel Photography

Setup	**In the Field:** The presence of the fishing boat in figure 7.63 is relatively uncommon for this area and provided a unique perspective for the Lake Washington dock area.
	On Your Own: Choose locations that are iconic, or classic, and try different positions, angles, or framing to show the location to give a fresh perspective on a well-photographed area. Include people in your images to provide an essence of the location. Narrow the scope of your image so that you present a clear story or message. Always ask permission to photograph local people. Even if you don't speak the language, you can use gestures to indicate your intent and question.
Lighting	**In the Field:** This image was taken just after sunset. The light adds a sense that the fishing boat has come to rest for the evening.
	On Your Own: Light for travel photos runs the full range. The challenge is to know when to shoot and when not to shoot. Ask yourself if the existing light is suited for the subject. If it isn't, wait for the light to change, or come back at a different time of day when the light is more appealing. Often, just waiting for a cloud to pass by offers enough diffusion to make a better picture.

Lens	**In the Field:** Canon EF 70-200mm, f/2.8L IS USM lens set to 140mm.
	On Your Own: Your lens choice depends on the scene that you're shooting and your distance from it. Use a telephoto zoom lens to bring distant scenes closer, and a wide-angle lens to capture large scenes such as festivals and fairs, or to include environmental context for people shots.
Camera Settings	**In the Field:** Aperture-priority AE mode. The white balance was set to AWB.
	On Your Own: To control the depth of field, choose Aperture-priority AE mode and set the white balance to the type of light in the scene.
Exposure	**In the Field:** ISO 100, f/8, 1/15 second.
	On Your Own: Set the ISO as low as possible, given the existing light. If you're photographing people, use a wide aperture such as f/5.6 to blur the background without making it unreadable. Watch the shutter speed in the viewfinder to make sure it isn't so slow that subject or hand motion doesn't spoil the picture.

Travel photography tips

✦ **Do your homework.** The more you study before traveling, the better understanding you'll have of the people and area, and the better your pictures will be.

✦ **Be cautious about deleting images.** As your trip progresses and you fill your memory cards or portable storage unit, you may be tempted to delete pictures to free up storage space. Be very careful when deleting pictures that you haven't seen at full size. You can easily delete images that could be the best of the trip with a little editing.

✦ **Keep an eye on your equipment.** Digital cameras are extremely popular, which makes them a target for thieves. Be sure to keep the camera strap around your neck or shoulder, and never set it down and step away. This sounds like common sense, but you can quickly get caught up in activities and forget to keep an eye on your camera.

✦ **Use reflectors.** Small, collapsible reflectors come in white, silver, and gold, and they are convenient for modifying the color of the light. They take little space and are lightweight.

✦ **Don't take too much equipment.** Carry just enough to fill your camera bag and ensure that the camera bag will pass airline requirements for carry-on luggage.

Weather and Seasonal Photography

Just as with sunset and sunrise, weather and the events that it brings create compelling photography subjects. Whether you photograph rain, snow, a stormy cloudscape, or fog, you can use the weather to set the mood of the image, to add streaks of falling rain or snow, and to show classic human and animal reactions to the weather.

A variety of techniques are effective in weather photos, but the first consideration is to protect the camera from moisture and dust. Many companies sell affordable weatherproof camera covers, and they are well worth the price. You can also fashion your own covering from water-repellant fabric or from a large plastic bag. Keep the covering in your camera bag in case there's an unexpected shower or snowfall.

Many of the techniques covered in earlier sections in this chapter can be used when you're taking weather photos. The following sections offer some tips for shooting in specific types of weather.

Falling rain and snow

You can choose to freeze the motion created by falling rain or snow by using a fast shutter speed. Conversely, you can show the rain or snow as streaks by using a shutter speed of 1/30 second or slower. The slower the shutter speed is, the longer the streaks. Try to choose a medium to dark background to more clearly show the rain or snow streaks.

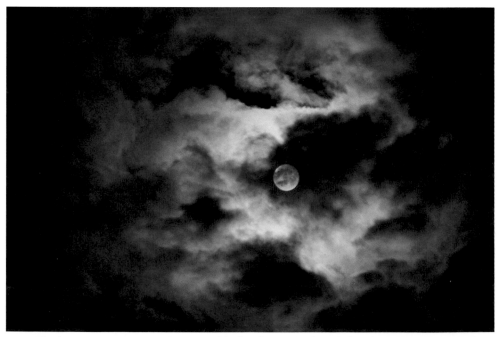

7.64 The harvest moon at Equinox provided a dramatic play of clouds across the moon in this image. The exposure was ISO 100, f/8, at 1.3 seconds using a Canon EF 70-200mm, f/2.8L IS USM lens set to 120mm.

Fog

Fog adds a sense of mystery and intrigue to a scene. Because the moisture in the air decreases sharpness, it enhances the soft, mysterious atmosphere of the image. Fog varies in color from light gray to almost white. Exposing fog scenes can be tricky; meter for the subject, and to ensure accurate color, try using a custom white balance.

Cross-Reference *Finding a custom white balance is a simple process of shooting a white object that fills the viewfinder, selecting the image so that its white balance data is imported, and then setting the camera for custom white balance. For more on setting a custom white balance, see Chapter 1.*

Snow

Regardless of where you live, the first snow of the season has a magical quality that brings almost everyone outdoors to enjoy it. Snow, like large expanses of dark water, fools the camera meter. To capture beautifully white snow, you can override the camera's tendency to underexpose the snow by setting a +1 to +2 exposure compensation.

Stormy skies

Huge, heavy, looming clouds with deep, rich colors are a favorite subject of photographers everywhere. When storm clouds begin forming, grab the Digital Rebel XTi/400D and head to your favorite shooting location with a wide-angle lens. Find a good foreground object and let the storm clouds lead the viewer's eye to the object.

Inspiration

Although weather can often be a stand-alone subject, photographing how the weather affects people, plants, and animals is a lot of fun. In rain scenes, look for people with umbrellas, wet animals, rain-beaded flora and fauna, or a farmer in a field looking up at the ominous clouds.

Also look for contrasts that underscore the weather. For example, you may find a pair of summer flip-flops frozen solidly to a deck, or rain collecting on cacti.

7.65 Sunny weather provides dramatic backlighting for this maple tree that is beginning to show fall color. The exposure was ISO 100, f/8, at 1/15 second using a Canon EF 24-105mm f/4.0L IS USM lens set to 92mm.

Taking weather and seasonal photographs

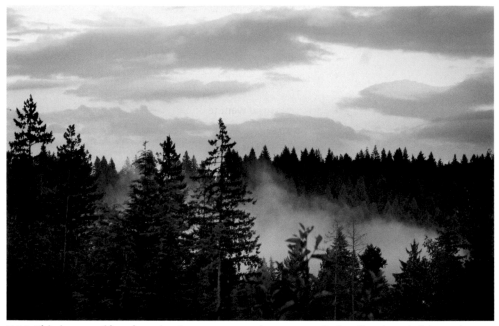

7.66 This image of low-hanging fog over a nearby community is offset by a bright early sunset sky.

Table 7.23
Weather and Seasonal Photography

Setup	**In the Field:** The image in figure 7.66 was captured from a second-story window. To compose the image, I wanted a diagonal line that followed the line of the fog, and so I included a series of foreground trees to create a diagonal direction.
	On Your Own: Watch the weather forecast to get a sense of when good weather photos might happen. Then watch the skies for dramatic cloud formations. Show images of how the weather affects people and buildings, as well as flora and fauna.
Lighting	**In the Field:** This image was taken in combination light that included a brighter sky with a shadowy foreground. During image editing, I had to use the Curves feature to equalize the differences between the bright sky and the dark foreground.
	On Your Own: Extremes in light characterize weather and seasonal photography and can provide priceless opportunities when shafts of light break through forested hillsides and fog-covered landscapes, and, of course, illuminate rainbows. Watch carefully for the best opportunities to capture scenes with spectacular light.

Lens	**In the Field:** Canon EF 100mm f/2.8 Macro USM lens.
	On Your Own: Your lens choice depends on the scene that you're shooting and your distance from it. Use a telephoto zoom lens to bring distant scenes closer, and a wide-angle lens to capture expansive scenes.
Camera Settings	**In the Field:** Aperture-priority AE mode. The white balance was set to auto (AWB).
	On Your Own: You want to control the depth of field, so choose Aperture-priority AE mode and set the white balance to the type of light in the scene.
Exposure	**In the Field:** ISO 100, f/8, 1/60 second.
	On Your Own: For most weather photos, an extensive depth of field is the ticket. Set the aperture at f/8 or f/11, and use a tripod if the shutter speed is slower than about 1/30 second. Because weather scenes change literally minute by minute, I often just grab the camera and shoot with whatever lens is on the camera.
Accessories	Having a tripod handy is a good idea for weather photos. Light can vary tremendously, and in lower light scenes, a tripod is necessary for slower shutter speeds.

Weather and seasonal photography tips

✦ **Use contrast to your benefit.** Take advantage of the extra-saturated color that overcast and rainy weather provides by including color-saturated flowers and foliage in your weather images.

✦ **Get the best color from your image.** To photograph a rainbow, set the Digital Rebel XTi/400D to ISO 100, press the AE Exposure Compensation button, and set a -1 to -1.5 compensation to deepen the colors.

✦ **Know your weather.** Veteran storm chasers and weather photographers emphasize the importance of learning as much as possible about weather and observing how the sun strikes different types of clouds.

✦ **Don't put the camera away when the weather clears.** Use the time after a rain shower to capture the sparkle on freshly washed streets and buildings.

Wedding Photography

Today's wedding photography runs the gamut from a photojournalistic shooting style to fashion shooting—all mixed with a little traditional portraiture for good measure. However, for wedding photographers, the goal of a wedding is to produce images that will stand on their own years from now as classic photographs.

These are lofty goals for photographers who are operating in a stressful environment compressed in a short time frame. Photography enthusiasts sometimes agree to shoot weddings for family and friends. It pays to know that even when shooting weddings as a favor, there is the potential for every heart-stopping disaster that can happen in photography, from malfunctioning gear to a missing or inebriated bride or groom and tense family disagreements. Whether you're an amateur or semi-pro, wedding photography is not for the faint-hearted.

Despite any wedding or equipment disasters, if you shoot a wedding for family or friends, it pays to put on a smiling face and roll with the flow. The bulk of wedding work happens after the wedding, in processing and editing the images and getting them to the couple.

©2006 Sandy Rippel

7.67 This image shows the happy couple just after the ceremony finished. The exposure for this image was ISO 100, f/10, at 1/200 second using a Canon EF-S 18-55mm lens set to 55mm.

Tip *If you are taking your camera to a wedding that is being photographed by a professional photographer, be sure to be considerate of the photographer. During the ceremony, keep your camera in your lap when the photographer is shooting near you or toward you. And wait until the photographer is finished shooting to take your pictures.*

Inspiration

Following the advice of top wedding photographers, think of making every wedding image strong—not just as a wedding image in the traditional sense, but also as a photograph. As with other specialty areas, think through what your style would be for wedding photography.

Think of how you can incorporate themes into the wedding that tie in with either decorations or the couple's interests.

7.68 Be sure to document the details of the wedding, such as table decorations, bouquets, and table favors. The exposure for this image was ISO 100, f/2.8, at 1/80 second using a Canon EF 25-70mm, f/2.8L USM lens set to 45mm.

Taking wedding photographs

7.69 Portraits such as this one of the bride and her maid of honor form a large part of the work in photographing a wedding.

<table>
<tr><td colspan="2" align="center">Table 7.24
Wedding Photography</td></tr>
<tr><td>**Setup**</td><td>**In the Field:** The image in figure 7.69 required finding an area with open shade to avoid getting deep shadows on the faces of the subjects. Posing should connect the subjects to help show their relationship and affection.</td></tr>
<tr><td></td><td>**On Your Own:** Before the ceremony begins, scout out shooting positions and leave something on a seat to reserve it. Some couples do not want the ceremony photographed, while others want it photographed but without the use of a flash. Be sure you know the couple's wishes and requirements before the ceremony begins.</td></tr>
<tr><td>**Lighting**</td><td>**In the Field:** Bright mid-afternoon sunlight was the rule of the day for this wedding, and so finding shade was difficult. Shade helps to avoid the subjects squinting in the bright sun, and it provides a much better quality of light for portraits.</td></tr>
<tr><td></td><td>**On Your Own:** If possible, work with the bride and bridal consultant during the early planning stages to plan where the wedding party will stand — for example, in an outdoor venue — so that the light is optimal for images.</td></tr>
</table>

Lens	**In the Field:** Canon EF 24-105mm f/4.0L IS USM set to 67mm.
	On Your Own: Your lens choice depends on the scene that you're shooting and your distance from it. Use a telephoto zoom lens to bring distant scenes closer, and a wide-angle lens to capture expansive scenes.
Camera Settings	**In the Field:** RAW capture, Aperture-priority AE mode.
	On Your Own: You want to control the depth of field, and so you can choose Aperture-priority AE mode and set the white balance to the type of light in the scene.
Exposure	**In the Field:** ISO 100, f/6.7, 1/320 second.
	On Your Own: In most wedding venues, sections of the wedding such as the ceremony, the dinner, and the dance occur in lighting that is consistent for the duration of the event. As a result, you can often set and use a custom white balance throughout the event as long as the light doesn't change.
Accessories	Having a tripod handy is a good idea for wedding photos, but a tripod limits your ability to move quickly, and it requires more shooting space that may not be readily available. A monopod is another good option.

Wedding photography tips

✦ **Look at the big picture, and understand what you are getting into.** Take wedding photography very seriously. In many ways, this is the most important day of someone's life.

✦ **Always have backup gear.** Most professional wedding photographers not only carry two camera bodies as they work, but also duplicates of critical pieces of equipment so that they can keep shooting, regardless of breakdowns. Renting spare camera bodies, lenses, flash units, and tripods is often the most economical strategy.

✦ **Plan for the worst.** Ask exhaustive questions ahead of time, such as whether the church or location allows flash or whether the couple wants flash for certain parts of the wedding festivities. If the wedding is outdoors, ask what alternate location the couple will use if the weather turns bad, and plan for lighting in both locations. The list of questions is almost endless, but pre-planning will help to ensure success on the day of the ceremony.

✦ **Hone your amateur psychologist skills.** You may need to be a good amateur psychologist as well as a good photographer, especially when dealing with disgruntled or divorced parents or an unhappy bride.

Downloading and Editing Pictures

✦ ✦ ✦ ✦

In This Chapter

Downloading with a USB cable

Downloading with a card reader

Downloading with a PCMCIA card

Converting RAW images

Editing images

Updating firmware and software

✦ ✦ ✦ ✦

Downloading digital images has come a long way in the past few years. Rather than crawling behind the computer to hook up cables, you can now use the USB cable that is supplied with your camera, or you can use an accessory card reader or PCMCIA (Personal Computer Memory Card International Association) card. Also, with direct-printing capability, you can print images directly from a memory card.

If you capture RAW images, you have a lot of latitude in processing them using either Canon's Digital Photo Professional program or Adobe's Camera Raw conversion program to tweak the original exposure, white balance, picture style, and more. When the image-editing cycle is complete, you can back up images to secure media for long-term storage.

Downloading with a USB Cable

Downloading using a USB cable is as simple as connecting the camera and the computer using a USB cable. The computer recognizes the camera as a removable drive. Because you must turn the camera on during download, you should ensure that the battery charge is sufficient to complete the download without interruption.

Note *If you're using a Mac, you see the Digital Rebel XTi/400D as a Digital Capture that can be imported.*

Organize and Back Up Images

One of the most important steps in digital photography is establishing a coherent folder system for organizing images on your computer. With digital photography, your collection of images will grow quickly, and a well-planned filing structure helps to ensure that you can find specific images months or even years from now.

Another good practice is to add keywords to image files. Some programs allow you to display and search for images by keyword — a feature that can save you a lot of time as you acquire more and more images.

The most important step is to back up images on a CD or DVD regularly. Many photographers make it a habit to burn a backup disc right after downloading pictures to the computer. Also, as with images on the computer, it's a good idea to have a filing system for your backup discs as well.

Canon provides programs for downloading and organizing images. Other programs are available for these tasks, but for this chapter, I use the Canon programs in the examples.

 Cross-Reference *For details on choosing JPEG or RAW capture options, see Chapter 1.*

Before you begin downloading images, be sure that the camera battery has a full charge. Then follow these steps to download pictures to your computer:

1. **Install the Canon EOS Digital Solution disk programs on your computer.**

2. **With the camera turned off, insert the camera's USB cable into an available USB slot on your computer.**

3. **Insert the other end of the USB cable into the Digital terminal located on the side of the camera, and then turn on the camera.** If Windows displays a Found New Hardware Wizard dialog box, click Cancel.

4. **If Windows asks you to select a program to launch the action, click EOS Utility, click Always use this program for this action, and then click OK.** The EOS Utility window appears on the computer screen, and the Direct Transfer screen appears on the camera's LCD monitor.

5. **Select the All images option on the camera, and then press the Print/Share button on the back of the camera.** The Save File screen appears. The blue Print/Share light blinks as the images transfer to your computer. When the transfer is complete, the ZoomBrowser EX screen appears on the computer with all of the transferred images selected.

 If you don't want to transfer all of the images on the card, you can also choose these transfer options:

 • **Only new images.** The camera automatically chooses the images to transfer.

- **Choose a transfer order.** To use this option, select the Playback menu on the camera. Select Transfer order, and then press the Set button. The Transfer order screen appears. Select Order, and then press Set. An image appears. Press the left and right cross keys to select an image and place a checkmark in the upper-left area of the image. Repeat this process for all of the images that you want to transfer. Press the Menu button twice to save your image selections to the CF card. The Menu screen displays.

- **Select images one-by-one to transfer.** Press the left or right cross key to select individual images.

6. **Choose the task that you want from the options in the left panel or on the toolbar in ZoomBrowser EX.** You can rotate, delete, zoom and scroll, view images as a slide show, stitch photos together for a panorama, send an image in e-mail, and lay out and print images in the ZoomBrowser EX dialog box.

7. **To edit images, click an image, click Edit, and then click Edit Image.**

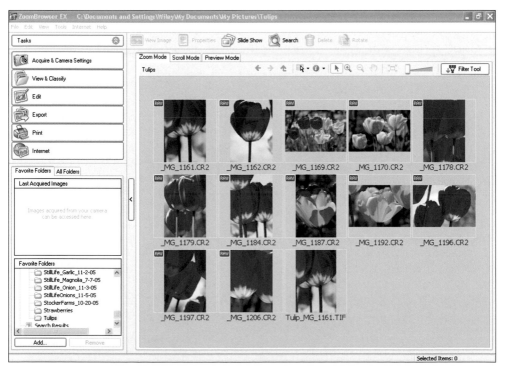

8.1 Canon's ZoomBrowser EX (for Windows) displays both JPEG and RAW images and includes tools for basic image-handling tasks. ImageBrowser is the comparable program for Mac computers.

Viewing and Organizing Programs

The Canon File Viewer Utility and ZoomBrowser EX are capable programs for viewing and arranging images. They also have the advantage of coming at no additional cost. However, you may want to consider other programs such as ACDSee (www.acdsystems.com) for viewing, managing, and performing batch operations on both JPEG and RAW images.

8. **Click one of the editing options on the Pick Editor screen.**

9. **Click Finish when you complete the editing of the image.**

10. **Click Save As, select the folder, and then type a filename for the image.** The Save As dialog box displays the filename that the camera has assigned. You can prepend the original filename or replace it by typing over it.

11. **Drag the Quality slider to set the quality that you want to use to save the image.**

12. **Click Save.** The ZoomBrowser EX window displays so that you can edit the next image.

13. **Turn off the camera, and then disconnect it from the computer.**

Downloading with a Card Reader

By far, the easiest way to download images is by using a card reader. A card reader is a small device that plugs into the computer with its own USB cable. When you're ready to download images, you insert the media card into the corresponding card-reader slot.

You can leave the card reader plugged into the computer indefinitely, making it a handy way to download images. Also, with a card reader, you don't have to use the camera battery while you download images.

Card readers come in single and multiple card styles. Multiple-card-style readers accept CompactFlash (CF) and other media card types. Card readers are inexpensive and virtually indestructible, and have a small footprint on the desktop. All in all, they are a bargain for the convenience that they offer.

After installing the card reader according to manufacturer recommendations, follow these steps to download images:

Note The steps may vary slightly depending on your card reader and computer's preferences.

1. **Remove the CF card from the camera, and insert it into the card reader with the holes on one long edge facing into the slot.** Push the card into the reader until it seats. Do not force it. A window opens, displaying the CF card folder.

Note If a window does not appear, then on the Windows desktop, double-click the My Computer icon. In the list of Devices with Removable Storage, double-click the icon for the CF card. The card reader appears in the list as a Removable Disk.

2. **Double-click the folder to display the images, select all of the images, and drag them to the folder where you want to store them.** You can also drag the entire folder to your computer's hard drive, or drag individual image files to various existing folders.

Tip

You can also upload edited or unedited images or directories. Drag and drop files to the card-reader icon. You can do the same with any browser, such as the one in Photoshop Elements. You can then take the card to any business that has a self-service printer that accepts CF cards. Only JPEG images are accepted.

Downloading with a PCMCIA Card

If you're traveling and you use a laptop computer, an easy solution for downloading images is to use a PCMCIA card. About the size of a credit card, the PCMCIA card fits into an available PC card slot on your laptop, and the CF card fits into the PCMCIA card. Be sure to look for a PCMCIA card that accommodates CF cards and/or microdrives.

If you are a laptop user, the advantages of a PCMCIA card make it well worth the small investment. However, some laptop computers have built-in CF card slots, which make a PCMCIA card unnecessary. In either case, the process of downloading is the same as with the card reader.

Converting RAW Images

A RAW image is unprocessed data that comes directly from the image sensor with minimal internal camera processing. While the settings that you used for exposure and white balance are recorded, they are not made permanent until you convert the image in a conversion program on your computer, and then save the image in TIFF or JPEG format. In fact, you can re-process RAW files months or years from now as upgrades to conversion programs are released, thereby potentially improving your image.

Cross-Reference

For more details about JPEG and RAW file formats, see Chapter 1.

Capturing images in RAW format is like getting a second chance to correct important settings such as the exposure compensation, white balance, and contrast — just as if you made the adjustments on your camera. Also, unlike working in JPEG format, RAW offers the opportunity to work at full resolution and in 16 bits per channel — which offers more color information than 8-bit images — to make adjustments with no degradation to the image.

On the EOS Digital Solution disk, Canon provides the Digital Photo Professional program for converting RAW files. Although RAW image conversion adds a step to the processing workflow, this important step is well worth the time spent processing images. To illustrate the process, here is a general overview of how you would use Digital Photo Professional to convert a RAW Digital Rebel XTi/400D image:

1. **Start Digital Photo Professional.**
The program opens with the
images in the currently selected
folder displayed. RAW images are
marked with a camera icon and
the word RAW in the lower-left
area of the thumbnail. On the right
side of the window, you can select
a different directory and folder.

2. **Double-click the image that you
want to process.** The RAW image
adjustment tool palette opens to
the right of the image preview. In
this mode, you can:

 • **Drag the Brightness slider to
 tweak the exposure to a neg-
 ative or positive setting.**

 • **Use the White-balance
 adjustment controls to adjust
 color.** You can click the Click
 button, and then click an area
 that is white in the image to set
 white balance, choose one of
 the preset white-balance set-
 tings from the Shot Setting
 drop-down menu, or click the
 Tune button to adjust the white
 balance using a color wheel.

 • **Choose a different Picture
 Style.** Click the drop-down
 arrow next to Standard and
 select a Picture Style from the
 list. The Picture Styles are the
 same as those offered on the
 menu on the Digital Rebel
 XTi/400D. When you change
 the Picture Style in Digital
 Photo Professional, the thumb-
 nail updates to show the
 change. You can adjust the
 curve, color tone, saturation,
 and sharpness. If you don't like
 the results, you can click Reset
 to change back to the original
 Picture Style.

 • **Adjust the black and white
 points on the image his-
 togram.** Drag the bars at the
 far left and right of the his-
 togram toward the center. By
 dragging the slider under the
 histogram, you can adjust the
 tonal curve. To set a Linear
 curve, you can select the Linear
 option, although I don't recom-
 mend using this adjustment
 because you cannot make fur-
 ther curve adjustments.

 • **Adjust the Color tone, Color
 saturation, and Sharpness.**
 Drag the sliders to adjust these
 settings. Dragging the Color
 tone slider to the right
 increases the green tone, and
 dragging it to the left increases
 the magenta tone. Dragging the
 Color saturation slider to the
 right increases the saturation,
 and vice versa. Dragging the
 Sharpness slider to the right
 increases the sharpness.

3. **Click the RGB image adjustment
tab.** Here you can apply a more
traditional RGB curve and apply
separate curves in each of the
three color channels, Red, Green,
and Blue. You can also adjust the
following:

 • **Drag the Brightness slider to
 the left to darken the image
 or to the right to brighten
 the image.** The changes that
 you make are shown on the
 RGB histogram as you make
 them.

 • **Drag the Contrast slider to
 the left to decrease contrast
 or to the right to increase
 contrast.**

- **Drag the Color tone, Color saturation, and Sharpness sliders to make the appropriate adjustments.**

4. **In the preview window, choose File ➪ Convert and save...** The Save As dialog box appears. In the Save As dialog box, you can set the bit-depth at which you want to save the image, set the Output resolution, choose to embed the color profile, or resize the image.

 Note The File menu also enables you to save the current image's conversion settings as a recipe. You can then apply the recipe to other images in the folder.

5. **Click Save.** The Digital Photo Professional dialog box displays until the file is converted. Digital Photo Professional saves the image in the location and format that you choose.

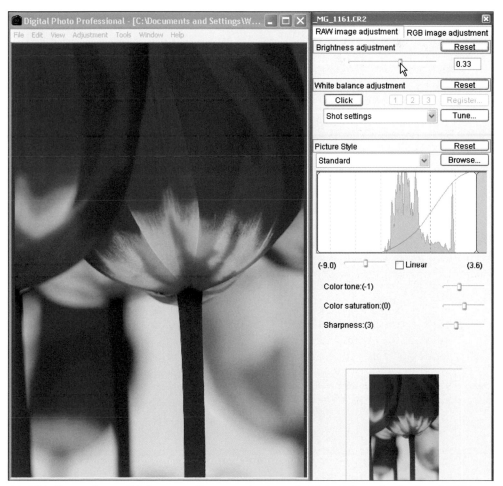

8.2 This figure shows Brightness adjustment in Canon's Digital Photo Professional RAW conversion window.

Editing Images

Whether you capture images in JPEG format or RAW, there are very few images that you cannot improve with at least some basic image editing. During the editing process, it's a good idea to follow a sequence of steps, or an editing workflow. The workflow not only helps to preserve and enhance image data, but it saves you time overall.

Tip *Good image correction begins with a properly calibrated monitor. Many devices are available in a range of prices to calibrate your monitor, or you can use the calibration wizard that Adobe includes with its products.*

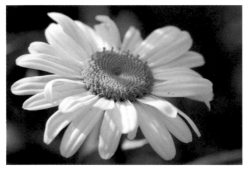

8.3 This is a JPEG capture from the Digital Rebel XTi/400D with a slight crop. The contrast and color are excellent, but with a little editing, the image can be improved. The exposure for this image was ISO 100, f/5.6 at 1/400 second.

Note *While it is beyond the scope of this book to provide step-by-step instructions for Photoshop Elements or Photoshop CS, you can access the Help menu of both programs to get detailed instructions.*

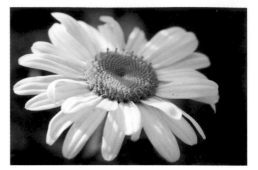

8.4 This is the edited image. I increased the contrast with a slight S curve, and I burned in some highlight areas around the edges of the frame so that they are not a visual distraction. I also sharpened the image slightly for printing.

What follows is a basic, sample workflow for editing images. You can follow this work-flow using either Adobe Photoshop Elements or Photoshop CS. Each step builds on the previous step. Of course, you can modify or rearrange the steps, but it's a good idea to establish a standard editing process that helps to ensure that you do not overlook steps and that you get the best possible results from your images.

✦ **Process, convert, and save a copy of the RAW images in TIFF or JPEG format.**

✦ **Adjust the tonal range of the image.** To adjust overall tonal levels, use the Levels command in Photoshop Elements or Photoshop CS. In the Levels dialog box, move the black-and-white point sliders inward to where the image data is higher than one pixel per tonal level, and then move the midpoint to the left or right to lighten or darken the image.

Improving Images with Curves

If you're using Photoshop CS2 or a later version, set a gentle S-shaped curve using the Curves command. The curve adds punch to the overall image by brightening highlights and midtones and darkening shadows slightly. Use the Curves command to nudge up image contrast, but avoid using it as a hammer to impose dramatic changes.

This image shows a slight S curve that I have set in the Curves dialog box in Photoshop.

✦ **Color-correct the image.** In the Curves or Levels dialog box, click the white and black points in the image using the eyedropper tools, and set the midtone (the middle eyedropper icon) by clicking an area in the image that should be midgray. If you set the midtone in the RAW conversion program, you don't need to repeat that step here.

✦ **Straighten the image.** If the horizon is tilted, or if lens distortion makes objects appear to fall toward the center of the image, you can use the Measure tool or Free Transform command to straighten horizontal and vertical lines in the image.

✦ **Crop the image.** Cropping the image eliminates areas that do not complement the composition or that are distracting. It's best to use the Crop tool judiciously because each crop results in a smaller image, and the smaller the image, the smaller the enlargement that you can print from it. This fact alone is reason enough to frame images carefully as you shoot.

✦ **Correct imperfections.** Spots or blotches on an image usually indicates dust on the image sensor. You can make quick work of some spotting tasks by converting the image to LAB mode and using the Dust and Scratches command on the A and B channels. For remaining spots, you can use the Healing Brush or Clone Stamp tool to clean up the image.

✦ **Dodge and burn selected areas of the image.** Dodge and burn are techniques that are used in a chemical darkroom to lighten or darken areas of an image, respectively. Similar tools are available in Adobe Photoshop programs. However, rather than using the Dodge and Burn tools, you can use the Levels command to lighten or darken the entire image, and then use the History brush to paint in the darker or lighter effect.

✦ **Convert the image to 8 bits per channel, if necessary.** If you want to save a copy of the image in JPEG format to post on a Web site or share with friends, you have to convert the image to 8-bit mode before saving a copy in JPEG format. You can only save sixteen-bit images as TIFFs or in Photoshop format. In Photoshop CS, the Mode command on the Image menu offers the 8 bits/Channel command.

✦ **For print or Web use, make a copy of the image.** Once you copy it, you can size it for printing or Web use as needed. Web images should be saved in JPEG format before sizing them.

✦ **Sharpen the image.** If you are preparing an image for printing or the Web, use the Unsharp Mask command to tweak image sharpness.

Note *I don't recommend using the Brightness and Contrast command because it can over-compress highlight and shadow values — a process that often results in a loss of image detail.*

Color Correction Values

Setting the white, midtone, and shadow target values in Photoshop helps to ensure consistent color correction. In the Levels dialog box, you can double-click each of the eyedropper icons and reset the default values. To display the Color Picker dialog box, double-click the black eyedropper icon. In the dialog box, you can type values for Red, Green, and Blue (RGB). Many photographers recommend resetting the RGB values as follows: White (R 240, G 240, B 240), Midtone (R 128, G 128, B 128), and Black (R 20, G 20, B 20).

When you exit the dialog box, you have the option to save the values as the default. If you click Yes to save the values as the defaults, then they are used until you change them again.

Updating Firmware and Software

One of the greatest advantages of owning a digital camera such as the EOS Digital Rebel XTi/400D is that Canon often posts updates to the firmware (the internal instructions) for the camera to its Web site. New firmware releases can add improved functionality to existing features and, in some cases, fix reported problems with the camera.

New firmware, along with ever-improving software, keeps your camera and your ability to process images current as technology improves. To determine if you need to update firmware, you can compare the firmware version number that is installed on your EOS Digital Rebel XTi/400D to the latest release from Canon on their Web site.

To check the current firmware version that is installed on your camera, follow these steps:

1. **Press the Menu button.**

2. **Press the Jump button to access the Tools 2 menu.**

3. **Rotate the Quick Control dial until you see the Firmware Ver., and then write down the number.** If the installed firmware is the same as or newer than the firmware that is available on the Web site, then you do not need to update the firmware, and the procedure for updating the firmware will not work.

You can download the latest version of firmware from the Canon Japan Web site. At the time of this writing, the Web site link has not yet been posted. You can check www.robgalbraith.com and search the

Camera Firmware Links on the far-right side of the home screen for a link to the latest firmware updates.

Before installing firmware updates, be sure that the camera battery has a full charge. You don't want the camera to lose power during the firmware update because it can cause the camera to become inoperable. You should also have a freshly formatted CompactFlash card available on which to copy the firmware update.

To download firmware updates and install them on the Digital Rebel XTi/400D, follow these steps:

1. **Insert the CF card in a card reader that is attached to your computer.**

2. **On the Canon Web page, read the instructions, scroll down to the License Agreement, click I agree, and then download the firmware.**

3. **Click the link under Files for Firmware Update that matches your computer's operating system, either Windows or Mac OS.**

4. **Click Save, and then navigate to the location on your computer for the CF card.**

5. **Click Save.** A Save window appears and shows the download progress.

6. **Navigate to the CF card location, and then double-click the .exe file to extract the firmware.** A Self-Extracting Archive window appears.

7. **Click OK.** A progress window appears. The firmware file with a .fir extension appears on the CF card.

8. **Insert the CF card into the camera.**

9. **Press the Menu button, and then select the Tools 2 menu.**

10. **Press the down cross key and select Firmware Ver., and then press the Set button.** The Firmware update screen appears.

11. **Press the right cross key to select OK.** The Firmware update screen appears with a progress bar. Do not turn off the power switch or touch any other camera buttons during the update process.

12. **Press the Set button to complete the firmware update.**

13. **Turn off the power switch, and then reload the battery.** You can verify that the new firmware is updated by repeating the first procedure in this section.

Note
> *You can format the card after the firmware is updated on the camera. You may also want to keep a copy of the firmware on your computer, in the event you ever want or need to reinstall or revert to this version of the firmware.*

You can also download new versions of Canon image-viewing and processing software from the Canon Web site. It's a good idea to check the Web site every month or so for new updates.

Appendixes

P A R T

♦ ♦ ♦ ♦

In This Part

Appendix A
Custom Functions

Appendix B
Internet Resources

Glossary

♦ ♦ ♦ ♦

Custom Functions

Custom Functions enable you to customize camera controls and operation to better suit your shooting style and to save you time. Once you set a Custom Function option, it remains in effect until you change it. Some Custom Functions are useful for everyday shooting, while others are for specific situations. For example, C.Fn-2: Long exp. noise reduction detects noise in long-exposure images and takes a second image to subtract out noise from the image.

 Note Canon refers to Custom Functions by using the abbreviation C.Fn-[number].

The EOS Digital Rebel XTi/400D offers 11 Custom Functions. You should carefully evaluate each function before changing it.

Changing a Custom Function

To change a Custom Function, follow these steps:

1. **Press the Menu button and select the Tools 2 tab.**
2. **Press the down cross key to select Custom Functions (C.Fn).**
3. **Press the Set button.** The Custom Function screen appears.
4. **Press the left or right cross key to select the Custom Function number that you want to change.**
5. **Press the Set button.**
6. **Press the up or down cross key to select the Custom Function option number.**

7. Repeat steps 4 through 6 to change other Custom Functions. The new Custom Function settings remain in effect until you change them.

8. When you're finished, press the Menu button to return to the menu.

Custom Functions and Options

The EOS Digital Rebel XTi/400D offers the following Custom Functions:

C.Fn-1: SET button/Cross keys funct. Allows you to change the function of the SET button and cross keys.

0: SET: Picture Style. Allows you to press the Set button to display the Picture Style options. When the menu displays, you can use it to select a Picture Style.

1: SET: Quality. Allows you to press the Set button to display the recording quality menu so that you can change the image quality setting.

2: SET: Flash exp comp. Allows you to press the Set button to display the flash exposure menu so that you can change the flash exposure compensation setting.

3: SET: Playback. Allows you to press the Set button to playback images on the CF card. The same function is also assigned to the right cross key.

4: Cross keys: AF frame selec. Allows you to press the Shutter button halfway and then press the cross keys to assign an autofocus point. Because the AF point selection screen is not displayed, you select the AF point while looking at the AF point selection display. To set automatic AF point selection, press the AF point selection/Enlarge button. To select the center AF point, press the Set button.

To change the ISO or other functions that are assigned to the cross keys, press the cross keys while the shutter speed and aperture are not displayed. If you press the button while the shutter speed and aperture are displayed, the setting screen does not appear.

C.Fn-2: Long exp. noise reduction. Allows you to turn noise reduction on or off for exposures of one second or longer.

0: Off. Turns long-exposure noise reduction off.

1: Auto. Automatically applies noise reduction for exposures of one second or longer, and applies noise reduction automatically if noise is detected. This setting is effective in most cases.

2: On. Performs noise reduction for all exposures of one second or longer. This option may reduce noise even for exposures where noise would not have been detected when using the Auto option. After you take a picture, the noise reduction process takes the same amount of time that the exposure took. You can't take more pictures until the noise reduction process is completed.

C.Fn-3: Flash sync speed in Av (Aperture-priority AE) mode. Enables you to set a faster flash-sync speed.

0: Auto. The flash-sync speed is automatically set to between 30 seconds and 1/200 second, depending on the scene brightness.

1: 1/200 sec. (fixed). Sets the flash-sync speed to 1/200 second in Aperture-priority AE mode. The faster sync speed in low or night light allows the background to go dark.

C.Fn-4: Shutter/AE Lock button. Changes the function of the AF/AE Lock button.

0: AF/AE lock. Default operation for the focus point so that both metering and autofocus are tied to the autofocus point.

1: AE lock/AF. Allows you to focus and meter separately. You press the AF/AE Lock button to focus, and then press the Shutter button halfway to lock exposure (AE).

2: AF/AF lock, no AE lock. In AI Servo AF mode, pressing the AF/AE Lock button momentarily stops auto-focusing to prevent the focus from being thrown off by an object that is passing between the lens and the subject. The camera sets exposure at the moment you take the picture.

3: AE/AF, no AE lock. In AI Servo AF mode, pressing the AF/AE Lock button starts and stops the continuous autofocus operation, and is handy for subjects that start moving and then stop. With this option set, the focus and exposure are theoretically at the optimum point because the exposure is set the moment that you take the image.

C.Fn-5: AF-assist beam. Controls whether or not the autofocus assist light is used by either the built-in flash or by an accessory Speedlite.

0: Emits. Both the built-in flash and an accessory Speedlite use the beam to establish focus.

1: Does not emit. Neither the built-in flash nor an accessory Speedlite uses the beam to establish focus.

2: Only external flash emits. The built-in flash does not use the AF-assist light, but an accessory Speedlite does use the light when necessary, provided that the Speedlite's AF-assist beam Custom Function is not set to Disabled.

C.Fn-6: Exposure level increments. Allows you to set the amount to use for shutter speed, aperture, exposure compensation, Auto Exposure Bracketing, etc.

0: 1/3-stop. Sets 1/3 stop as the exposure increment for shutter speed, aperture, exposure compensation, and Auto Exposure Bracketing changes.

1: 1/2-stop. Sets 1/2 stop as the exposure increment for shutter speed, aperture, exposure compensation, and Auto Exposure Bracketing changes.

C.Fn-7: Mirror lockup. Allows the camera's reflex mirror to be locked up or not.

0: Disable. The mirror cannot be locked up.

1: Enable. By locking up the mirror, you can avoid camera shake from the mirror's reflex action during long exposures. Lock-up also avoids the mirror slap that can blur images taken with a telephoto lens. Mirror lockup is also used for manual image sensor cleaning.

C.Fn-8: E-TTL II. Allows you to choose evaluative or average flash metering for an external Canon Speedlite.

0: Evaluative. Allows automatic flash for all types of light.

1: Average. An advanced option for photographers who want to control an external Canon Speedlite. The function averages the entire flash metering area. Exposure compensation that is set on the camera is not executed, and so you must use flash exposure compensation.

C.Fn-9: Shutter curtain sync. Determines whether the flash fires at the beginning or end of an exposure.

0: 1st-curtain sync. The flash fires after the shot is exposed.

1: 2nd-curtain sync. The flash fires just before the exposure ends. You can use this option to create a light trail that follows subjects such as cars at night.

C.Fn-10: Magnified view. Allows you to display playback images at a magnified view during either playback or review and playback.

0: Image playback only. Plays back images at normal display size.

1: Image review and playback. Hold down the Print/Share button and press the Enlarge button to see a magnified view during image review right after shooting. You can magnify and reduce the display by pressing the Enlarge and Reduce buttons. To magnify the playback image with the right cross key, press the Enlarge button.

C.Fn-11: LCD display when power ON. Allows you to specify whether the LCD displays camera settings when the camera is turned on.

0: Display. Displays the camera settings.

1: Retain power OFF status. When you press the DISP button to turn off the LCD, and then turn off the camera, to save battery power, the LCD will not turn on when you turn the camera on again. You can still display the cross key shortcut menus by pressing the keys, and other menu screens and image playback also appear. If you press the DISP button to turn off the LCD, and then you turn the camera off, the LCD turns on when you turn the camera on again.

Internet Resources

A wealth of valuable information is available for photographers. This section is a handy resource to help you discover some of the many ways to learn more about both the EOS Digital Rebel XTi/400D and about photography.

Canon

If you want to access the technical specifications for your camera, register your camera online, learn more about your camera, explore new lenses, or get the latest firmware, visit the Canon Web site.

EOS SLR

To learn more about the EOS SLR systems, you can visit the Canon Advantage page at www.consumer.usa.canon.com/ir/controller?act=CanonAdvantageCatIndexAct&fcategoryid=111.

Firmware

To download new firmware updates for the EOS Digital Rebel XTi/400D, see the section on firmware in Chapter 8. On the Canon Web site, the Download Library includes an option to download the setup guide and camera manual in English, Spanish, French, or Chinese.

Accessories

When you want accessories for the EOS Digital Rebel XTi/400D, the Canon Accessory Annex offers everything, including AC adapters, battery grips, battery packs, and macro ring lights. You can find the Accessory Annex at www.estore.usa.canon.com/default.asp.

Lenses

You can find information about Canon lenses at www.consumer.usa.canon.com/ir/controller?act=ProductCatIndexAct&fcategoryid=111.

Photography Publications and Web Sites

Some of the popular photography magazines also have Web sites that offer photography articles. Here are a few of the venerable photography magazines' Web sites.

✦ *Photo District News:*
 www.pdnonline.com

✦ *Communication Arts:*
 www.commarts.com/ca

✦ *Digital Photo Pro:*
 www.digitalphotopro.com

✦ *Popular Photography & Imaging:* www.popphoto.com

✦ *Shutterbug:*
 www.shutterbug.net

✦ *Digital Image Café:*
 www.digitalimagecafe.com

✦ *PC Photo:* www.pcphotomag.com

✦ *Digital Photographer:*
 www.digiphotomag.com

✦ *Outdoor Photographer:*
 www.outdoorphotographer.com

Photography Workshops

A variety of workshops offer training for photographers. Here is a selection of some workshops.

Anderson Ranch Arts Center

www.andersonranch.org

Ansel Adams Gallery Workshops

www.anseladams.com

BetterPhoto

www.betterphoto.com

Brooks Institute Weekend Workshops

http://workshops.brooks.edu

Eddie Adams Workshop

www.eddieadamsworkshop.com

The Workshops

www.theworkshops.com

Mentor Series

www.mentorseries.com

Missouri Photo Workshop

www.mophotoworkshop.org

Mountain Workshops

www.mountainworkshops.org

Palm Beach Photographic Centre Workshops

www.workshop.org

Photography at the Summit

www.richclarkson.com

www.photographyatthesummit.com

Rocky Mountain Photo Adventures

www.rockymountainphotoadventures.com

Santa Fe Workshops

www.santafeworkshops.com

Toscana Photographic Workshop

www.tpw.it

Woodstock Photography Workshops (The Center for Photography at Woodstock)

www.cpw.org

Glossary

If you're new to the language of digital photography, this list of commonly used terms should be helpful.

A-DEP (Automatic Depth of Field AE) The camera mode that automatically calculates sufficient depth of field for near and far subjects within the coverage of the nine AF focusing points, such as when several people are sitting at various distances from the camera.

AE Automatic exposure.

AE lock Automatic exposure lock. This is a camera control that lets you lock the exposure from a meter reading. After the exposure is locked, the photographer can then recompose the image.

AF lock Autofocus lock. This is a camera control that locks the focus on a subject and allows you to recompose the image without the focus changing. You can usually activate this feature by pressing the Shutter button halfway down.

Ambient light The natural or artificial light within a scene. This is also called available light.

Angle of view The amount or area seen by a lens or viewfinder, measured in degrees. Shorter or wide-angle lenses and zoom settings have a greater angle of view, while longer or telephoto lenses and zoom settings have a narrower angle of view.

Aperture The lens opening through which light passes. Aperture size is adjusted by opening or closing the diaphragm. Aperture is expressed in f/numbers such as f/8, f/5.6, and so on. See also *F-number*.

Aperture priority (Av Aperture-priority AE) A semiautomatic camera mode in which you set the aperture (f-stop), and the camera automatically sets the shutter speed for correct exposure. See also *Av*.

Artifact An unintentional or unwanted element in an image caused by an imaging device, or as a by-product of software processing such as compression. Artifacts can include flaws from compression, color flecks, and digital noise.

Artificial light The light from an electric light or flash unit. This is the opposite of natural light.

Assigning a profile Refers to attaching a specific color space or space profile to an image. The profile translates the color numbers of an image and assigns them to specific colors in the profile. Different profiles are used for different devices, such as display and output devices. For example, sRGB is the profile of choice for electronic display devices, including monitors, whereas Adobe RGB is preferred for print output devices.

Autofocus The camera automatically focuses on the subject using the selected autofocus point shown in the viewfinder, or tracks a subject in motion and creates a picture with the subject in sharp focus. Pressing the Shutter button halfway down activates autofocus.

Automatic exposure The camera meters the light in the scene and automatically sets the shutter speed, ISO, and aperture necessary to make a properly exposed picture.

Automatic flash When the camera determines that the existing light is too low to get either a good exposure or a sharp image, it automatically fires the built-in flash unit.

Av Abbreviation for Aperture Value. It is also used to indicate Aperture-priority mode. See also *Aperture priority (Av Aperture-priority AE)*.

Backlighting Light that is behind, or pointing to the back of, the subject.

Barrel distortion A lens aberration resulting in a bowing of straight lines outward from the center.

Bit The smallest unit of information used by computers.

Bit depth The number of bits used to represent each pixel in an image that determines the image's color and tonal range.

Blocked up A term for shadow areas in an image that lack detail due to excess contrast.

Blooming Bright edges or halos in digital images around light sources, and bright reflections caused by an oversaturation of image-sensor photosites.

Bounce light Light that is directed toward an object, such as a wall or ceiling, so that it reflects (or bounces) light back onto the subject.

Bracket To make multiple exposures, some above and some below the average exposure calculated by the light meter for the scene. Some digital cameras can also bracket white balance to produce variations from the average white balance calculated by the camera.

Brightness The perception of the light reflected or emitted by a source; the lightness of an object or image. See also *Lightness* and *Luminance.*

Buffer Temporary storage for data in a camera or computer.

Bulb A shutter-speed setting that keeps the shutter open as long as the Shutter button is fully depressed.

Burn A traditional darkroom technique for making an area of an image darker by giving

it more exposure (or light). Image-editing programs have adapted the technique to achieve the same effect, which is also called burning in.

Calibration In hardware, a method of changing the behavior of a device to match established standards, such as changing the contrast and brightness on a monitor. Calibration should occur before a device is profiled, to reduce the amount of compensation that the profile must include for the device. In software, calibration corrects the color cast in shadows and allows adjustment of non-neutral colors that differ between an individual camera and the camera's profile used by Adobe's Camera Raw, for example.

Camera profile A process of describing and saving the colors that a specific digital camera produces so that colors can be corrected by assigning the camera profile to an image. Camera profiles are especially useful for photographers who often shoot under the same lighting conditions, such as in a studio.

Chroma noise Extraneous, unwanted color artifacts in an image.

Chromatic aberration A lens phenomenon that bends different-colored light rays at different angles, thereby focusing them on different planes. Two types of chromatic aberration exist: Axial chromatic aberration shows up as color blur or flare, and Chromatic difference of magnification appears as color fringing, where high-contrast edges show a line of color along their borders. The effect of chromatic aberration increases at longer focal lengths.

Cloning In image-editing programs, the process of replacing part of an image by copying another area of the image over it. This technique is often used to remove or add objects from or to a digital image, or to cover dust spots and other image imperfections.

CMOS (Complementary Metal-Oxide Semiconductor) The type of imaging sensor used in Digital Rebel XTi/400D to record images. CMOS sensors are chips that use power more efficiently than other types of recording media.

Color balance The color reproduction fidelity of a digital camera's image sensor. In a digital camera, color balance is achieved by setting the white balance to match the scene's primary light source. You can adjust color balance in image-editing programs using the color Temperature and Tint controls.

Color cast The presence of one color in other colors of an image. A color cast appears as an incorrect overall color shift, and is often caused by an incorrect white-balance setting.

Color space In the spectrum of colors, the subset of colors included in the specific space or range. Different color spaces include more or fewer colors. Commonly used color spaces include sRGB and Adobe RGB.

Color temperature A numerical description of the color of light, measured in Kelvin. Warm, late-day light has a lower color temperature, whereas cool, early-day light has a higher temperature. Midday light is often considered to be white light (5,000 K), and flash units are often calibrated to 5,000 K. See also *Kelvin*.

Compositing The process of combining all or part of two or more digital images into a single image. Compositing is performed using an image-editing program.

Compression A means of reducing file size. *Lossy* compression permanently discards information from the original file. *Lossless* compression does not discard information from the original file, creating an original file without any data loss.

Contrast The range of tones from light to dark in an image or scene.

Contrasty A term used to describe a scene or image with great differences in brightness between light and dark areas.

Cool Describes the bluish color associated with higher color temperatures. This term is also used to describe editing techniques that result in an overall bluish tint.

Crop To trim or discard one or more edges of an image. You can crop when taking a picture by changing position (moving closer) to exclude parts of a scene, by zooming in with a zoom lens, or via an image-editing program.

Daylight-balance General term used to describe the color of light at approximately 5,500 K; some examples are midday sunlight or an electronic flash.

Depth of field The zone of acceptable sharpness extending in front of and behind the primary plane of focus in a photo.

Digital zoom A method of making a subject appear closer by cropping away the edges of the scene. Digital zoom reduces the overall file size. Some cameras then increase file size by estimating where to add similar pixels to bring the file back up to full resolution.

DPI (Dots per Inch) A measure of printing resolution.

Dye sublimation A type of photo printer that uses gaseous color dyes to create a continuous-tone image that resembles a traditional photograph.

Dynamic range The difference between the lightest and darkest values in an image. A camera that can hold detail in both highlight and shadow areas over a broad range of values is said to have a high dynamic range.

Exposure The amount of light reaching a light-sensitive medium, such as the film or an image sensor. This is the result of the intensity of light multiplied by the length of time during which the light strikes the medium.

Exposure compensation A camera control that allows the photographer to overexpose (plus setting) or underexpose (minus setting) images by a specified amount from the metered exposure.

Extension tube A hollow ring attached between the camera lens mount and the lens that increases the distance between the optical center of the lens and the sensor, and decreases the minimum focusing distance.

F-number A number representing the maximum light-gathering ability of a lens, or the aperture setting at which a photo is taken. It is calculated by dividing the focal length of the lens by its diameter. Wide apertures are designated with small numbers, such as f/2.8, and narrow apertures are designated with large numbers, such as f/22. See also *Aperture*.

F-stop See *Aperture* and *F-number*.

Fast Refers to film, digital camera settings, and photographic paper that have high sensitivity to light. This term also refers to lenses that offer a very wide aperture, such as f/1.4, and to a short shutter speed.

File format The form (data structure) in which you store digital images, such as JPEG, TIFF, RAW, and so on.

Filter A piece of glass or plastic that is usually attached to or placed in front of the lens to alter the color, intensity, or quality of the light. You can also use filters to alter the rendition of tones, reduce haze and glare, and create special effects such as soft focus and star effects.

Flare Unwanted light reflecting and scattering inside the lens, and causing a loss of contrast and sharpness (and/or artifacts) in the image.

Flat Describes a scene, light, photograph, or negative that displays little difference between dark and light tones; the opposite of contrasty.

Focal length The distance from the optical center of the lens to the focal plane when the lens is focused on infinity. The longer the focal length is, the greater the magnification.

Focal point The point on a focused image where rays of light intersect after reflecting from a single point on a subject.

Focus The point at which light rays from the lens converge to form a sharp image. This is also the sharpest point in an image and is achieved by adjusting the distance between the lens and image.

Frame Used to indicate a single exposure or image. This also refers to the edges around the image.

Front light Light that comes from behind or beside the camera to strike the front of the subject.

Gigabyte The typical measure of the capacity of digital mass-storage devices; slightly more than one billion bytes.

Grain A speckled appearance in photos. In film photographs, grain appears when the pattern of light-sensitive silver halide particles or dye molecules becomes visible under magnification or enlargement. In digital images, grain appears as multicolored flecks, and is also referred to as noise. Grain is most visible in high-speed film photos and in digital images that are captured at high ISO settings. See also *Noise*.

Gray-balanced The property of a color model or color profile where equal values of red, green, and blue correspond to a neutral gray value.

Gray card A card that reflects a known percentage of the light that falls on it. Typical grayscale cards reflect 18 percent of the light. Gray cards are standard for taking accurate exposure-meter readings and for providing a consistent target for color balancing during image capture using a custom white balance, and the color-correction process when you are using an image-editing program.

Grayscale A scale that shows the progression of tones from black to white using tones of gray. This also refers to rendering a digital image in black, white, and tones of gray.

Highlight A term describing a light or bright area in a scene, or the lightest area in a scene.

Histogram A graph that shows the distribution of tones in an image.

Hot shoe A camera mount that accommodates a separate (external) flash unit. Inside the mount are contacts that transmit information between the camera and the flash unit and that trigger the flash when you press the Shutter button.

Hue The color of a pixel defined by the measure of degrees on the color wheel, starting at zero for red. The color of the pixel depends on the color system and controls.

ICC (International Color Consortium) A group of companies devoted to developing industry-wide standards for color management. For more information, go to www.color.org.

ICC profile A standard format data file defined by the ICC to describe the color behavior of a specific device. ICC profiles maintain consistent color throughout a color-managed workflow and across computer platforms.

Infinity The farthest position on the distance scale of a lens (approximately 50 feet and beyond).

ISO (International Organization for Standardization) A rating that describes the sensitivity to light of film or an image sensor. ISO in digital cameras refers to the amplification of the signal at the photosites. This is also commonly referred to as film speed. ISO is expressed in numbers, such as ISO 125, and each successively higher ISO number doubles as the sensitivity to light doubles; for example, ISO 200 is twice as sensitive to light as ISO 100.

JPEG (Joint Photographic Experts Group) A lossy file format that compresses data by discarding information from the original file.

Kelvin A scale for measuring temperature based around absolute zero. The scale is used in photography to quantify the color temperature of light. See also *Color Temperature* and *Warm*.

LCD (Liquid Crystal Display) Commonly used to describe the image screen on digital cameras.

Lightness A measure of the amount of light that is reflected or emitted. See also *Brightness* and *Luminance*.

Linear A relationship where doubling the intensity of light produces double the response, as in digital images. The human eye does not respond to light in a linear fashion. See also *Nonlinear.*

Lossless A term that refers to file compression that discards no image data. This compression type can discard image data as long as it can recreate the data later – for example, it can discard redundant image data. TIFF is a lossless file format.

Lossy A term that refers to compression algorithms that discard image data, often in the process of compressing image data to a smaller size. The higher the compression rate, the more data that is discarded, and the lower the image quality. JPEG is a lossy file format.

Luminance The light reflected or produced by an area of the subject in a specific direction and measurable by a reflected light meter. See also *Brightness* and *Lightness*.

Macro lens Describes a lens with a close focusing distance that produces the subject at one-half to life-size magnification.

Manual A camera mode in which you set both the aperture and the shutter speed.

Megabyte Slightly more than one million bytes.

Megapixel A measure of the capacity of a digital image sensor. Also, one million pixels, or picture elements.

Memory card In digital photography, removable media that stores digital images, such as the CompactFlash media that is used to store Digital Rebel XTi/400D images.

Metadata Data about data, or more specifically, information about a file. Data embedded in image files by the camera includes aperture, shutter speed, ISO, focal length, date of capture, and other technical information. Photographers can add additional metadata in image-editing programs, including name, address, copyright, and so on.

Middle gray A shade of gray that has 18 percent reflectance.

Midtone An area of medium brightness or middle gray in an image; a medium-gray tone in a photographic print. A midtone is neither a dark shadow nor a bright highlight.

Mode dial The large dial on the top right of the camera that allows you to select shooting modes in the Basic and Creative Zones.

Moiré Bands of diagonal distortions in an image that are caused by interference between two geometrically regular patterns in a scene or between the pattern in a scene and the image sensor grid.

Mottle An uneven gray area of a photographic print.

Noise Unwanted visible artifacts that degrade digital image quality. See also *Grain.*

Nonlinear A relationship where a change in stimulus does not always produce a corresponding change in response. For example, if the light in a room is doubled, the room is not perceived as being twice as bright. See also *Linear.*

Normal lens or zoom setting A lens or zoom setting whose focal length is approximately the same as the diagonal measurement of the film or image sensor that is used. In 35mm format, a 50mm to 60mm lens is considered to be a normal lens. A normal lens setting most closely represents the perspective of human vision.

Open up To switch to a lower f-stop, which increases the size of the diaphragm opening.

Optical zoom Subject magnification that results from the lens contrasted with subject magnification achieved by cropping the image to make the subject appear closer.

Overexposure Exposing film or an image sensor to more light than is required to make an acceptable exposure. The resulting picture is too light.

Panning A technique of moving the camera horizontally to follow a moving subject, which keeps the subject sharp but creates a creative blur of background details.

Pincushion distortion A lens aberration causing straight lines to bow inward toward the center of the image.

Pixel The smallest unit of information in a digital image. Pixels contain tone and color that can be modified. The human eye merges very small pixels so that they appear as continuous tones.

Plane of critical focus The most sharply focused area of a scene.

Polarizing filter A filter that reduces glare from reflective surfaces such as glass or water at certain angles.

PPI (Pixels per Inch) The number of pixels per linear inch on a monitor or image file. This term is used to describe overall display quality or resolution.

RAM (Random Access Memory) The memory in a computer that temporarily stores information for rapid access.

RAW A proprietary file format that has little or no in-camera processing. Processing RAW files requires special image-conversion software such as Canon's Digital Photo Professional or Adobe's Camera Raw conversion program. Because image data has not been processed, you can change key camera settings, including exposure and white balance, in the conversion program after you take the picture.

Reflected light meter A device — usually a built-in camera meter — that measures light that is emitted by a photographic subject.

Reflector A surface, such as white cardboard, that is used to redirect light into shadow areas of a scene or subject.

Resampling A method of averaging surrounding pixels to add to the number of pixels in a digital image. This method is used to increase resolution of an image in an image-editing or RAW conversion program to make a larger print from the image.

Resolution The number of pixels per side of a 1mm × 1mm square, or the number of pixels in a linear inch. Resolution is the amount of information present in a digital image to represent detail in that image.

RGB (Red, Green, Blue) A color model that is based on additive primary colors of red, green, and blue. This model is used to represent colors based on how much light of each primary color is required to produce a given color.

Saturation As it pertains to color, a strong, pure hue that is undiluted by the presence of white, black, or other colors. The higher the color purity is, the more vibrant the color.

Sharp The point in an image at which fine detail and textures are clear and well defined.

Sharpen A method in image editing of enhancing the definition of edges in an image to make it appear sharper. See also *Unsharp Mask*.

Shutter A mechanism that regulates the amount of time during which light is allowed into the camera to make an exposure. Shutter time or shutter speed is expressed in seconds and fractions of seconds, such as 1/30 second.

Shutter priority (Tv Shutter-priority AE) A semiautomatic camera mode that allows you to set the shutter speed and the camera to automatically set the aperture (f-number) for correct exposure.

Side lighting Light that strikes the subject from the side.

Silhouette A scene where the background is much more brightly lit than the subject.

Slow Refers to film, digital camera settings, and photographic paper that have low sensitivity to light, and therefore require more light to achieve accurate exposure. This term also refers to lenses that have a relatively small aperture, such as f/3.5 or f/5.6, and to a long shutter speed.

SLR (Single Lens Reflex) A type of camera that enables the photographer to see the scene through the lens that takes the picture. A reflex mirror reflects the scene through the viewfinder. The mirror retracts when you press the Shutter button.

Speed Refers to the relative sensitivity to light of photographic materials such as film, digital camera sensors, and photo paper. Speed of photographic materials such as film is indicated by the ISO number. This term also refers to the ability of a lens to allow more light in by opening the lens to a wider aperture.

Spot meter A device that measures reflected light or brightness from a small portion of a subject.

sRGB A color space that encompasses a typical computer monitor.

Stop See *Aperture*.

Stop down To switch to a higher f-stop, thereby reducing the size of the diaphragm opening.

Telephoto A lens or zoom setting with a focal length longer than 50mm to 60mm in a 35mm format.

Telephoto effect The effect that a telephoto lens creates to make objects appear to be closer to the camera and to each other than they really are.

TIFF (Tagged Image File Format) A universal file format that most computers and image-editing applications can read and display. The TIFF format is commonly used for images, supports 16.8 million colors, and offers lossless compression to preserve all of the original file information.

Tonal range The range from the lightest to the darkest tones in an image.

Top lighting Light that strikes a subject from above, such as sunlight at midday.

TTL (Through The Lens) A system that reads the light that is passing through a lens and that will expose film or strike an image sensor. A TTL system is useful when using accessories — such as filters, extension tubes, and teleconverters — that reduce the amount of light reaching the film or sensor.

Tungsten lighting Common household lighting that uses tungsten filaments. Without filtering or adjusting to the correct white-balance settings, pictures taken under tungsten light display a yellow-orange color cast.

Underexposure Exposing film or an image sensor to less light than is required to make an accurate exposure. The resulting picture is too dark.

Unsharp Mask In digital image editing, a filter that increases the apparent sharpness of the image. The Unsharp Mask filter cannot correct an out-of-focus image. See also *Sharpen*.

Value The relative lightness or darkness of an area. Dark areas have low values, and light areas have high values.

Viewfinder A viewing device on the camera that allows the photographer to see all or part of the scene that will be included in the final picture. Some viewfinders show the scene as the lens sees it. Others show the approximate area that will be captured in the image.

Vignetting Darkening of edges on an image that can be caused by lens distortion, using a filter, or using the wrong lens hood. This effect is also used creatively in image editing to draw the viewer's eye toward the center of the image.

Warm Reddish colors that are often associated with lower color temperatures. See also *Kelvin*.

White balance The relative intensity of red, green, and blue in a light source. On a digital camera, white balance compensates for light that is different from daylight to create correct color balance.

Wide angle Describes a lens with a focal length shorter than 50mm to 60mm in full-frame 35mm format.

Index

Numbers

8-bit mode, image editing, 230

A

ACDSee, image viewer/organizer, 224
action shots, Shutter-priority AE (Tv) mode, 44–45
action/sports photography, 125–130
A-DEP (automatic depth of field) mode
 architectural photography, 125
 autofocus points, 7
 Creative Zone mode, 6
 group shots, 42–43
Adobe Camera Raw
 black-and-white image conversions, 131
 digital noise reduction, 72
 upsampling, 157
Adobe Lightroom, black-and-white image conversions, 131
Adobe Photoshop Elements, 228–230
Adobe RGB color space, when to use, 32
AE (Auto-exposure) lock, exposures, 49–50
AEB (Auto Exposure Bracketing), tricky lighting conditions, 48–49
aesthetics, still-life photography, 193
AF (Autofocus) points, selection criteria, 53–55
AF (Autofocus) system
 AE (Auto-exposure) lock, 49–50
 focusing modes, 52–53
 metering modes, 46–47
AF Point Selector button, AF point selections, 54–55
AI Focus AF mode, still subjects, 52
AI Servo AF mode, moving subjects, 52
alternative processing, fine-art photography, 157
amateur/local events, action/sports photography, 130
animal/pet photography, 174–178
Aperture-priority AE mode (Av)
 aperture settings, 75
 candid photography, 141
 Creative Zone mode, 6
 day-to-day shooting, 43–44
 environmental portrait photography, 147
 silhouettes, 204

apertures
 candid photography, 141
 depth of field factor, 76–78
 fireworks photography, 167
 intensity element, 73–76
 telephoto lenses, 102
 wide angle lenses, 100
architectural photography, 120–125
assistants, child photography, 146
atmospheric temperature, color temperature, 85
auto bracketing, white balance settings, 26
auto clean, overriding, 2
Auto Exposure Bracketing (AEB), tricky lighting conditions, 48–49
Auto Focus
 point-and-shoot pictures, 2
 portrait photography, 146
 viewfinder display, 18
Auto Playback, slide show view, 57–58
Auto reset, file numbering method, 33
Auto White Balance (AWB), 24–27
Auto-exposure (AE) lock, exposures, 49–50
Autofocus (AF) points
 initial setup, 7
 selection criteria, 53–55
Autofocus (AF) system, focusing modes, 52–53
automatic depth of field (A-DEP) mode
 architectural photography, 125
 autofocus points, 7
 Creative Zone mode, 6
 group shots, 42–43
automatic sensor cleaning, enabling/disabling, 63–64
Av (Aperture-priority AE) mode
 aperture settings, 75
 candid photography, 141
 Creative Zone mode, 6
 day-to-day shooting, 43–44
 environmental portrait photography, 147
 silhouettes, 204
AWB (Auto White Balance), 24–27

B

baby/child wrangler, child photography, 146
backdrops
 flower/macro photography, 161
 landscape/nature photography, 165

backgrounds
environmental portrait photography, 150
portrait photography, 182
still-life photography, 193
symmetry consideration, 113–114
backlighting
Center-weighted Average metering mode, 47
directional light condition, 93
Partial metering mode, 47
backup gear, wedding photography, 219
backups, images, 222
Basic Zone modes
AF point selection, 53–54
aperture settings, 74–75
autofocus points, 7
automatic settings, 36–37
Close-up, 39
Evaluative metering mode, 46–47
Flash-off, 41
Full Auto, 36, 37
image quality settings, 23
JPEG image quality, 3–4
Landscape, 38–39
metering modes, 8
Night Portrait, 40–41
Portrait, 38
shutter speeds, 78
Sports, 39–40
batteries
Battery Grip BG-E3, 18
charging cycle, 18
date/time backup, 18
image download issues, 222
life span, 19
NB-2L lithium-ion Battery Pack, 18
operating temperatures, 18
photojournalism, 181
Battery Grip BG-E3, optional battery pack, 18
black-and-white photography, 130–134
blemishes, image editing, 229
blur shots, shutter speeds, 78
bubble level
keystoning, 101
low-light/night photography, 171
burn/dodge, image editing, 230
burst rate, Continuous Drive mode, 125
burst speed, 27 Large/Fine JPEG images, 19
business photography, 135–138

C

camera controls, illustrated, 14–16
camera covers, weather/seasonal photography,
212
cameras, USB cable connections, 221–224

camera-to-subject distance
composition element, 116
depth of field factor, 76–78
candid photography, 138–141
Canon EOS Digital Solution, 222–227
Canon File Viewer Utility, 224
Canon Speedlite 550EX, accessory flash, 184
Canon's Digital Photo Professional
black-and-white image conversions, 131
Dust Delete Data, 63–65
captions, stock photography, 198
card readers, image downloading, 9, 224–225
catch-lights, portrait photography, 184
CD/DVD drives, image backups, 222
Center-weighted Average, metering mode, 8, 47
CF (CompactFlash) Type I/Type II media cards
formatting, 19–20
image transfers, 9
charging cycle, NB-2LH lithium-ion Battery Pack,
18
child photography
parental permission, 120
techniques, 142–146
Close-up mode
automatic settings, 39
Basic Zone mode, 5
close-up shots, macro lenses, 103–104
clothing, portrait photography, 185
clouds, sunrise/sunset photography, 207
Cloudy/Twilight/Sunset mode
diffused light conditions, 87
sunset shots, 87
white balance settings, 24–27
color corrections, image editing, 229, 230
color filters, Monochrome Picture Style, 31–33
color hues, lighting element, 83–85
color spaces
Adobe RGB, 32
sRGB, 32
color temperature
lighting element, 84–85
white balance adjustments, 24
colors
architectural photography, 125
business photography, 138
composition element, 114–115
flower/macro photography, 161
sunrise/sunset photography, 207
travel photography, 209
weather/seasonal photography, 215
CompactFlash (CF) Type I/Type II media cards. *See
also* media cards
formatting, 19–20
image transfers, 9

CompactFlash card door, red access light, 2, 21
compensation, exposure, 47–48
complementary colors, composition element, 114–115
composition
 business photography, 138
 colors, 114–115
 depth of field, 115–116
 differential focusing, 115
 focus, 115–116
 panoramic photography, 174
 practice techniques, 108–109
 rule of thirds, 109
 simple versus complex, 108
 space/perspective, 116
 street photography, 199
 symmetry, 110–114
 travel photography, 207
 viewpoints, 116
compression, JPEG versus RAW file formats, 22–23
computers
 image transfers, 8–10
 USB cable downloads, 221–224
conceptual shots, stock photography, 195
contact sheets, Index Display, 57
continuous, file numbering method, 33
Continuous Drive mode
 action/sports photography, 125
 AEB (Auto Exposure Bracketing), 48–49
 burst rate, 125
 child photography, 142
 pet/animal photography, 175
 setting, 7–8, 55–56
contrast, weather/seasonal photography, 215
contrasty light, hard/harsh light conditions, 90–91
conversation, portrait photography, 188
Creative Zone modes
 A-DEP (Automatic Depth-of-Field), 42–43
 AE (Auto-exposure) lock, 49–50
 AF (Autofocus) modes, 52–53
 AF point selections, 53–55
 aperture settings, 75–76
 Aperture-priority AE (Av), 43–44
 autofocus point settings, 7
 Custom Functions, 55
 Drive mode settings, 7–8
 environmental portrait photography, 147
 exposure compensation, 46–47
 FE (Flash-exposure) lock, 61, 62
 Flash-exposure lock, 184
 image quality settings, 23
 ISO settings, 4
 JPEG image quality, 3–4
 JPEG+RAW image quality, 3–4
 Manual (M), 45

metering modes, 8, 46–47
 Program AE (P), 42
 shutter speeds, 78
 Shutter-priority AE (Tv), 44–45
cropping, image editing, 229
cross keys
 ISO settings, 4
 picture scrolling, 2
 white balance settings, 4
current events, photojournalism, 181
curved lines, grace symbolization, 113
Custom Functions
 changing, 235–236
 Creative Zone modes, 55
 description, 236–237,
Custom Function options, 236–237
Custom, white balance settings, 24–27

D

date/time backup battery, 18
Date/Time menu, date/time setting, 3, 20–21
dates, initial setting, 3, 20–21
Daylight mode
 midday hours, 86–87
 white balance settings, 24–27
day-to-day shots, Aperture-priority AE (Av) mode, 43–44
"decisive moment", street photography, 200
depth of field
 composition, 115–116
 differential focusing, 115
 focus element, 76–78
 increasing/decreasing techniques, 116
 landscape/nature photography, 165
 macro lenses, 104
 panoramic photography, 174
 Program AE mode, 42
 street photography, 199
 telephoto lenses, 102
 wide angle lenses, 100
destinations, travel photography, 207
Dfine program, digital noise reduction, 72
diagonal lines, strength/dynamic tension, 112
differential focusing, depth of field control, 115
diffused light
 soft lighting condition, 91
 white balance settings, 87
digital noise, high ISO settings, 72
Digital Photo Professional
 black-and-white image conversions, 131
 Dust Delete Data, 63–65
 RAW format conversion, 225–227
diopter adjustments, viewfinder display, 18
Direct Image Transfer, image transfers, 9
direction, symmetry element, 111

directional light, lighting conditions, 92–93
DISP button
 image histogram display, 51
 image information display, 58–59
distortion, wide angle lenses, 101, 121
dodge/burn, image editing, 230
downloads
 card readers, 224–225
 PCMCIA cards, 225
 USB cable connection, 221–224
drive modes
 Continuous, 55–56
 Single-shot, 55
 switching between, 7–8
Dust Delete Data, obtaining/applying, 63–65

E

8-bit mode, image editing, 230
electronic flash, white balance settings, 88
elevated shots
 action/sports photography, 130
 flower/macro photography, 161
environmental portrait photography, 146–150
EOS Utility
 image transfers, 9
 USB cable downloads, 222–224
equipment
 theft concerns, 211
 wedding photography, 219
Evaluative metering mode, pros/cons, 8, 46–47
event photography, 150–153
everyday shots, normal lens, 102
exposure bracketing, sunrise/sunset photography, 204
exposure compensation
 landscape/nature, 165
 portrait, 184
 sunrise/sunset, 204
exposures
 AE (Auto-exposure) lock, 49–50
 AEB (Auto Exposure Bracketing), 48–49
 architectural photography, 124
 compensation, 47–48
 equivalent exposures, 80–81
 evaluation techniques, 50–51
 image histograms, 50–51
 intensity, 70, 73–76
 low-light/night photography, 167
 metering modes, 45–47
 scene light, 70
 sensitivity, 70, 71–73
 time, 70, 78–80

extenders
 action/sports photography, 130
 lens focal length, 105–106
eye level, pet/animal photography, 178

F

facial expressions, portrait photography, 188
Faithful Picture Style, when to use, 28–31
family albums, photojournalism, 181
fast-action shots, flash-sync speeds, 61
FAT32 file system, media cards, 19
FE (Flash-exposure) lock, Creative Zone modes, 61, 62
file formats
 JPEG (Joint Photographic Experts Group), 22–23
 RAW, 22–23
files, numbering conventions, 33
filters
 black-and-white, 131–132
 fine-art, 157
 landscape/nature, 161
fine-art photography, 154–157
fireworks photography, 167
firmware, updating, 231–232
flash
 built-in versus external, 60–61
 business photography, 138
 candid photography, 141
 event photography, 151
 fast-action scenes, 61
 Flash-exposure (FE) lock, 61, 62
 low-light conditions, 88
 pet/animal photography, 175
 portrait photography, 183–184
 Red-eye reduction, 61
 wedding photography, 219
 white balance settings, 24–27
Flash off, Basic Zone mode, 5
flash photography, 184
Flash-exposure (FE) lock, Creative Zone modes, 61, 62
flashlights, low-light/night photography, 171
Flash-off mode, automatic settings, 41
flash-sync speed, shutter speeds, 60–61
flower/macro photography, 157–161
fluorescent light, white balance settings, 89
focal length
 depth of field factor, 76–78
 environmental portrait photography, 149
 lens extender, 105–106
 macro lenses, 103
 multiplication factor, 99–100

focus
AF (Autofocus) points, 53–55
AF (Autofocus) system, 52–53
autofocus beep, 39
composition, 115–116
depth of field factor, 76–78
flower/macro, 161
low-light/night, 171
pet/animal, 178
portrait, 188
still-life, 193
fog, weather/seasonal photography, 213
food photography, shallow depth of field, 76
freeze frames
fast shutter speeds, 125
shutter speeds, 78, 80
Sports mode, 39
front camera controls, illustrated, 14
front lighting, directional light condition, 92
f-stop. *See* apertures
Full Auto mode
automatic settings, 37
Basic Zone mode, 5
illustrated, 36
point-and-shoot pictures, 2
versus Program mode, 41

G

gallery prints, fine-art photography, 157
give-and-take, child photography, 146
Green filter
black-and-white photography, 132
Monochrome Picture Style, 31
group shots
A-DEP mode, 42–43
business photography, 138
extensive depth of field, 76
posing techniques, 183

H

hand position, portrait photography, 188
hard/harsh light, contrasty light conditions, 90–91
harmonizing colors, composition element, 114–115
histograms
image evaluations, 50–51
landscape/nature photography, 161
horizontal lines, stability/peacefulness, 112
horizontal shots, rule of thirds, 109

I

image quality, JPEG versus RAW file formats, 22–23
image series, fine-art photography, 157

images. *See also* pictures
Auto Playback, 57–58
backing up, 222
deleting concerns, 211
digital noise checking, 72
DISP button information display, 58–59
editing techniques, 228–230
erasing, 59
Index Display, 57
keyword organization, 222
magnifying, 59
protecting, 59
recording quality setting, 3–4
single-image playback, 56–57
viewing, 56–59
white balance auto bracketing, 26
Index Display
electronic contact sheet view, 57
magnifying images, 59
inspirations
action/sports, 127
architectural, 122
black-and-white, 132
business, 135–136
candid, 139
child, 144
environmental portrait, 147
event, 151
fine-art, 155
flower/macro, 158
landscape/nature, 163
low-light/night, 168
panoramic, 172
pet/animal, 175–176
photojournalism, 179
portrait, 185
still-life, 190
stock, 195
street, 199–200
sunrise/sunset, 205
travel, 209
weather/seasonal, 213
wedding, 217
intensity, exposure element, 70, 73–76
International Organization for Standardization (ISO)
initial setup, 4
sensitivity, 71–73

J

jagged lines, tension, 113
Joint Photographic Experts Group (JPEG) file format
when to use, 22–23
white balance auto bracketing, 26

K

keystoning, wide angle lens, 101
keywords
 image organization, 222
 stock photography, 198

L

landmarks, travel photography, 209
Landscape mode
 automatic settings, 38–39
 Basic Zone mode, 5
 narrow aperture settings, 74
landscape/nature photography
 extensive depth of field, 76–77
 techniques, 161–165
Landscape Picture Style
 landscape/nature, 162
 when to use, 28–31
laptops, PCMCIA card downloads, 225
large objects, panoramic photography, 174
LCD display
 approximate image remaining information, 19
 illustrated, 16–17
 shutter speeds, 78
left/right cross keys, picture scrolling, 2
lens controls, illustrated, 14–15
lenses
 action/sports, 125–129
 aperture settings, 73–76
 architectural, 120–125
 candid, 139–141
 children, 143–145
 environmental portrait, 147–149
 events, 151–153
 extenders, 105–106
 fine-art photography, 154
 fireworks photography, 167
 flower/macro photography, 157–159
 focal-length multiplication factor, 99–100
 landscape/nature, 162–164
 macro, 97, 103–104
 normal, 96, 100, 102
 panoramic photography, 171–173
 pet/animal photography, 175, 177
 photojournalism, 178–180
 portraits, 182, 187
 shutter speeds, 78–80
 single-focal-length (prime), 97, 98–99
 still-life photography, 189–192
 stock photography, 194–197
 street photography, 199, 202
 sunrise/sunset, 203, 205–206
 telephoto, 96–97, 100, 102–103
 tilt-and-shift, 121

weather/seasonal, 212–214
wedding photography, 216–219
wide angle, 96, 100–102
zoom, 97–98
lens flare, backlighting product, 93
lighting
 action/sports photography, 130
 AE (Auto-exposure) lock, 49–50
 AEB (Auto Exposure Bracketing), 48–49
 aperture settings, 73–76
 architectural photography, 121
 backlighting, 93
 black-and-white photography, 134
 color hues, 83–85
 color temperatures, 84–85
 diffused, 87
 directional lighting conditions, 92–93
 electronic flash, 88
 environmental portrait photography, 150
 event photography, 153
 flower/macro photography, 161
 fluorescent light, 89
 front, 92
 hard/harsh light conditions, 90–91
 ISO settings, 4, 71–73
 landscape/nature photography, 165
 metering modes, 8, 45–47, 90
 midday, 86–87
 portrait photography, 183
 shutter speeds, 78–80
 side, 92
 soft light conditions, 91
 street photography, 203
 sunrise, 86
 sunset, 87
 top, 92
 travel photography, 209
 tungsten light, 88–89
 white balance settings, 4, 24–27
lines, 112–113, 125
lithium-ion batteries
 charging cycle, 18
 life span, 19
local/amateur events, action/sports photography, 130
locations
 environmental portrait, 150
 events, 153
 pet/animals, 175
 travel photography, 207, 209
 weddings, 219
Long Exposure Noise Reduction, low-light/night photography, 167
lossless compression, RAW format, 23

lossy compression, JPEG format, 22
low-light shots
architectural photography, 125
Flash-off mode, 41
shallow depth of field, 76
Shutter-priority AE (Tv) mode, 44–45
low-light/night photography, 165–171
L-series Canon lenses, lens extender, 105–106

M

M (Manual) mode
aperture settings, 75–76
automatic setting override, 45
Creative Zone mode, 6
fireworks photography, 167
low-light/night photography, 166
macro lenses
depth of field, 104
focal lengths, 103
magnification factors, 104
when to use, 97
macro shots, Close-up mode, 39
macro/flower photography, 157–161
magnification
Index Display, 59
macro lens factor, 104
Manual (M) mode
automatic setting override, 45
aperture settings, 75–76
Creative Zone mode, 6
fireworks photography, 167
low-light/night photography, 166
Manual reset, file numbering method, 33
marketability, stock photography, 198
media cards. *See also* CompactFlash (CF) Type
I/Type II media cards
CF (CompactFlash) Type I/Type II, 19–20
FAT32 file system, 19
file numbering methods, 33
formatting, 19–20
red access light, 21
shooting pictures without, 20
speed ratings, 19
metadata, date/time information, 20–21
metering modes
AE (Auto-exposure) lock, 49–50
Center-weighted Average, 47
Evaluative, 46–47
Partial, 46, 47
switching between, 8
microdrives, Digital Rebel XTi400D support, 19
midday, white balance settings, 86–87
mixed-light shots, custom white balance settings,
26–27

Mode dial
Basic Zone modes, 3–5, 36–41
Creative Zone modes, 3–6, 41–45
Full Auto mode, 2, 36, 37
moisture, weather/seasonal photography, 212
Monochrome Picture Style
black-and-white photography, 131–132
fine-art photography, 157
toning effects, 31–33
when to use, 28–31
motion blurs, slow shutter speeds, 125
moving subjects, AI Servo AF mode, 52

N

natural forms, black-and-white photography, 134
nature shots, Portrait mode, 38
nature/landscape photography, 161–165
NB-2LH lithium-ion Battery Pack, charging cycle,
18
NDGrad filter, landscape/nature photography, 161
NeatImage, digital noise reduction, 72
Neutral Picture Style, when to use, 28–31
Night Portrait mode
automatic settings, 40–41
Basic Zone mode, 5
night/low-light photography
architectural photography, 125
techniques, 165–171
NIK Software's Dfine, digital noise reduction, 72
Noise Ninja, digital noise reduction, 72
normal lenses
everyday shots, 102
focal-length multiplication factor, 100
still-life photography, 189
when to use, 96

O

One-Shot AF mode, still subjects, 52
operating temperatures, batteries, 18
Orange filter
black-and-white photography, 132
Monochrome Picture Style, 31
outdoor shots, rule of thirds, 109

P

P (Program AE) mode
aperture settings, 75–76
shiftable mode, 5, 42
Creative Zone mode, 5
panning, blurring background elements, 125
panoramic photography
Manual (M) mode, 45
techniques, 171–174
Partial metering mode, spot meter equivalent, 8,
46, 47

patience, candid photography, 141
PCMCIA cards, image downloading, 225
people, travel photography, 207, 209
permissions
 event photography, 153
 photojournalism, 181
 privacy issues, 120
perspective
 business photography, 138
 composition element, 116
 telephoto lenses, 102
 wide angle lenses, 101
pet/animal photography, 174–178
photo "stories", street photography, 203
photography
 image backups, 222
 keyword organization, 222
 privacy issues, 120
photojournalism, 178–181
Photoshop CS, image editing techniques, 228–230
Photoshop, upsampling, 157
PhotoStitch, panoramic photos, 172
Picture Styles
 Faithful, 28–31
 Landscape, 28–31
 Monochrome, 28–33
 Neutral, 28–31
 Portrait, 28–31
 Standard, 28–31
 still-life photography, 193
 user-defined, 30, 31–32
pictures. *See also* images
 metadata information, 20–21
 point-and-shoot, 2
 scrolling, 2
 shooting without media cards, 20
 USB cable download, 221–224
place-and-space, architectural photography, 125
playback
 Auto Playback, 57–58
 DISP button information display, 58–59
 Index Display, 57
 single-image, 56–57
Playback button, picture scrolling, 2
point-and-shoot pictures, Full Auto mode, 2
polarizing filters
 architectural photography, 124
 landscape/nature photography, 162
portfolios, stock photography, 198
Portrait mode
 automatic settings, 38
 Basic Zone mode, 5
 environmental portrait photography, 147
 wide aperture settings, 74
portrait photography, 182–188

Portrait Picture Style, when to use, 28–31
portraits
 rule of thirds, 109
 shallow depth of field, 76–77
poses
 environmental portrait photography, 150
 portrait photography, 184, 188
positional shots, event photography, 153
prime (single-focal-length) lenses, pros/cons, 98–99
privacy issues, public/private locations, 120
private property, privacy issues, 120
Program AE mode (P)
 aperture settings, 75–76
 Creative Zone mode, 5
 shiftable mode, 5, 42
 versus Full Auto mode, 41
props, portrait photography, 182
protection, images, 59
psychology skills, wedding photography, 219
public property, privacy issues, 120

Q

Quick Tour
 auto clean override, 2
 Auto Focus, 2
 autofocus point setup, 7
 Basic Zone modes, 3–4, 5
 CompactFlash card door, 2
 Creative Zone modes, 3–4, 5–6
 date/time setting, 3
 Drive modes, 7–8
 Full Auto mode pictures, 2
 image recording quality settings, 3–4
 image transfers, 8–10
 initial pictures, 1–3
 ISO settings, 4
 metering modes, 8
 picture scrolling, 2
 Playback button, 2
 white balance settings, 4

R

rain/snow, weather/seasonal photography, 212–213
RAW format
 fine-art photography, 157
 histogram evaluation, 51
 image conversions, 225–227
 when to use, 22–23
rear camera controls, illustrated, 15–16
Red filter
 black-and-white photography, 132
 Monochrome Picture Style, 31
Red-eye reduction, supported exposure modes, 61

reflectors, travel photography, 211
research, travel photography, 207, 211
resolutions, stock photography, 194
right/left cross keys, picture scrolling, 2
rule of thirds, composition, 109

S

safety, low-light/night photography, 171
scale, landscape/nature photography, 165
scene coverage, telephoto lenses, 102
scene framing, landscape/nature photography, 165
scene light, exposure element, 70
scrapbooking, photojournalism, 181
scrim, diffuse light, 87
seasonal/weather photography, 212–215
Self-timer/Remote control mode
 AEB (Auto Exposure Bracketing), 48–49
 Drive mode setting, 7–8, 55
 low-light/night photography, 171
sense of balance, symmetry element, 111
sense-of-place, landscape/nature photography, 165
sensitivity, exposure element, 70, 71–73
sensors
 auto clean override, 2
 automatic cleaning, 63–64
 focal-length multiplication factor, 99–100
 ISO settings, 4
 shutter speeds, 78–80
session planning, child photography, 146
Shade, white balance settings, 24–27
shadow compensation, business photography, 138
sharpness, image editing, 230
Shutter button
 auto clean override, 2
 Auto Focus point, 2
 restoring LCD/viewfinder display, 17
shutter speeds
 action/sports photography, 130
 flash-sync speed, 60–61
 freeze motion, 125
 increasing/decreasing, 78–80
 motion blurs, 125
 Program AE mode, 42
Shutter-priority AE mode (Tv)
 Creative Zone mode, 6
 low-light shots, 44–45
side lighting, 47, 92
silhouettes, sunrise/sunset photography, 204
Single
 AEB (Auto Exposure Bracketing), 48–49
 Drive mode setting, 7–8, 55
single-focal-length (prime) lenses, 98–99
slide shows, Auto Playback, 57–58
snapshots, Full Auto mode, 37
snow scenes, exposure compensation, 46–47

snow/rain, weather/seasonal photography, 212–213
soft light, lighting condition, 91
software, updating, 231–232
speed ratings, media cards, 19
Sports mode
 automatic settings, 39–40
 Basic Zone mode, 5
sports/action photography
 Shutter-priority AE (Tv) mode, 44–45
 techniques, 125–130
spot meters, Partial metering mode equivalent, 46, 47
sRGB color space, when to use, 32
stadium venues, shallow depth of field, 76
Standard Picture Style, when to use, 28–31
still subjects, 52
still-life photography
 Portrait mode, 38
 shallow depth of field, 76
 techniques, 188–193
stock photography, 193–198
stop action shots
 Sports mode, 39
 shutter speeds, 78, 80
straightening, image editing, 229
street photography, 198–203
styles, stock photography, 198
subject framing, portrait photography, 188
subjects
 environmental portrait, 150
 fine-art, 154
 portrait, 146
 rule of thirds, 109
 still-life, 190
 symmetry considerations, 114
sunrise/sunset photography
 techniques, 203–207
 white balance settings, 86, 87
symmetry
 backgrounds, 113–114
 composition pros/cons, 110–111
 direction, 111
 fill frames, 113
 lines, 112–113
 sense of balance, 111
 subject framing, 114
 tone, 111

T

telephoto lenses
 action/sports, 125
 apertures, 102
 architectural, 120–125

Continued

telephoto lenses *(continued)*
 candid, 141
 depth of field, 102
 focal-length multiplication factor, 100
 landscape/nature, 165
 perspective, 102
 portrait, 182
 scene coverage, 102
 still-life, 189
 street, 199
 when to use, 96–97
temperature
 color versus atmospheric, 85
 operating, 18
 white balance adjustments, 24
terms, 243–252
texture emphasis, black-and-white photography,
 134
thumbnails, Index Display, 57
tilt-and-shift lenses, perspective distortion
 correction, 121
Time value (Tv), Creative Zone mode, 6
times
 exposure element, 70, 78–80
 initial setting, 3, 20–21
tonal divisions, black-and-white photography, 134
tonal range
 image editing, 228
 symmetry element, 111
toning effects
 black-and-white photography, 132
 Monochrome Picture Style, 31–33
top camera controls, illustrated, 15
top lighting, directional light condition, 92
travel photography, 207–211
treats/toys, pet/animal photography, 178
Tungsten
 household lights/lamps, 88–89
 white balance settings, 24–27
Tv (Shutter-priority AE) mode
 Creative Zone mode, 6
 low-light shots, 44–45
Tv (Time value), Creative Zone mode, 6

U

updates, firmware/software, 231–232
upsampling
 fine-art photography, 157
 stock photography, 194
USB cables, image downloading, 221–224

V

vertical lines, motion/strength implication, 113
vertical shots, rule of thirds, 109

viewfinder display
 diopter adjustments, 18
 illustrated, 17–18
 shutter speeds, 78
viewpoints, composition consideration, 116

W

water-repellant fabric, 212
wavy lines, peaceful movement implication, 113
WB SHIFT/BKT function, white balance
 adjustments, 24, 26
weather/seasonal photography, 212–215
Web sites
 ACDSee, 224
 Anderson Ranch Arts Center, 240
 Ansel Adams Gallery Workshops, 240
 BetterPhoto, 240
 Brooks Institute Weekend Workshops, 240
 Canon, 239–241
 Canon Picture Styles, 30
 Communication Arts, 240
 Digital Image Cafe, 240
 Digital Photo Pro, 240
 Digital Photographer, 240
 Eddie Adams Workshop, 240
 firmware updates, 231
 Mentor Series, 240
 Missouri Photo Workshop, 240
 Mountain Workshops, 240
 NeatImage, 72
 NIK Software's Dfine, 72
 Noise Ninja, 72
 Outdoor Photographer, 240
 Palm Beach Photographic Center Workshops,
 240
 PC Photo, 240
 Photo District News, 240
 Photography at the Summit, 241
 Popular Photography & Imaging, 240
 Rocky Mountain Photo Adventures, 241
 Santa Fe Workshops, 241
 Shutterbug, 240
 Toscana Photographic Workshop, 241
 Woodstock Photography Workshops, 241
 The Workshops, 240
Web-friendly images, image editing, 230
wedding photography, 216–219
white balance
 color temperatures, 24, 84–85
 diffused, 87
 electronic flash, 88
 fluorescent light, 89
 initial setup, 4
 midday, 86–87

settings, 24–27
sunrise, 86
sunset, 87
tungsten light, 88–89
White Fluorescent
 fluorescent light conditions, 89
 white balance settings, 24–27
wide angle lenses
 apertures, 100
 architectural photography, 120–125
 depth of field, 100
 distortion, 101, 121
 focal-length multiplication factor, 100
 keystoning, 101
 perspective, 101
 portrait photography, 182
 still-life photography, 189
 when to use, 96
"wow" factor, action/sports photography, 130

Y
Yellow filter, 31, 131

Z
zigzag lines, sense of action, 113
zoom lenses
 action/sports, 126
 architectural, 120–125
 candid photography, 139
 pros/cons, 97–98
 still-life, 189
 street photography, 199
ZoomBrowser EX, image viewer/organizer, 222–224

Pack the essentials.

These aren't just books. They're *gear*. Pack these colorful how-to guides in your bag along with your camera, iPod, and notebook, and you'll have the essential tips and techniques you'll need while on the go!

0-470-11007-4 • $19.99
978-0-470-11007-2

0-470-03748-2 • $19.99
978-0-470-03748-5

0-471-78746-9 • $19.99
978-0-471-78746-4

0-470-05340-2 • $19.99
978-0-470-05340-9

0-471-79834-7 • $19.99
978-0-471-79834-7

0-7645-9679-9 • $19.99
978-0-7645-9679-7

Also available
PowerBook and iBook Digital Field Guide • 0-7645-9680-2 • $19.99
Digital Photography Digital Field Guide • 0-7645-9785-X • $19.99
Nikon D70 Digital Field Guide • 0-7645-9678-0 • $19.99
Canon EOS Digital Rebel Digital Field Guide • 0-7645-8813-3 • $19.99

Available wherever books are sold
Wiley and the Wiley logo are registered trademarks of John Wiley & Sons, Inc. and/ or its affiliates. All other trademarks are the property of their respective owners.

WILEY
Now you know.
wiley.com